JAPAN
FROM
ANIME
TO ZEN

T0152255

QUICK TAKES
ON CULTURE, ART, HISTORY, FOOD
. . . AND MORE

JAPAN
FROM
ANIME
TO ZEN

DAVID WATTS BARTON

with illustrations by Yuko Nagasaki

Stone Bridge Press • *Berkeley, California*

To Iku:

For years of advice, inspiration, and love.

The moon is beautiful.

Published by
Stone Bridge Press
P. O. Box 8208, Berkeley, CA 94707
TEL 510-524-8732 · sbp@stonebridge.com · www.stonebridge.com

Text © 2021 David Watts Barton.

Illustrations by Yuko Nagasaki.

Front-cover design and artwork by Iku Oyamada, HI(NY) Design.

All rights reserved.

No part of this book may be reproduced in any form without permission from the publisher.

Printed in the United States of America.

10 9 8 7 6 5 4 3 2 1 2025 2024 2023 2022 2021

p-ISBN 978-1-61172-063-1

e-ISBN 978-1-61172-945-0

CONTENTS

三 Traditional Arts and Culture 119

PREFACE

Everyone understands that Japan is an important country. But it is useful to remember why. For despite its modest size, Japan consistently punches above its weight.

Among countries measured by land mass, Japan is ranked 61st; with 377,930 square kilometers it is barely bigger than Germany or Vietnam and a bit smaller than California. Despite its modest size, the country is roundly impressive. Japan's population ranks eleventh in the world (but is projected to drop below 125 million in 2021 after exceeding 128 million in the first two decades of this century). And in terms of economic output, Japan is positively dazzling: Though it has recently been overtaken in second place by China—which has a population more than ten times as large—Japan's is the third-largest economy in the world.

But beyond its population and economy, Japan consistently ranks near the top of the charts in measures of quality of life: literacy, education, safety, access to medical care, health. That Japan is a successful nation is well known.

But there is a level beyond all of these on which Japan excels, the level of culture. Japan's cultural products are admired around the world, and not just sushi, anime, and karaoke. Rather, Japan is admired for the fullness and uniqueness of its culture: To say something is Japanese is to understand and admire it for its holistic, organic coherence, even if the speaker isn't well versed in the meanings

of Kabuki, the ritual of the tea ceremony, or the nuances of ikebana design.

Despite having its share of societal problems—Japan is by no means perfect, and life for the Japanese can be more stressful and less secure than is imagined from the outside—Japanese society is still remarkably cohesive. Its blend of ancient and modern is united by a distinct Japanese sensibility that is clear even to outsiders.

Most people have little difficulty picturing the superficial expressions of that sensibility: graceful, carefully dressed women and men; efficient, well-functioning cities; studious, respectful children; high-quality food, elegantly served; naturalistic, balanced works of art and architecture; and a seamless integration of technology into daily life. None of these impressions are wrong; they are external expressions of a culture that *insists* on all these things being true.

But these impressions are, of course, incomplete. Despite its many accomplishments, Japan is also a country where women are still effectively second-class citizens, where men sexually objectify girls with the tacit approval of society, and where the suicide rate is at or near the top of the list among the most affluent countries in the world. Social isolation is a growing problem, especially for older people, but also for the young, who literally hide out from modern life in enormous numbers. The cultural drive for conformity, for social responsibility, for ever-greater education in a stagnant economy—as well as other pressures inherent in Japan's cultural and economic greatness—can carry a heavy price. The deeper one dives under the surface of modern Japan, the more obvious these costs become.

Most of these darker aspects are hidden, and visitors won't find their attention drawn to them. Likewise, this book won't dive too deeply into the contemporary sociology of

Japan, which is a book or two of its own. Japan is a big, modern country with a long, complex history. In *Japan from Anime to Zen*, we will deal with the basics.

What we aim to show is that Japanese culture is very much of a piece, that everything is connected to everything else in ways that only slowly reveal themselves: Concepts of symmetry and simplicity, the deep love of nature (and the manipulation of it), the power of space (and the unspoken), the admiration of the imperfect and the aging, and the striving for perfection—these are among the subtleties that animate and unify Japanese culture into something distinctive.

This book began as a series of blog posts for a website called japanology.org, and many of these essays first appeared there. This book expands upon those posts with additional research, new material, and new essays, all aimed at presenting a unified whole. The text is organized into five subject areas: Food and Drink; Modern Arts, Entertainment, and Sports; Traditional Arts and Culture; History and Archetypes; and The Foundations of Japanese Culture. Each section contains more than a dozen short chapters addressing different topics.

Japan from Anime to Zen can be dipped into at any point, particularly as you encounter a topic during a visit; there is no need to start at the beginning and finish at the end. But contrary to what the title suggests, *Japan from Anime to Zen* is not a dictionary or an encyclopedia; nor is it in any way comprehensive. The subject of Japan is huge, and this book doesn't aim to cover everything—that is impossible. But it does offer some insights into aspects of Japanese food, sports, history, arts, architecture, social norms, and religion that the visitor is likely to encounter or perhaps overlook. The idea is to help you be a bit more informed than you might otherwise be.

This book aims to be an informative companion to

travel guidebooks with a where/what/when/how—and how much?—focus. It offers a look at the myriad elements of Japanese culture that you will encounter. For instance: What is that stone pillar you see in Japanese gardens, looking a little like a totem pole of rough shapes piled one atop the other (chapter 84)? Who were the samurai or the ninja, before they were historical or fantasy characters (chapter 60)? How do sumo wrestlers get so big, and why are they so admired (chapter 29)? How are Pure Land Buddhism and Zen Buddhism different (chapter 80)?

There are practical answers too: How does one behave in an *onsen*, at the dinner table, or in a temple or a shrine ... and what's the difference between the last two (chapter 81)? What Japanese movies should I see before I go (chapter 22)? What's the deal with the gorgeous wrapping of seemingly everything (chapter 43)?

Getting to know Japanese culture is a lifelong endeavor, and no one expects a short-time visitor to become anything approaching an expert. For all its extravagant politeness, which many read as friendliness, perhaps even openness, Japan is that oldest of Western clichés about Asia: It is mysterious. To a substantial degree that is by design. Most Japanese, and certainly the state itself, feel strongly that Japan is for the Japanese. The culture is designed on many concepts you will read about here, including the distinction between in-groups (*uchi*) and out-groups (*soto*)—and you are very much *soto*. It is a culture in which there are specific names for the face you show the world (*tatemae*) and your true face (*honne*). It is a country—less touristed than others—that is designed to be seen and appreciated, but not necessarily understood.

And yet, with this book's concise glimpses into aspects of this complex, intimidating, and profoundly beautiful country, you may find that you understand it just a little bit

better—certainly quite a bit better than if you'd just walked and gawked around Tokyo, Kyoto, or Osaka. You may also see things in Japan that you might not have noticed had you not read about them here. After all, part of Japan being "mysterious" is that much of its culture is unseen and unspoken. *Honne* and *tatemae* (chapter 76)—mentioned just above—are good concepts to know about when parsing confusing social interactions, but so is the whole notion of a "high-context" versus "low-context" society (chapter 75), a foreign concept to most Westerners, who live in decidedly low-context societies.

The risk here is that, when you find out about the myriad subtleties of Japanese culture, you will be horrified to know how many social land mines have been laid for you—and how many you have already stepped on, with only the Japanese around you hearing the explosion. Of course, they would never actually say anything about the social carnage you have just created; the Japanese are far too polite for that. On the other hand, being clued-in, even just slightly, might help you sidestep some of those landmines, and gain just a bit of respect from the Japanese around you. Not that you would ever know that they noticed your effort; they're far too polite for that, too.

* * *

Many Japanese words have found their way into English usage or are already familiar to non-Japanese readers. Such words in this book are presented in roman type, that is, they are not italicized, although some exceptions have been made for consistency. Names of Japanese people are given in Western style, family name last, except in the case of historical figures or others whose names are more familiar when presented family name first.

JAPAN

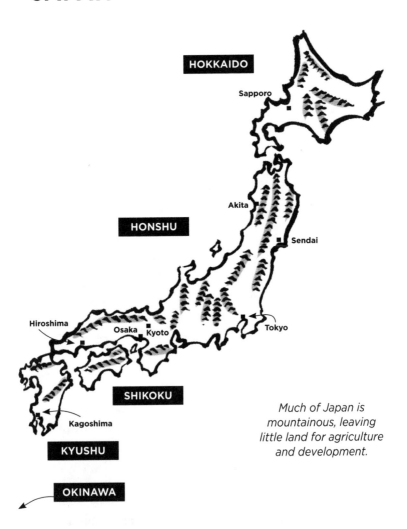

HOKKAIDO

Sapporo

Akita

HONSHU

Sendai

Hiroshima

Osaka

Kyoto

Tokyo

SHIKOKU

Kagoshima

KYUSHU

OKINAWA

Much of Japan is mountainous, leaving little land for agriculture and development.

INTRODUCTION

A LAND APART: JAPAN'S SPECTACULAR, DIVERSE GEOGRAPHY

Geography isn't just destiny, as the old saying points out; it can also be culture, cuisine, and worldview.

Witness Japan.

Japan is a *shimaguni*, or "island country," of 6,852 islands, a mountainous, lush-but-rugged land that stretches from a subtropical south to a largely temperate north. It lies east of the Koreas and Russia, at latitudes roughly similar to the United States. Tokyo sits at about the same latitude as Las Vegas, Nevada, and Tangier, Morocco.

Despite the abundance of islands, four of which dominate and fewer than five hundred of which are inhabited, Japan is not a large place; it ranks 61st in size among the nations of the world, the same as Germany. It is roughly comparable in square kilometers to California and Italy.

Japan is defined by several crucial geographic features: It is more than 73% mountain and, with urban encroachment, less than 12% of its land is now arable. The islands are surrounded by, and permeated by, the sea. No spot in Japan is more than 150 kilometers from its coast, which stretches nearly 30,000 kilometers; and the country gets a tremendous amount of rainfall, which causes most of those mountainous areas to be heavily forested.

There is a fourth feature, perhaps the most dramatic and famous, and certainly the deadliest: Japan is one of the world's most unstable geologic areas, with fully 10% of the active volcanoes in the world—forty in total. A visitor can be in Japan for weeks without feeling an earthquake, but this seismically active land can experience anywhere from one thousand to fifteen hundred measurable earthquakes a year, or roughly three to four a day.

The 1923 Kanto Earthquake was the deadliest on record, killing more than one hundred thousand people in Tokyo. But more recently, earthquakes in Kobe (in 1995) and Tohoku (internationally known as the Fukushima Quake, in 2011) were disastrous events for the densely populated country. The latter brought on a second disaster: The nation's largest-ever quake at magnitude 9.0, it occurred offshore and created an enormous tsunami that damaged or destroyed more than a million buildings, killed nearly sixteen thousand people, and caused a nuclear reactor to melt down, releasing enormous amounts of radioactive water into the all-important sea.

Japan's seismic instability has also given the country its highest point: Mount Fuji, or as the Japanese call it, Fuji-san, a dormant volcano of 3,776 meters that is Japan's national symbol. The mountain is yet another natural threat: Fuji-san last exploded in 1707, but given its proximity to the Tokyo metropolitan area and its tens of millions of residents, Fuji-san is a sleeping giant.

Another element in Japan's geography is its wet, monsoonal climate, contributing rain, snow, and a constant high humidity through all seasons. Only 1% of Japan's surface is composed of lakes, and the biggest lake, Biwa, just north of Kyoto, is one of the country's major sources of potable water. More important, though, are the archipelago's rivers. None are very long—the longest is the Shinano, which stretches 367 kilometers—but

their steepness means there are often cascades that make them perfect for generating hydroelectric power.

The highest mountains in Japan are the three ranges that run north-south across the islands, centered on the biggest island, Honshu. They are generally called the Japanese Alps (or, in Japan, the Nihon Arupusu). Due to the volcanic nature of the land, many of these mountains feature hot springs, or *onsen*, which are of major appeal to both the Japanese and visitors.

Given the rugged, mountainous land, the Japanese have always turned to the sea for sustenance and inspiration; it plays an outsized role in the country's cuisine, its art, and its long isolation from the rest of the world. The sea provides much of the country's food—whether fish or sea vegetables, especially kelp—thanks to the confluence of the warm Oyashio Current coming up from the tropics and the colder Tsushima Current coming down from the Arctic. Where these currents meet, at around the 36th parallel, just north of Tokyo, is one of the world's great fisheries.

Just as importantly, the sea has for centuries insulated and isolated Japan from the Asian continent—even at its closest point to the mainland, it is still 193 kilometers from Russia, its closest neighbor. By contrast, at its closest point, Britain is only 34 kilometers from Europe. Much of Japan's character can be attributed to this one geographical fact. Living in a rugged, turbulent, but exceptionally lush land, ringed by bountiful but isolating seas, Japan's destiny has been, and continues to be, determined largely by its remarkable geography.

And nowhere does Japan's geography, and in particular its intimate, literally all-encompassing relationship to the sea, inform Japan more than in its cuisine. So that is where we begin.

FOOD AND DRINK

No matter how interested in the history or culture or religion of Japan you may be when visiting the country, one thing is for sure: You are going to want to eat. You're going to want to eat *a lot*.

Along with French and Chinese, Japanese food is one of the world's most distinctive cuisines. Whether you're looking forward to a steaming fresh bowl of ramen (or one of the other numerous noodle dishes the Japanese excel at making), or small plates of delicately flavored sushi, sashimi, or *takoyaki* (octopus balls), or one of Japan's under-appreciated curries, or its wide array of truly strange specialties (one of which can kill you if your chef prepares it incorrectly), or even some of the best French and Chinese food in the world, you will find it in Japan.

Japanese chefs don't just excel at Japanese food: The Japanese attention to detail in ingredients, preparation, and presentation— all done with a subtle flair—has led the country, Tokyo in particular, to become home to a staggering variety of restaurants serving international cuisine, from the humble American hamburger to French haute cuisine. Japan certainly ranks with France according to France's prime standard: In 2020 the Michelin Guides to worldwide dining gave their vaunted three-star rating to twenty-two restaurants in Japan, second only to France (with twenty-eight). The United States is a distant third with fourteen.

And that's before we address what the Japanese have done with Scotland's formerly unbeatable gustatory export, Scotch whisky. Let it suffice to say that Japan has no lack of fine dining possibilities. More than that, even the most humble of Japanese eateries, even the fastest of fast food, exists on a level that few other cuisines can hope to aspire to. The Japanese enjoy food, are endlessly creative, and appreciate quality. The combination is nearly unbeatable.

Japan's food culture is all the more remarkable for the country's relative dearth of arable land—a mere 12% of the country— much of which is planted with rice. Because land is so scarce, and

standards are so high, agriculture is an intense undertaking in Japan, with greenhouses and small farms still growing much of the produce and livestock. Japan's farmers are "artisanal" by necessity as well as by nature.

These constraints have also forced the Japanese to become creative with what they do have. And what they have, more than anything else, is a whole lot of ocean. The waters surrounding Japan, from inland seas to wide-open ocean, provide Japan with an abundant supply of fish. But not only fish: Seaweed, cultivated all along the country's coasts, has been turned by the Japanese from what most cultures have considered, well, a "weed" into something integral to Japanese food. Just try having sushi rolls or rice balls or *dashi*, Japanese cuisine's crucial broth base, without the crucial ingredient: dried seaweed.

The Japanese are so inventive with their limited resources, and so finely attuned to flavor, that less than a century ago a Japanese scientist came up with a so-called "fifth flavor," which he dubbed *umami*. In this section, we explore some basic aspects of the ingredients, techniques, tastes, and even table manners that make eating in Japan a singular experience. Let's begin where all good journeys begin, at the dining table.

1. Condiments and Ingredients in Japanese Cuisine

Nearly everyone who lives in a modern city is familiar with Japanese food, which along with Italian, Chinese, and American cuisines is an essential part of an international diet. Everyone knows that rice, noodles, and tofu, along with

chicken, fish, beef, and a great variety of vegetables, are familiar Japanese staples.

But what often makes Japanese food pop is the extraordinary number of condiments and ingredients that either inform the flavors of or add a little something extra to the finished dishes. Far beyond the basic condiments of many international cuisines—the familiar salt and peppers—the variety of Japanese ingredients combine to make Japanese cuisine one of the most distinctive in global gastronomy.

Many of the condiments are familiar to us now, and some—sesame oil, soy sauce, chili sauce—are central to other cuisines. But others, such as bonito flakes, *nori*, and dried shiitake mushrooms, are unique to Japanese cuisine. Still others, such as curry powder, are familiar from other cuisines but are distinctively different in their Japanese form.

There are dozens to choose from, but to keep things manageable, here are eight of the most common ingredients and condiments that you will find in nearly every Japanese meal. There are many more to explore, but these are a good place to start:

- **Shoyu** (Japanese soy sauce): Like so many things, soy sauce first came to Japan from China more than a thousand years ago. But *shoyu*—made from soybeans, wheat, salt, and yeast—and its derivatives such as *tamari* and *ponzu*, are a bit less salty than Chinese soy sauce. *Shoyu* still provides the same lift to foods, especially when used with that staple of any Japanese meal, short-grain white rice. But whatever you do, do not put *shoyu* directly on a bowl of white rice—it is considered something close to sacrilege.

- **Katsuobushi**, or bonito flakes: These flakes of dried and smoked skipjack tuna are a crucial ingredient in

dashi, which forms the basis of many broths, which are in turn a part of many Japanese soups, stews, and other dishes. As with other dried fish such as anchovies, bonito flakes show up everywhere, imparting Japan's beloved *umami*.

- **Shiromiso** (white miso): An ingredient well known for its many uses, white miso is just one of the pastes made from fermenting a combination of soybeans and barley. Miso is, of course, the base in miso soup (yet another *umami*-flavored dish), but it is also used in a variety of marinades and salad dressings. White miso takes considerably less time to ferment than red miso, which has a stronger taste and is therefore used somewhat less often.

- **Nori**: Seaweed is one of Japan's singular contributions to global cuisine, and its uses and benefits continue to be discovered. One of the most nutritious foods in the world (if your body can absorb it, not all can), seaweed shows up in dozens, even hundreds of Japanese dishes. *Nori* is just one of many varieties of seaweed (*wakame* is also useful), but *nori* is particularly well known for its role in many varieties of sushi, and it is used as a wrapping on that most popular of Japanese snacks, the rice ball (*onigiri*). It is also shredded or crushed and used as a condiment sprinkled over many dishes.

- **Komezu** (rice vinegar): Another condiment that comes in many forms, this fermented liquid does everything from providing a dipping sauce for tempura to serving as a binding agent to hold sushi rice together for *nigiri*. Whether sweetened or spicy, *komezu* is considerably less acidic than Western vinegars.

- *Goma abura* (toasted sesame oil): Sesame seeds and their oil are a powerful flavor that is used throughout international cuisine, particularly in Asia and the Middle East, but nowhere have the subtleties of this strong flavor been better harnessed than in Japanese food. A flavoring rather than a cooking oil, when used sparingly it imparts a wonderful, nutty aroma.

- **Dried shiitake mushrooms**: Perhaps the most distinctive flavor on this list, and yet another source of the fifth flavor, *umami*, dried shiitake mushrooms have a flavor that stands out even among mushrooms, known in Japanese as *kinoko*.

- *Furikake*: A condiment you will not see in any other cuisine, *furikake* is a powdered combination of dried and ground fish, sesame seeds, chopped seaweed, sugar, and salt and is most commonly sprinkled on rice.

These are a handful of the ingredients and condiments common in Japanese food. But there are many others, including unusual tastes such as *menma* (dried bamboo), *rayu* (chili oil), *karashi* (powdered mustard), sinus-frying *wasabi*, citrusy *ponzu* sauce, and the piquant pickled plums known as *umeboshi*.

2. The Greenest Staple: Sea Kelp and Its Many Uses

Whether as an ingredient in soups or salads, in the broth *dashi*, or as a topping or a quick snack, the various forms of sea kelp are a versatile, nutritious, and extremely tasty part of Japanese cuisine.

These many forms of the brown algae known as *Laminaria* grow over hundreds of square kilometers of Japan's ocean, from the frigid waters off northern Hokkaido all the way to subtropical Okinawa. Processed and used in different ways, the many different varieties, from familiar *konbu* and *nori* to exotic *ogonori* and *tosaka*, are a big part of why Japanese cuisine is such a unique adventure.

Sea kelp's essential nutrients are staggering: Calcium, iron, magnesium, manganese, iodine, phosphorus, zinc, and a wealth of crucial B vitamins (including hard-to-get B6 and B12), as well as Vitamins C, E, and K—and even large amounts of protein—make sea kelp one of the planet's healthiest foods.

Each type of kelp is different, and each is used for very different purposes. Both *ogonori* and *tosaka*, which are preserved with salt, are eaten only as cold salads. *Nori* is eaten only after being dried and otherwise processed, while *wakame*, sweeter, lighter, and silkier in texture, is dried and then rehydrated—but doesn't benefit from much cooking.

Kanten (known elsewhere as agar-agar) is virtually flavorless but is renowned as a replacement for gelatin, free of the animal sources of other gelatins, and is thus perfect for vegetarian cooking. *Mozuku*, usually eaten with rice vinegar, is said to have anti-cancer properties.

The big three seaweeds used in Japanese cuisine are *konbu*,

Wakame *is a popular sea kelp.*

wakame, and the seaweed that started it all, and whose name was the original generic name for all seaweed: *nori.*

Konbu (Laminaria japonica), for instance, has practically no protein, while *nori* is nearly half protein (by weight) and is loaded with vitamins and minerals, including vitamins A and B1, and crucial zinc, iron, and calcium. It is also high in dietary fiber and amino acids, including glutamine, which can be credited for bringing the world the "fifth taste," *umami* (the other four being, of course, sweet, salty, bitter, and sour).

If that doesn't make you want to eat it every day, you'll want to know that a group of researchers in Great Britain discovered in 2010 that *konbu's* fiber (alginate) helps prevent fat absorption. Like every seaweed, it is very low in calories, can

help reduce swelling, improve liver function, clean the blood, and decrease cholesterol levels.

Konbu is equally important for its use as a key ingredient in the all-important seasoning, *dashi.* Cooked together with dried flakes of the bonito fish and the water of rehydrated shiitake mushrooms, *dashi* assures that the flavor of *konbu* works its way into dishes in which you may not see seaweed at all.

Nori was originally the generic Japanese word for seaweed but now refers to this specific species of red algae. For a millennium *nori* was eaten as a paste, but it is now known as the product of the 18th-century process of rack drying, similar to papermaking, that produces the paper-thin green-black sheets that are used in sushi making, to cover rice balls, as a snack on its own, and in shredded form, as a popular topping on various noodle soups. It is perhaps the best-known (and most-eaten) form of seaweed in the West.

An interesting historical note: After calamitous harvests in the 1940s and 1950s, *nori* cultivation declined, as did its consumption. It was given an unlikely rebirth when an English scientist named Kathleen Drew-Baker discovered an improved way of cultivating the plant, through her studies of a similar kelp in Wales. When Japanese scientist Sokichi Segawa found her work, Japan's understanding of *nori* cultivation was enhanced and production resumed. Baker was rewarded with a posthumous statue in Uto City in Kumamoto Prefecture and the honorific "Mother of the Sea."

Wakame (undaria) is the third and newest of the most popular sea kelps and has been cultivated in any significant quantity only since the early 1960s. It can be eaten fresh and is particularly enjoyable in the seasonal soup *suimono*, paired with fresh bamboo shoots. Or it can be dried and reconstituted for use in *sunomono*, a rice vinegar-flavored salad that also includes cucumbers.

Seaweeds are also seasonal, so if they're not pickled or dried, you'll find different varieties available depending on when you're in Japan. But whenever you go, and whatever your destination, you are sure to find at least one dish—and usually many—whose flavor, texture, nutrition, and even appearance depend on this versatile Japanese ingredient.

3. *Umami*, Japan's "Fifth Flavor"

The Japanese didn't invent what has come to be known as the "fifth flavor"—in addition to the well-known sweet, salty, bitter, and sour—but a Japanese man isolated the chemical responsible and named it *umami*.

In 1907, a chemist at Tokyo's Imperial University named Kikunae Ikeda had an insight that the flavor of one of Japan's staple foods—the broth called *dashi*, a basic ingredient in countless soups, sauces, and stews—had a quality that, chemically and gastronomically, qualified it as a distinctive flavor.

By 1908, Ikeda had isolated the chemical, L-glutamine (an amino acid), and given his discovery a new name: *umami*, combining the words for "delicious" (*umai*) and "taste" (*mi*). By 1909, he had developed a chemical process for isolating the brown crystals that contained the flavor.

Ikeda's discovery was scientific proof of what the Japanese, and chefs the world around, had known for centuries, that there is a "brothy" or "meaty" taste to some foods, particularly meats, seafoods, cheeses, and fermented foods, that is uniquely satisfying. The presence of *umami* can add dimension

to foods, balancing out other flavors—especially salty, but also sweet—and give dishes a depth and satisfaction.

Subsequent Japanese chemists such as Shintaro Kodama (a student of Ikeda's) and much later, Akira Kuninaka, discovered other foods that contained the chemical elements of *umami*, including *dashi's* main ingredient, bonito flakes, and much later, shiitake mushrooms. Kuninaka added greatly to the research when he proved that it was the chemical synergy between ribonucleotides and L-glutamine that created even stronger *umami* flavors.

Still, it wasn't until 2000, when scientists found receptors in the tongue that responded specifically to *umami* chemicals, that the taste was joined to the other four basic tastes. Before that, *umami* was generally thought to be something that enhanced other flavors but was not itself distinctive.

It was the combining of certain foods—what chemists call components but cooks know as ingredients—that produced *umami* flavor by reinforcing and thus strengthening each ingredient's *umami* quality. This is why meats and vegetables create such satisfying flavors, whether in a French ratatouille or a Vietnamese *pho*. Potatoes, tomatoes, eggs, asparagus, mushrooms, walnuts all can, when combined with the right other ingredients, produce an *umami* flavor. Elsewhere, *umami* is the dominant flavor of one of the world's most common food bases: chicken broth, which gets its *umami* from the chicken bones. Likewise, tomato sauces are full of L-glutamine, and when combined with, say, Parmesan cheese ... *umami*!

Because of the ubiquity of *dashi*, the Japanese are familiar with the flavor on its own. It is particularly fitting that *umami* is a Japanese word, because the Japanese are particularly fond of this flavor, it being prominent in such staple foods and sauces as soy sauce, fish sauce, dried fish, seaweed,

pickled plums—and that standby beverage of any Japanese meal, green tea.

Similarly, the fermented vegetables that are so popular in Japan have an *umami* taste because of the combination of various vegetables with the yeast or bacteria that ferment them. Cured meats and aged cheeses, which are not Japanese in origin but which many Japanese love, are also *umami*—as if anyone had to tell you that.

Like fermenting and curing, cooking is a significant aspect of the development of *umami* flavors. Raw meat isn't *umami*, nor are many vegetables; but put them in a pot and let them cook—preferably for a long time—and the *umami* flavors burst out. It's chemistry.

That said, it may be that virtually all humans respond to *umami* flavors because we are given food with a strong *umami* flavor from the moment we are born. Breast milk has approximately the same quality and quantity of *umami* components as a hearty broth.

Ikeda's discovery was not confirmed by Western scientists for many years, long after his death in 1936, but he is not to be pitied. He quickly realized the value of what he had found. He took the chemical that he had isolated and packaged it as a cooking ingredient that quickly became a staple seasoning in Japan and all over Asia and the rest of the world: monosodium glutamate, or MSG. MSG was particularly popular in its "home" country. When in 1986 Westerners were asked to list the basic tastes, they listed sweet, sour, salty, and bitter. But when Japanese were asked the same question, they answered sweet, sour, salty and bitter ... and "Ajinomoto," the commercial name for the global brand of L-glutamine crystals that Ikeda manufactured. And although Ikeda is long departed, the company he founded has its name on one of Tokyo's biggest sports venues: Ajinomoto Stadium.

4. Some Exotic Foods the Japanese Love

Japan offers more extraordinary food experiences than nearly any other country in the world. Even if you want French crepes, or Italian *osso bucco*, or Sichuan stir-fry—even just a great cheeseburger—the Japanese can cook it and cook it well.

While one can explore almost infinite variations on Japanese noodles, Wagyu beef, or seaweed dishes, things can get even more interesting. The Japanese palate is inexhaustibly curious, even daring, and the country is home to dishes that may challenge even the most sophisticated, well-traveled gourmand's tastes.

There are foods available in Japan that some might object to on various grounds—among them horse, whale, and various sea creatures that are cooked while still alive—but for adventurous eaters who think they've eaten it all, here are eight exotic dishes served around Japan that you may want to consider:

- Fish liver is popular in Japanese cuisine, which may be news to many, especially since—fish have livers? Well, of course they do. One of the most popular is the liver of the monkfish, an exceedingly unattractive fish that is known in Japan for its delicious liver, known as *ankimo*. Salted and served with a *ponzu* sauce and considered by some to be comparable to *foie gras, ankimo* is one of Japan's greatest delicacies.

- The Japanese make everything—from tofu to soy sauce—from soybeans. But perhaps the most elegant, simple and simply delicious product of the humble

bean is *yuba*. Known in English as "tofu skin," *yuba* is a side product of the heating of soymilk and, as with many Japanese foods, it can be processed in a number of different ways, even into a pastry called *yuba manju*. Perhaps the best is a simple little bowl of creamy *yuba*, which is almost like a pudding—one of the most delicate flavors in Japanese cuisine.

- Once you get past the occasional sense that your food is staring back at you, taking a mouthful of *chirimen jako* is less unnerving than might be expected. Whether dried and chewy or fresh and moist, these tiny sardines have a nice flavor and nothing at all in the way of bones. A popular bar food, they go well with either beer or sake.

- *Fugu* is the Japanese name for pufferfish, a poisonous fish that is toxic to the point of total paralysis. But in the hands of the proper chef—and you do want to make sure he's a chef who knows what he's doing—it is apparently quite an interesting dish—and psychological challenge. Like many Japanese foods, *fugu* actually has quite a light taste. It's the potential for something going wrong—which of course hardly *ever* happens—that gives the experience its "flavor."

- Fish roe are a popular component of many different Japanese dishes, from the ubiquitous *tobiko* sprinkled on sushi, to *ikura* (salmon roe), which explodes with fatty, fishy goodness with every bite. But one of the most popular forms of roe in Japan is less well known to outsiders: *Mentaiko*, or marinated cod or pollack roe, is so popular that in addition to being eaten raw on its own, it may show up in rice balls or even as a flavor of potato chips.

Fugu, *or pufferfish,*
requires a licensed chef
to prepare safely.

- While fish roe is widely eaten, a less common dish
 is fish sperm, or what the Japanese call *shirako*. Not
 actually the sperm itself, *shirako* is the sac that holds
 the cod's sperm, so it's larger, chewier, and less gooey
 than one might expect. Served fried or steamed, it is
 at its creamiest when served uncooked. Another dish
 that is better eaten than contemplated.

- There are all manner of shellfish available from
 the seas that surround Japan, but one of the finest
 is *torigai*, the Japanese version of what the English
 know as cockle and what translates as "heart clam."
 Fishermen have to get a special license to harvest
 them, and they are mostly found in the waters of
 Shizuoka Prefecture. Only harvested in the spring,
 torigai are rare, expensive, and delicious.

- Saving the greatest challenge for last, *natto* is, as
 they say, an acquired taste. Most Japanese seem to
 have acquired it, as it is often referred to as "Japanese
 comfort food." Comparable to a very pungent cheese,

this concoction of fermented soybeans—with a very sticky, crunchy, and mucus-like texture that is an acquired *feel*—did not strike this eater as particularly cheese-like. Or tasty. But if you're looking for distinctive flavors, and something that's said to be very good for you—*natto* may be a taste worth acquiring.

5. Rice and Its Many Products

When one wants to say "meal" in Japanese, one says the word *gohan* or perhaps *meshi*. Both words literally mean "cooked rice." That etymology says much about the central role that rice plays in the Japanese diet. Valued as currency in the past, rice is still used in a remarkable variety of ways, from housing elements to cosmetics to booze to, yes, food. Without rice, the Japanese diet wouldn't be very Japanese.

Asian wet rice, or "paddy" rice—known by the botanical name *Oryza sativa*—is an annual grass that is grown from spring to fall all over Japan, the seasons varying with the latitude of the area. The variety grown in Japan, known as *Oryza sativa japonica*, thrives in the archipelago because it likes Japan's more temperate climate, rather than the tropical climate favored by its botanical cousin *Oryza s. indica*. In fact, some strains of Japanese rice have been developed to grow in northern climates that few would think of as capable of supporting rice cultivation.

Of the nearly 2.5 million farms in Japan, roughly 85% are dedicated at least in part to growing rice, even though the average Japanese rice farm is less than two acres. Because of this, these farms make but a tiny profit and most rice farmers

cultivate the crop as a part-time vocation. Consequently, most rice farmers are more than sixty-five years old.

Despite the ubiquity of this crop, the volume of paddy rice grown in Japan as of 2017 is barely more than 11 million metric tons, just a third of the 33 million metric tons grown in Thailand and a quarter of the 44 million metric tons grown in Vietnam. Production in Indonesia, Bangladesh, India, and China far outstrips Japan's. But despite government regulation, which subsidizes farmers and bans competition from imported rice, rice farming in Japan is in steady decline. Rice in Japan is also very expensive, five to six times more expensive than in other rice-centric countries, a fact that Japanese accept because of what they consider its superior quality.

The Japanese remain passionate about rice, and visitors may be surprised to find they are eating rice in forms that may not be obvious. In addition to rice in dishes such as sushi, *donburi, chahan* (fried rice), *omuraisu* (omelet rice), *onigiri* (rice balls), and breakfast dishes such as *kayu* (rice porridge) and *tamago kake gohan* (egg rice), a visitor will also likely be consuming rice in noodles, sake, bread and pastries made with rice flour, and desserts such as *wagashi* and ice-cream-filled *mochi*.

Many of those foods depend on the particular qualities of the *japonica* variety, which is a short-grain rice that is stickier than rice grown in other regions. This makes the rice clump more easily, which, as anyone who has had *nigiri-zushi* or *onigiri* knows, is a crucial element of these staples.

Non-edible rice products are also a part of daily life in Japan. Primary among them is rice straw, the non-edible part of the plant, which constitutes about half the biomass created by rice farming. It is a troublesome byproduct because of the air pollution created when it is burned, a common practice all over the rice-growing world. The Japanese, ever keen

to use every part of everything they grow, have found myriad uses for this rice byproduct, from roofing material to feed for livestock.

Most ingenious is the use of rice straw to create one of the Japanese home's most distinctive features: the tatami floor. Created from up to 35 kilograms of highly compressed rice straw, tatami mats offer solid-yet-yielding flooring that works beautifully with the traditional Japanese habit of sitting and even sleeping on the floor.

Another rice byproduct is the husks that are removed from the rice grains during processing. White rice may be nutritionally inferior to whole-grain rice because it lacks fiber, but Japanese prefer its taste, and it is certainly more useful in the creation of staples such as *mochi*, rice flour, rice noodles, and sake. Rice husks are used in the production of important items such as bedding, seedbeds for other crops, livestock feeds, ceramics, filters, and even oil, the source of rice bran wax, which is used in some cosmetics.

Today rice cultivation and even consumption is in overall decline in Japan. On average, Japanese consumption per capita has declined by a remarkable 50% since 1965, as the Japanese diet and lifestyle have grown ever-more international. But rice retains a unifying and symbolic significance. In a country in which more than half of foods consumed are imported, rice remains symbolic of the desire for food security and even of national identity. Eating Japanese rice—the only kind of rice most Japanese know—is considered one's patriotic duty, a tasty duty indeed.

6. Noodles: Udon, Ramen, Soba, Yakisoba, and Somen

Although rice-based sushi has become an international staple food, in Japan you won't have too many meals without encountering one of the country's other culinary basics: noodles.

Whether in the form of udon, soba, *yakisoba*, somen, the universally popular ramen, or some other variety, Japan's love affair with noodles is rich and varied. In a broth, in hot dishes, or in cold salads with a variety of dipping sauces, the Japanese can do nearly anything with noodles.

Travelers are wise to try different noodle dishes while visiting Japan. Since the ways that noodles are served in Japan are largely regional, be sure to try the local ramen, soba, or udon wherever you go—their preparation is likely to be quite different from the ones you tried only 50 kilometers away.

RAMEN

Despite its ubiquity, and the variety of forms it can take, ramen is a relatively new addition to Japanese cuisine: It was introduced from China barely more than one hundred years ago. It was known as *shina soba* (Chinese soba) until the 1950s, when it got its current name, the Japanese pronunciation of the Chinese word *lamian*—literally "pulled noodle"—a reference to the process by which it is made.

But it was the 1958 creation of instant ramen by inventor Momofuku Ando that made ramen a national, and then international, favorite. Instant ramen is so beloved by the Japanese that it was once chosen by popular vote as "the greatest Japanese invention of the 20th century." There is a whole museum dedicated to it in Yokohama.

Ramen is arguably the king of noodles in Japan, despite its late arrival. These thin wheat noodles are served in a variety of broths, from *shio* (salt) and *shoyu* (soy sauce) to *tonkotsu* (pork bone) and the newest style of ramen, miso. Unlike other Japanese noodles, ramen is almost always served hot and is a quick and cheap solution to inconvenient hunger anywhere in Japan.

While a bowl of ramen can contain many different ingredients, the secret ingredient of the noodle itself is a form of alkaline water known as *kansui*, originally from the lakes of Inner Mongolia, which is said to give the noodles a firmer texture than, say, yakisoba. Eggs are often substituted for the *kansui*; most use a chemical concoction that mimics the effect.

SOBA

Soba noodles are made primarily (but not exclusively) of buckwheat (soba), which gives them a strong, distinct flavor. Various soba dishes are *zaru soba, kake soba,* tempura *soba, kitsune soba,* and *tororo soba.* Be mindful: The word "soba" is often used for all noodles, but soba noodles also describe a particular kind. They are easy to distinguish by their brown color and dense texture.

Soba noodles, in their various forms, are perhaps the healthiest choice of all of Japan's many noodles, and given their low wheat content they can be good for those wanting to avoid gluten (look for the word *juwari,* which means 100% buckwheat).

UDON

Udon noodles are the most substantial of Japanese noodles, thick and with a chewy texture. Made from wheat flour, udon is served hot in the winter and cold in the summer, varying just as much as ramen and soba dishes. Because of their

neutral flavor, udon noodles go with everything from curried broths to toppings that include deep-fried fish, various vegetables, pork ... the possibilities are endless.

Even the udon noodles themselves are available in great variety, many boiled, some deep-fried, but they are generally considered to be best when fresh (as opposed to dried). Shapes include flat, wide, and thin, and others that are much thicker and rounder.

YAKISOBA

Despite its name, yakisoba isn't a kind of buckwheat noodle; it is made with wheat flour. Like ramen, it is a relatively recent creation, having first appeared in Japan (from China) in the early 20th century. It is most often served as a fried noodle, but there's also *yakisoba-pan*, in which the noodles are laid lengthwise on a hotdog bun (*pan*) and then garnished with mayonnaise and shreds of pickled ginger. Yes, the Japanese will literally eat anything.

SOMEN

The last basic form of Japanese noodle is again wheat-based, and not so different in flavor and texture from udon. But somen noodles are much thinner and are made not just with flour and water, but also with vegetable oil, and they are stretched while being formed, which gives them a somewhat more substantial mouth feel, despite their tiny diameter.

Somen are often served cold, especially in summer, with a bonito-flake-based dipping sauce called *tsuyu* that can be further flavored with ginger or onion for a wonderful cooling effect. One literally cool way to eat *somen* is as *nagashi somen* (flowing noodles). The noodles are placed in long open bamboo stalks through which fresh, cold water is flowing. Diners

can then pick the noodles out of the flow with chopsticks and dip them in *tsuyu* or some other dipping sauce.

* * *

These are just a few of Japan's noodle options. Try them all.

7. Japan's "Greatest Invention": Instant Ramen

For all their culture's artistry, subtlety, and sophistication, the Japanese are a practical people. So when, in 2000, it came time to answer pollsters about what they consider their country's greatest accomplishments of the 20th century, their top choice was the essence of practicality: instant ramen.

Instant "ramen"—which is actually just dried ramen noodles, not the complex, fresh soup that has become an international sensation—was invented in 1958 by Momofuku Ando. The inventor came up with a process to preserve them until it was time to add water. But it wasn't until 1971 that Nissin, Ando's company, created the "cup of noodles" that we now know as instant ramen.

Instant ramen got the top spot in Japan because it perfectly fits the Japanese desire for simple, tasty food that can be eaten quickly and easily. Turns out the Japanese are not alone in this desire, as any college student can tell you. Instant ramen is also a source of pride because, no matter how many anime films or manga comic books are served to the world, how many SONY stereos are listened to, or how many Toyotas

or Hondas are driven, no other Japanese invention reaches as far or as deep as Cup Noodles, Top Ramen ... or *ramyeon* in Korea, or even *instant-nudel* (noodles) in Germany. More than a hundred billion packages of instant noodles are now consumed every year around the world. China consumes nearly half of that number and dwarfs all other countries' consumption, even Japan's, which comes in third. Momofuku himself was born and raised in Taiwan and began life as Go Pek-Hok. He became a naturalized Japanese citizen and married a Japanese woman, and Japan adopted him as its own.

Fresh ramen itself, as opposed to the instant variety, is currently enjoying a sushi-like vogue as Japan's latest, greatest culinary export. One need only wait in line for two hours at downtown New York's Ippudo to discover what the Japanese have long known: Ramen is a dependable, delicious, and a by-and-large affordable all-in-one meal. From the attention paid to the broth to the consistency of the noodles, and the delicate garnishes of *chashu* (marinated roasted pork belly), *menma* (dried bamboo shoots), and *nori*—aficionados are known to obsess over every element.

Entire books have been written about the many subtleties and glories of ramen, but besides the obvious components, there is a crucial ingredient a casual diner won't notice. *Kansui* is an alkaline solution added to the flour and water when making ramen noodles that helps develop the gluten in the noodles to give them their characteristic chewiness, as well as their yellow color.

No self-respecting ramen lover would ever make the claim that instant ramen is even the same food as fresh ramen, let alone as good. Many ramen places, even as far away as California, won't even allow their ramen to be delivered, because the noodles won't reach their destination in the proper condition.

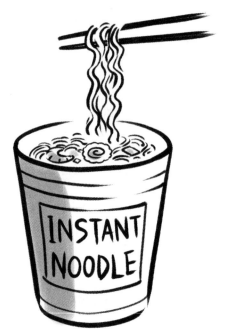

Ramen in a cup features flash-fried, then "reanimated" noodles.

So what was Ando's innovation? The trick was to flash-fry the noodles in such a way that they can be "reanimated" by the simple addition of hot water. We take it for granted now, but in 1958, it was a surprising and instantly successful innovation. The result was noodles that, ideally, retained the texture and chewiness the Japanese prize. Add a blend of dried ingredients usually comprising monosodium glutamate, some dried green onions or shrimp, maybe *nori*, and—it must be said—ungodly amounts of sodium, and voila: a meal. It's not the healthiest of meals—most just-add-water ramen products are the result of so much industrial processing that they make McDonald's hamburgers look like health food by comparison—but don't tell that to instant ramen fans.

Still, if instant ramen has been your idea of ramen, you owe it to yourself to visit one (or ten) of the world's thousands of ramen houses, especially if you find yourself in Japan, where the choices will overwhelm and delight. Make your way to the city of Fukuoka, on the island of Kyushu, and you will find more than two thousand ramen shops … in a city of 1.5 million! Whether it's "Japan's greatest invention" or not, you will never look at instant ramen the same way again.

8. Farm-to-*Hashi* in Japan

Anyone who has traveled around Japan has likely marveled at how many farm plots dot all but the most urban areas. A trip on any high-speed Shinkansen line will offer the passenger fleeting glimpses of rice paddies and gardens that lie, green and lush, amidst Japan's office towers, houses, and apartment blocks.

Gardening and farming are integrated into modern Japanese cities and suburbs because the former have always been there; it is the cities that have grown up around them. The Japanese love cultivating plants in general—not to mention eating them—but the country's arable land is extremely limited, less than 12% of the archipelago. Farming must be done wherever it is possible.

Add to this the Japanese attitude, often based on more than mere chauvinism, that foreign-grown food is not as good as homegrown, and the desire for locally grown produce makes perfect sense in Japan. The current vogue for what has been dubbed farm-to-table, or farm-to-fork, would seem to be a perfect fit for Japan. Call it farm-to-*hashi* (chopsticks).

Or use the Japanese local name *chisan-chisho*, which roughly means "local production for local consumption."

That said, Japan, as a modern country with a passion for quality as well as convenience and food safety, has its own industrial farming chain, a well-established series of steps in the production of food that make farm-to-table dining a rarity. But a handful of restaurants in Tokyo and Kyoto are beginning to do what Americans would call "cutting out the middleman," eliminating as many steps as possible from the farm—or, rarely, from the sea—to the restaurant table.

Most prominent is in the town of Tsuruoka, Yamagata Prefecture, on the west coast of Tohoku, four hours to the north of Tokyo. Tsuruoka has been designated by UNESCO as one of only eighteen Creative Cities of Gastronomy world-wide, and the only one in Japan. Here, the city encourages farmers and chefs to work in concert to preserve and promote indigenous crops and their use in gastronomy.

Farm-to-table restaurants in Japan include Soholm Cafe+Dining in Osaka, known for its daring chefs and devotion to local ingredients; the two We Are the Farm restaurants in Tokyo; and Noz by T.Y. Farm, a more casual eatery that focuses on "exotic" Western vegetables like kale and arugula. It recently opened a branch in Shinagawa, Tokyo.

The latest entry on this small list of restaurants is Kigi, in Chiyoda, Tokyo. This elegant restaurant, which, like the others, focuses on fresh vegetables, hopes to make its name by also specializing in fish, which makes it one of only two restaurants in Tokyo that serve fish the same day it is caught.

Another remarkable example is Hiiragitei, an *izakaya* (pub-food) restaurant in Kyoto's old and fashionable Gion district, where the family of three—husband, wife, and adult son—serve a delicacy that's rare even in Japan. It is, in fact, literally rare: Hiiragitei serves several forms of chicken *tartare*, a

dish that would send restaurant health inspectors around the world into a frenzy of ticket-writing. Salmonella is nothing to be trifled with. But at tiny Hiiragitei, each chicken is selected daily, slaughtered under exacting conditions, and then transported and prepared carefully. This is an extreme example, as virtually no vegetables or even meats carry the dangers of raw chicken; but it shows how careful management of the food supply chain can deliver high-quality ingredients.

Another facet of this farm-to-table trend serves another growing need of the modern gourmand: the desire to feel close to the land or to the sea—to the sources of all food and of all life.

Some Japanese are bringing those sources of food right into their own lives; not just their home gardens but even into some offices. A shining example is the Pasona Group, a recruiting firm in which indoor farming is literally integrated into its headquarters. Using proper lighting and advanced irrigation techniques, Pasona's nine-story office tower in Tokyo devotes 20% of its square footage to farming: a rice paddy in the building's lobby and more than two hundred different varieties of vegetables and herbs growing in conference rooms and other offices. Even the building itself is sheathed in greenery, giving the entire operation an exceedingly low carbon footprint.

But the most impressive aspect is that the company gives its fifteen hundred employees some time every day to tend to their crops, which are then harvested and served in the company dining room. The psychological and dietary benefits of this office-to-table farming are clear to nearly everyone at the organization and are a dazzling validation of Japanese ingenuity.

The Japanese have always considered food and farming a crucial aspect of Japanese life and society. The 21st century sees the country, and its restaurateurs, taking full advantage

of its natural bounties, its agricultural traditions, and the overarching Japanese passion for quality.

9. What Makes Kobe Beef the World's Best?

In the world of beef, there are top sirloin steaks from Omaha, *steak au poivre* in France, and *lomo* from Argentina. But Kobe beef stands alone, with a reputation for high quality and a deep mystique surrounding its breeding and raising practices.

Beef cattle have been raised in Japan back to pre-history, but in very small numbers, given the rugged terrain of this mountainous archipelago. Because of imperial decree, until very recently, the native cattle—Wagyu beef cattle, a name that combines the ancient name for Japan, *Wa*, with *gyu*, for beef—have been bred in isolation, and are thus distinct from the more common European breeds that have spread around the world.

But given that so many things in Japan are, or at least seem to be, from a long-established tradition—think tea cultivation, seaweed in cuisine, and traditional post-and-beam architecture—visitors are often surprised to learn that world-famous Kobe beef has barely reached the half-century mark.

Kobe beef only became internationally known in the late 1950s and early 1960s, when cattle ceased to be beasts of burden, and it was only in 1983 that the Kobe Beef Marketing and Distribution Promotion Association was formed to oversee quality and protect the Kobe trademark.

But the Japanese cattle producers applied themselves to this new industry as the Japanese do to nearly everything, investing a great deal of care and subtlety in Wagyu beef's development. The result is one of the finest cuts of beef ever produced.

The desired qualities of Kobe beef—even marbling, a distinctive flavor, great tenderness, and a unique quality of fat—are important. But just as compelling is the manner in which it is raised: Very few Argentinian cattle ranchers are likely to give their bovine charges massages, and even fewer American cattlemen are going to be found sharing their beer with their livestock.

The result is a variety of beef that is highly prized and just as highly priced, with a pound going for as much as $300 in Japan. A 10-ounce tenderloin steak is currently on the Empire Steak House menu in New York City for $200. And that's for Wagyu beef that likely never set a hoof on Japanese soil.

So, what makes Kobe beef so special, besides the world-famous price?

Tajima cattle are fattened considerably longer that cattle in the United States, living about twenty-six to thirty-two months, compared to eighteen months for U.S. cattle. Kobe cattle are not "free range," or "grass fed"—trends that are growing in the U.S. market—for a variety of reasons. Densely populated Japan doesn't have much range land, and certainly not in the Kobe area, a vast conurbation. In any case, each individual beast is so valuable that most Japanese beef ranchers are loath to leave their precious charges out in any open field (or weather).

Considering that they are being raised to be slaughtered, Wagyu beef have it easy. During the hot summer months they are fed with a bottle of beer a day if they don't eat because of the heat. They are kept largely indoors to preserve their

energy and are given special oil massages, which are thought to distribute their subcutaneous fat and promote the even marbling for which Kobe beef is known.

When the cattle are slaughtered, the qualities that make Kobe beef so special come fully into play. If all has gone well, the meat from the cattle is consistently marbled. Not just that, but the quality of the fat itself is qualitatively different from that of most beef. The melting point of fat of Kobe beef is said to be considerably lower than that of common beef fat, meaning it requires less cooking. And it is also said to be much higher in unsaturated fat, with high levels of oleic acid, making it similar to olive oil.

Because it is so popular in Japan itself, very little Kobe beef is exported, and a hoof-and-mouth disease outbreak in 2010 led the United States to ban Kobe beef for several years. The relatively small number of individual animals that may qualify as Kobe beef is a big part of why the resulting meat is so expensive. Only about three thousand head of cattle can be called Kobe, a result of the high costs and labor-intensive nature of raising the cattle, as well as the length of time they are allowed to mature.

Most of the Wagyu beef produced today is raised outside of Japan, largely because of the greater availability of grazing land and cheap feed. It is then sent to Japan for the final finishing needed to please that discriminating market. Beef called "Kobe" outside of Japan is most likely the result of this process. It may well have grown up in California (or Australia) and been "finished" in Japan.

But to be true Kobe beef, the animal must be a Tajima cattle, actually born and slaughtered in Hyogo Prefecture, with a high marbling ratio, among other factors. Thus, Kobe beef is hard to come by in most of the world, yet another good reason to visit Japan.

10. Table Manners to Know

There are few places, even in manners-conscious Japan, that offer more opportunities to violate local customs than the dining table. Nowhere else do such clear rules come in conflict with such a basic need: We are, after all, hungry.

So here are ten tips—things to do as well as things not to do—for dining in Japan. Most would not be noticed at a Japanese restaurant in New York or Beijing or Stockholm, but they would be in Kyoto, and they are easy enough to follow, if you know about them.

1. The Japanese always offer words of gratitude before and after a meal: At the start, one says *Itadakimasu*, which translates as "I gratefully receive." At the end of the meal, the phrase of contentment is *gochiso-sama-deshita* (very roughly, "It was a feast") . A simple compliment is *oishii*, "the food is delicious," but if you really like something, the ultimate compliment is *okawari!*, "more food, please!"

2. If you are given a hot towel (*oshibori*) at the beginning of the meal, it is intended for washing your hands, and your hands only. Using it to wipe off your face or neck is inappropriate, as good as that hot (or cold) towel may feel. It is not for wiping spills on the table, either.

3. Eating sushi is so common around the world that it's easy to forget that it is a Japanese tradition, and as such, there are rules, including: Never, ever put wasabi in soy sauce and make a paste to dip sushi in. The proper way is to put a small bit of wasabi on the top of the sushi and then carefully turn the sushi

upside down and dip it in the soy sauce. This way, the wasabi and the soy sauce mix but remain distinct, and the rice stays white. Related tip: A piece of sushi is one piece—biting it in half is simply not done and can create quite a mess. But there's good news: It is fine to eat sushi with your hands.

4. What Westerners call "chopsticks" are *hashi* in Japanese, and they are a minor minefield in any language. While using *hashi*, don't point with them while eating, hover them over foods you are trying to decide between, suck on the ends to get the last of that delicious sauce, stab pieces of food you want with one end, wave them in the air, or otherwise wield them like weapons. Other rules that may be less obvious: Don't rub disposable *hashi* together to remove wood threads, don't leave them sticking up vertically in a bowl, or lay them across the top of your bowl. Above all, never, ever pass food with *hashi* to someone else's *hashi*, which will remind many Japanese of the ritual of passing cremated bones with *hashi* at funerals. Place the shared food on your friend's plate instead.

5. As tricky as *hashi* may be, it is impolite to hold your free hand under your food to catch it if you drop it. While that may seem impractical, imagine your palm holding a wet piece of fish, or a clump of soy-soaked rice. When eating rice, pick up the bowl first, then the *hashi*; hold the bowl in your left hand, in front of your chin, and use the *hashi* to lift the rice into your mouth.

6. Soy sauce is widely used outside Japan, but it is uniquely respected here. Do not pour it over your food, especially white rice; some Americans have

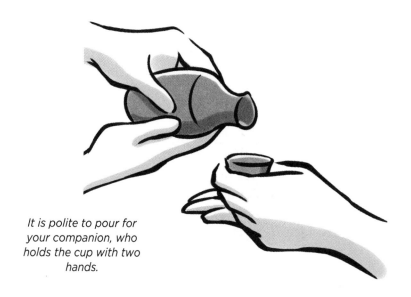

It is polite to pour for your companion, who holds the cup with two hands.

compared it to slathering a piece of bread with ketchup—it is simply not done. Instead, put it in the saucer and dip your food in it. If you dip rice or sushi in it, do not leave grains of rice floating in it. And don't take more than you need; it's considered bad form to leave soy sauce in the dish.

7. In a group of people drinking, it is customary to wait until all drinks are poured or served and then to toast with a warm *kanpai* (cheers!). It is also polite, when sharing sake or other alcoholic beverages, to keep your drinking partners' drinks topped off. You pour theirs and they pour yours. This is a place where good manners really do lend a wonderful feeling of camaraderie to a meal.

8. If you think rice is difficult, consider noodles, particularly in soup! Noodles are tricky for everyone, so it is perfectly fine to raise your bowl (not your plate!) and use the *hashi* to guide the noodles into

your mouth. And it gets better. Slurping noodles is acceptable, even encouraged. As for the soup itself, you may drink the broth out of the bowl as though it were a cup. But burping is as much a no-no in Japan as anywhere.

9. Eating every grain of rice in a bowl is considered to be polite; not wasting this most crucial of Japanese foods makes a lot of sense. Japanese strive to eat everything on their plate, in appreciation for what they have been given. In a counterintuitive cultural quirk, leaving food on your plate implies to the Japanese that you want more food, while an empty plate signifies that you are satisfied. So unless you want more of that curry dish you find too spicy, finish what you've been given!

10. Finally, when you're done eating, it is polite to return all of your dishes and utensils to where they were at the start of the meal, with the *hashi* on their holders (or back in their disposable envelopes) and the lids back on the bowls. And when dining out, remember that tipping isn't done in Japan and many other Asian countries—and is often considered downright rude.

11. The Fine Art of *Kaiseki* Dining

While many gourmands around the food world laud the current trend of "farm-to-fork" cuisine—with its focus on fresh,

local, seasonal ingredients and simple-but-elegant presentation—the Japanese have been raising the same approach to a high art for centuries.

Kaiseki, Japan's multicourse haute cuisine, has been refined over the four hundred years since it was introduced as a meal served during the Japanese tea ceremony. It is still served in this original, simpler form known as *cha-kaiseki*; in its finer form, it is known as *kaiseki-ryori*. Both forms of *kaiseki* are presented to the diner as a set menu, served as much to the eyes as to the palate.

Originally vegetarian and austere, *kaiseki* has evolved into the most elegant of Japanese dining experiences and has earned Japanese restaurants around the world many coveted Michelin stars.

As with the original tea house version, the contemporary *kaiseki-ryori* is served with great care given to its presentation, from the artistic plating of each dish to the setting in which the dinner is served—with each diner given a view, often of a garden—that complements the food.

The dishes, some subtle, some elaborate, come in a particular sequence in which each dish complements the previous dish and prepares the way for the next, always with attention to balance and variety. From a lighter dish focused on vegetables to a heavier one of grilled fish, then back to something to cleanse the palate, a *kaiseki* chef is always concerned with flow and variation. In that way, the diner does not tire over the course of a dozen dishes or more. This is a meal as a performance of flavors, textures, and, of course, visuals.

The original 16th-century *cha-kaiseki* was simple, consisting of miso soup and three dishes. This is now the standard form of Japanese meals, often referred to as a *setto*, or set meal. But today's *kaiseki-ryori* is something else altogether, a parade of dishes that almost always features an appetizer,

some sashimi, perhaps sushi, a simmered dish (and/or soup), a steamed dish (and/or a hot pot), a grilled fish or meat, pickled vegetables, and a dessert.

The variety of dishes created within those categories is almost limitless. Fish is more common than meat, and dairy never appears. Since there is an emphasis on fresh, seasonal produce, the seasoning of various vegetables is light, the better to emphasize their natural flavors.

While *kaiseki* is served all over the developed world, and certainly all over Japan, it is most at home in Kyoto. It grew under the auspices of the Imperial Court and its nobles, whose tastes for the finer things in life drove chefs to impressive gastronomic heights even for a culture as refined as Japan's— achievements they continue to strive for even now.

Kaiseki can be quite expensive, with most high-end restaurants starting at ¥15,000 and going as high as ¥40,000, $140– $380 at fall 2020 exchange rates. There are often different price levels offered, sometimes described in the traditional terms of *sho, chiku, bai* (pine, bamboo, plum), with pine being most expensive. But there are also lunchtime versions available at roughly half the price, and some restaurants have started serving "mini-*kaiseki*" for those on a budget.

But this is one high-end meal in which you can actually see where that money is going: A *kaiseki* can be an unforgettable experience, in the high quality of the ingredients and the skill with which they are prepared, and in the deliberate, delicate, and often breathtakingly beautiful manner in which each dish is displayed.

Plating is an art in high cuisine all over the world, but *kaiseki* raises it to a level simply not seen elsewhere. A *kaiseki* dish can look like a work of art as beautiful as any flower arrangement or painting, with handmade dishes—sometimes rough, *wabi-sabi* pottery, sometimes elegant china—often

one-of-a-kind pieces. On them are set hair-thin shaved sea-weed, tuna sashimi in the shape of a rose, single tiny leaves of micro-greens, petals of flowers, thin slices of beef, *kanji* characters written in delicate sauces beneath tiny, layered morsels of almost indescribable flavor. *Kaiseki* is not just a meal, but a cultural experience that fuses the finest elements of Japanese life, cuisine, and art.

12. Beyond the Pub: Japan's *Izakaya* Culture

Kaiseki dining is a rare and expensive thing, but Japan's dining options are many, from *kaiseki* all the way down to cheap vending-machine eats and surprisingly tasty convenience store fare. In between are a wide range of restaurants, including another dining style, *izakaya*, or pub food, that is becoming popular all over the world. *Izakaya* is the Japanese equivalent of the international gastropub, a place to eat and drink in a setting that is high quality but informal and friendly.

Izakaya first became popular during the rapid modernization of the Meiji period beginning in 1868, but it gained contemporary popularity a hundred years later, during the Japanese go-go years of the 1980s. Today's *izakaya* offer a slow-paced, eat-and-drink-as-you-go style, with drinks and dishes being ordered and appearing at the table in a relaxed, informal style (as contrasted with *kaiseki*'s highly orchestrated pace). International analogs are Spanish tapas, Turkish *meze*, or perhaps even Chinese dim sum.

Although some *izakaya* are *nomi-hodai* (all you can drink)

and *tabe-hodai* (all you can eat) styles, most *izakaya* allow drinkers—and in this format, drinking is the focus—to order as they go along, with the drinks and eats being totaled up at the end of the evening.

Most evenings start with a beer (*biiru*), even if drinkers intend to move on to sake or cocktails. After all, beer is a universal language, and the Japanese speak it with enthusiasm. *Izakaya* are generally after-work or even happy-hour affairs, so drinking remains the focus. Along with beer, sake is a mainstay, but *shochu* drinks and other cocktails are also popular. Wine is less common, and you may find that your favorite red doesn't really go with a lot of Japanese food. But if you're a wine drinker, most *izakaya* will be able to produce a decent bottle or two.

Whisky is also popular, especially Japanese whiskies, which are blended to work particularly well with Japanese food.

The food at *izakaya* can be standard items such as edamame (boiled soy beans), *tsukemono* (pickled vegetables), and tofu in various forms, but things can get much more interesting as the evening wears on, with *gyoza* (dumplings), *karaage* (fried chicken, octopus, or vegetables), sashimi slices, and *kushiyaki* or *yakitori* (various meats grilled on skewers) making frequent appearances. Many diners will finish with a hearty rice or noodle dish.

As with many forms of bar food, most often plates are shared among the group, rather than enjoyed separately. But however you eat it, most of this bar food is likely to be of the consistently high quality that most Japanese establishments maintain. This being Japan, the variations on these basics can be overwhelming, and some menus can be intimidatingly extensive. But chosen wisely, no more than two or three dishes at a time and washed down with the beverage(s) of

choice, *izakaya* snacks can add up to a balanced, healthy, and filling meal. (Note: Although *izakaya* usually do have sushi, this is not their specialty, and if you have any sense of sushi quality, you may find it to be less than ideal. Better to stick with sushi bars.)

Izakaya began as small, informal affairs, with seating on tatami mats at low tables, similar to the local pub, and traditionally marked with red paper lanterns hanging outside. But today large, well-lit chains—such as Tsubohachi, Watami, Shoya, and many others—have sprung up to serve the large and often rambunctious post-work gathering holes that *izakaya* have come to be. Seating at tables has become much more common.

Whatever the style of the place, some diners like to *izakaya* crawl, grabbing a drink (or two) and a bite (or two) at the first stop, then moving on to a second to repeat the process. If you have a short time in Japan, this is a great way to experience different places, but be warned: A lot of *izakaya* do fill up after work, which can mean a wait for a table at the next establishment. Better perhaps to linger in one place, enjoying the slow pace of the traditional *izakaya*—this, after all, is the whole point to this delightful dining tradition.

Sit down, have a beer, order a snack, and chat. Then order a sake, and something more substantial, and then yet another drink, and another—after all, *izakaya* are one of the relatively few places in Japan where one is encouraged to get a little (or a lot) loose. In any case, what's your hurry? You're in an *izakaya*, there's no need to go anywhere else!

13. All About Sake

The word "sake" is actually a generic Japanese word that refers to any alcoholic beverage. In Japan, then, vodka is "sake," as is beer, which now outsells sake there. What English speakers call "sake" is what the Japanese call *seishu* (clear liquor) or *nihonshu* (Japanese liquor). But since English-speakers routinely call it "sake," we will continue with that usage here.

Sake has grown in popularity internationally at the same time that it has declined in its home country. The arrival of other kinds of liquor, wine, and beer in Japan has led the Japanese to drink from a wider range of alcoholic beverages, and thus while there were 3,229 sake breweries in Japan in 1975, that number had fallen to roughly 1,000 in 2016.

The brewing and crafting of sake is more than a millennium old in Japan, a complex process that has long captivated Japanese *toji* (sake brewers), who have developed many subtle variations over the centuries. The process has benefited from advancements in manufacturing and chemistry, and the finer sakes rise to a level comparable to great wines on sensitive palates. Here are five things that to know about sake for beginners:

1. The taste of sake depends on the variety of rice that is used in its production, much as wine's flavor depends on the variety of grapes used. The type of rice used is called *sakamai*, and it is a larger grain, containing less protein than the rice the Japanese eat. Since what is fermented in the rice is the starch, milling and polishing are crucial to removing the outer husk where the protein lies; the more the rice is polished, leaving only the pure white starch, the higher quality the sake can be. There are more than eighty varieties of *sakamai*, each with its own flavor.

Sake stored in barrels is used in festivals and has a cedar-wood flavor that many aficionados enjoy.

2. The quality of water used in the sake-making process—from washing the rice to diluting the finished product—contributes not just to the flavor but to the color. The quality and chemical composition of the water is closely watched, since water with too much iron, for instance, can affect the color and the taste, while potassium and magnesium will boost the speed and intensity of the fermentation process. "Hard" water, with a higher mineral content, is known to produce a drier flavor, while "soft" water produces a sweeter sake. To this day, many breweries in Japan are clustered in Niigata and Hyogo prefectures, where the water is considered to be particularly good.

3. The ingredient that turns rice and water into sake is a mold, *Aspergillus oryzae*, which sake makers call *koji* mold. *Koji* mold is also used to ferment soybeans into miso, soy sauce, and the stronger alcoholic beverage *shochu*, as well as rice vinegar. This tiny but mighty

mold is so crucial to Japanese cuisine that in 2006 the Brewing Society of Japan officially declared *koji* mold to be Japan's "national fungus." Along with *koji* mold, yeast is added to produce a double-fermentation process unique to sake. After fermentation and filtering, sake is stored for between six months and a year, beyond which little actual "aging" is accomplished. Unlike wines, few sakes benefit from extended storage.

4. Also unlike wine, although it is sometimes discussed in terms of its "notes" and subtle flavors, the creation of sake is closer to that of beer. While wine is made by fermenting the sugar in grapes into alcohol, sake is made by converting the starch in rice into sugars, which are then fermented into sake. During the rationing of World War II, sake brewers were forced to add extra alcohol and even sugar to the rice mash to make the process more efficient and productive, and this has remained a part of the manufacture of most sake in Japan. Thus, only about 25% of Japanese sake is designated *junmai*, or pure sake, the highest quality. Sake that contains distilled alcohol should not be considered "watered down," however, since the addition actually fosters flavor and aroma. Even so, sake's 18–20% alcohol content is higher than that of both beer (6–9%) and wine (9–16%).

5. Whether it is *futsu-shu* (basic) grade; *honjozo*, a mid-grade with some alcohol added; *ginjo* or *daiginjo*, both premium grades using highly polished rice; or even *junmai* grade with no alcohol added, sake is remarkably flexible in how it may be served. Though cheaper sakes may be improved by heating, some high-grade

sakes also taste better heated, while others are preferred chilled, depending on the season and the setting or the food being served. When heated, sake is usually served in a small earthenware or porcelain bottle called a *tokkuri*, and it is sipped from a small porcelain cup the Japanese call a *sakazuki*.

Most important, when drinking sake of whatever grade or style, don't forget to top off your drinking companions' glasses!

14. The Unique Qualities of Japanese Whisky

When in 2015 the authoritative whisky publication *Jim Murray's Whisky Bible* named Suntory's Yamazaki Single Malt Sherry Cask 2013 the "best whisky in the world," it was a pronouncement felt around the world of distilling. Despite growing praise for Japanese scotches, most observers had long assumed that great scotch could only be made in its native Scotland. But here was a Japanese distillery coming out on top.

This had happened ten years before, when Nikka's Yoichi whisky and Suntory's Hibiki had won top awards. But after Murray's declaration, the floodgates opened for all Japanese whiskies. What had been consumed only in Japan came to be in such demand worldwide that stock ran short, and auctions began fetching sky-high prices for a single bottle of Japanese whisky. A bottle of 1960 Karuizawa Ichiro single-malt scotch

from Japan's smallest distillery, Venture Whisky, fetched an eye-popping $118,500 at auction in Hong Kong in 2015.

Those who hadd followed the maturation of the Japanese whisky industry over nearly a century were probably thinking, "It's about time." But the arc of that story reads like a typical tale of Japanese success, beginning with the devoted study of a foreign art, the gradual adaptation to Japanese tastes, and the constant refinement and exquisite attention to detail.

In the case of Japanese whisky, most distillers still use malted or even peated barley imported from Scotland, and their choice of waters and locations for the distilleries have led to the creation of what are widely considered some of the best whiskies in the world.

Nevertheless, Murray's 2015 declaration was a pivotal moment that marked a culmination of a history—and confirmation of an industry—that started when the first commercial bottle was released in 1924. But the groundwork for that bottle had been laid shortly before, beginning in earnest in 1918, in—of course—Scotland.

It was in 1918 that Masataka Taketsuru went to Scotland to study the making of Scotch whisky. Studious and detail oriented, Taketsuru came back to Japan in 1920 with a Scottish wife and a deep knowledge of, and subtle appreciation for, the ingredients and processes that contribute to making the world's finest whiskies. He was soon hired by Shinjiro Torii, the founder of Japan's oldest distillery, Suntory, and together the men essentially founded the Japanese whisky industry.

As is often the case of the Japanese and their adoption of foreign traditions, Taketsuru and Torii first aimed to recreate the qualities of classic Scotch, importing bourbon barrels and malted and peated barleys from Scotland, and other distillers followed suit. But over the years, some Japanese distillers have adopted such local elements as barrels made from native

Mizunara oak trees, as well as locally grown barley, moving beyond the perfect copy to something uniquely Japanese.

Together, Torii and Taketsuru grew the Yamazaki Distillery outside of Kyoto for more than a decade. Taketsuru left in 1934 to pursue his notion that a whisky could be best developed in the cool highlands of Hokkaido, where the landscape roughly echoes the windswept highlands that produce classic scotch. The company that eventually emerged is one of Japan's best known: Nikka.

Japan still has only ten distilleries compared to Scotland's more than one hundred, and Japanese whiskies, while indebted to the original, are becoming quite distinct. This is due in part to the structure of the industry, and in part to Japanese tastes.

Japanese whisky makers developed their products to appeal to the uncommonly subtle Japanese palate, incorporating more local grains and even woods (in the casks) to create something distinctly Japanese: sometimes lighter, for sipping, or heavier, since the Japanese often drink their whisky with water, or soda, or even with a squeeze of lemon. Many Japanese also drink whisky with food, a less-common practice elsewhere, so the flavors can't be overpowering. Japanese whiskies need to be versatile and robust, some aimed at discriminating scotch sippers and others at less-exacting cocktail drinkers.

The structure of the industry also matters. In Scotland, blenders use the products of a variety of different distillers, but in Japan most distillers make their own blends, from their own products. While single-malt scotches get a lot of notice among aficionados, most Japanese whiskies are blends, made from different batches of single malt, and most are not sipped but are used in a variety of cocktails such as the ever-popular highball.

This had traditionally limited the range of Japanese scotch whiskies, because of the narrow choice of stocks available for blending. But in recent years, the distilleries have expanded their own creations, giving their own blenders more to work with and even making Japanese blends more diverse and exciting, a force to be reckoned with.

15. A Guide to Japanese Tea

Tea, its cultivation and consumption, are crucial to Japan and its culture. Such elegant traditional rituals as the Japanese tea ceremony and more modern innovations such as green tea ice cream have created the impression that Japan and tea are nearly synonymous.

In fact, Japan accounts for a relatively small amount of global tea production and a surprisingly small percentage of the world's tea consumption. Japan is the world's 10th largest producer, and it's even lower on the scale of consumption: At one kilo per capita per year, the Japanese are 24th in global consumption, while the Turks drink seven times that much. Even the British and Irish drink more tea.

But as in other things, the Japanese make up in style and quality what they lack in sheer quantity. Japan's green tea is its own unique gift to the world and to itself.

Most tea drunk around the world, green, red, black, or otherwise, comes from the same plant: *Camellia sinensis*, which originated in the southern Chinese provinces of Sichuan and Yunnan, and in northern Myanmar. The different "kinds" of tea are created through the varied ways in which the leaves of that basic plant are grown, picked, and processed. In that way,

diverse cultures have put their own stamp on tea, to the point that many are unaware that Japanese green tea, Indian *chai*, and Chinese *oolong* all come from the same plant.

By far the most popular form of Japanese tea is *sencha* ("roasted tea"), which is steamed and then pan-roasted to prevent oxidation. It is a relatively recent development, having been created by Soen Nagatani in 1748, but it is estimated to account for 80% of Japanese consumption. *Sencha* is known for its astringent quality as well as its delicate taste and aroma. If you are drinking tea in Japan, it is probably a form of *sencha*.

The other popular form of tea made and consumed in Japan is *matcha*, a green powder that is used in the Japanese tea ceremony, in instant tea, and even in such modern delights as green tea ice cream. But there are many others, and all can be easily sampled in Japan.

Although the Japanese discovered tea when it was brought from China in the 6th and 7th centuries, cultivation of tea in Japan—which, like nearly everything Japanese at that time, was centered around Nara and Kyoto—didn't start until actual seeds were brought from China by priestly envoys Saicho in 805 and Kukai in 806 CE. Today, tea is cultivated all over Japan, from the moist, warm areas of the west coast of Kyushu and northern Honshu, to the area west of Mount Fuji, where Shizuoka Prefecture produces nearly half of Japan's tea.

From the start, tea was appreciated by the Japanese for the same reasons it was enjoyed by the Chinese: its curative properties, the mental focus it gave, and its subtle flavors. In 1211, the Zen priest Eisai (1141–1215) published a book entitled *Kissa Yojoki* (*How to Stay Healthy by Drinking Tea*).

Eisai's book begins, "Tea is the ultimate mental and medical remedy and has the ability to make one's life more full and complete." It was the first of many meditations on, and explanations of, tea in Japan. Subsequent centuries have seen

steady developments in the cultivation, processing, and ritualization of this modest leaf and its beverages.

The manufacture of tea developed over the centuries, from the 9th-century method of steaming it to the 13th-century development of powdering it into *matcha*, from the 18th-century development of *sencha* to the 20th-century use of machinery. During various processes the tea leaves can be fermented (or steamed to prevent fermentation), allowed to oxidize or partially oxidize, or rolled and powdered to create vastly different results.

Certainly, the most refined and ritualized expression of the Japanese fascination with tea is the tea ceremony, which, like tea itself, was first imported from China. It has long served as a medium of relaxation, spiritual expression, diplomacy, courtship, and ritual for its own sake, and is discussed at length in chapter 51 of this book.

The man who first codified the Japanese tea ceremony in the 16th century, Sen no Rikyu (1522–91), was clear that great care was to be taken in brewing and drinking tea, and in his teachings he was careful to explain a spiritual path that emphasized tea's four principles: *Wa* (harmony), *Kei* (respect), *Sei* (purity), and *Jaku* (tranquility).

But in typical Japanese fashion, with modesty and understatement, he added, "Tea is naught but this: First you heat the water. Then you make the tea. Then you drink it properly. That is all you need to know."

Or as one common Japanese phrase has it, *Shaza kissa*: Sit down and have some tea.

16. *Wagashi*: Japan's Irresistible Sweets

While foreigners may not think of Japanese cuisine as being particularly focused on desserts, let alone candy, the Japanese themselves are wise to one of Japan's most delightful delicacies: *wagashi*.

Using a fairly limited list of ingredients—glutinous rice, adzuki beans, nuts, and, of course, sugar—the Japanese give full rein to their flair for creating subtle flavors out of unassuming elements. Not only that: *Wagashi* confectioners are among Japan's most talented artisans, turning those modest ingredients into brilliant, beautiful little works that evoke the seasons and nature's beauties, creating morsels that delight the eye as well as the tongue.

The four seasons are aesthetically important in Japan, showing up in literature, painting, flower arranging, festivals, clothing, and even in sweets. *Wagashi* are often formed into shapes of flowers and leaves, like a cherry (*sakura*) leaf, for example. This makes *wagashi* a particularly beloved gift for visits to Japanese friends or, for that matter, to take home as delicious souvenirs.

The ingredients of various *wagashi* are simple but remarkably malleable, and none of them more so than the pounded glutinous rice that becomes, almost magically, that most basic of *wagashi*: *mochi*. Chewy, infinitely moldable, and with a neutral but pleasant flavor, *mochi* can be filled with adzuki bean paste, fried, frozen with ice cream inside, or given other twists. As anyone who has had it knows, *mochi* is one of Japan's many gastronomic miracles.

But *mochi* is not alone: Adzuki beans, when combined with sugar, make a wonderful, subtly sweet red paste known

as *anko*, which fills more than a few *mochi* forms. One of them is the popular *daifuku*, in which a thin membrane of *mochi* is stretched around a cluster of *anko*, or even whole adzuki beans, or perhaps a little bit of fruit, giving *daifuku* a distinctive look.

Monaka is another favorite *wagashi*, it too made of glutinous rice flour. But instead of being pounded fine like *mochi*, the rice flour is made into a batter, which is baked into light, thin cakes that are then filled with *anko* (or other fillings). *Monaka* are often formed to look like blossoms.

Yatsuhashi is Kyoto's famous specialty, with its distinctive texture (if unbaked) and an unusual (for Japan) cinnamon smell. You may find it formed into any number of fanciful shapes, the flour itself infused with other flavors that might include green tea or sesame.

Kintsuba is another simple *wagashi*, composed of solidified *anko* that has been floured and lightly fried, giving it a crunchy, delicate texture somewhat like a donut.

Manju features *anko* wrapped in dough, then steamed. *Manju* may also contain other flours, sugar, and even egg, and in some areas it is baked rather than steamed.

Yokan looks the most like much Western candy, but don't be fooled. Though it can be bar-shaped, this isn't chocolate, but a jellied red bean paste.

Namagashi are perhaps the prettiest *wagashi*, formed into a variety of floral shapes that change almost week to week, depending on the season. A great gift, but only if it's to be delivered within a couple of days, as *namagashi* are very perishable!

Perhaps the most popular *wagashi* in Japan is *dango*, made once again of rice flour, sometimes other flours, baked or boiled, and dipped in sugar or perhaps even a salty soy sauce. Though simple, *dango* are popular all over the country, and

Dango are sweet puffballs on skewers dipped in sugar or soy sauce.

the word *dango* has even become a shorthand for a particular hairdo. Add sesame seeds and you have *goma-dango*!

There are many other forms of *wagashi* that are regional as well as seasonal, and confectioners in various parts of the country have developed very distinctive variations, using local ingredients, inspired by local plants or other seasonal ephemera. When traveling Japan, seeking out the local *wagashi* specialties is a worthwhile touristic pursuit.

Westerners, especially Americans who are used to enormous amounts of sugar in their sweets, will find that *wagashi* are far more subtle in their sweetness and won't deliver the sugar hit that many crave. But when paired with a cup of astringent green tea, wagashi are not just pretty to look at; they have a subtle, delightful sweetness that won't lead to the crash and burn of American candy. This makes *wagashi* yet another way in which the subtlety and sophistication of Japan can slowly alter one's expectations of how life is supposed to be.

MODERN ARTS, ENTERTAINMENT, AND SPORTS

Food is just one of the many ways this small island nation has been able to express its ability to create whole worlds out of the most basic of materials. While there is much about Japan that is indigenous, the Japanese have shown a profitable ability, through their entire history, to take the creations of other cultures and develop them into something distinctly Japanese.

For centuries, most of that cultural input came from China and Korea, which brought Japan everything from Buddhism to ramen. But from the late 19th century to the present, cultural import has come most often from the West. And although the Japanese did not create comic books or animated films (or electronic pop music or baseball), few other cultures have taken borrowed arts to as great and original artistic and popular heights.

Film was perhaps the first place that Japan made a postwar impression on the rest of the world, with directors such as Akira Kurosawa, Yasujiro Ozu, and Kenji Mizoguchi becoming internationally known soon after World War II. But they were just the vanguard, as more film directors, visual artists, novelists, and clothing designers made their presence known on the international stage. The animator Hayao Miyazaki is widely considered one of the greatest filmmakers of the last thirty years, and Japanese anime has influenced the wider world of animation and filmmaking in myriad ways.

But Japanese artists also deserve credit for creating popular art forms that were then exported to the rest of the world—martial arts in particular. Going back a thousand years, the world's first novel was not written in England or Italy but in Japan. *The Tale of Genji* was written in the early 11th century, when Europeans who could read were largely limited to the Bible. Not only that, *Genji* was written by someone who was widely considered beneath education, even literacy, in the West: a woman, Murasaki Shikibu.

Contemporary Japan is also one of the world's centers for fashion and visual arts. And Japanese architects—for buildings that

enliven the skyline of not just Tokyo and Osaka but of New York, São Paolo, Los Angeles, Paris, and other global cities—have over the years won more of the coveted Pritzker Prizes for Architecture than architects of any other nation.

The qualities of Japanese modernism, whether in art or architecture or fashion, are based on Japanese sensibilities that have endured through the centuries, underpinning works that use contemporary materials to express timeless ideas about form, function, and the use of space, as well as the reverence for simplicity and nature that has always been part of Japanese aesthetic expression.

And in case you don't find J-Pop to your liking, remember that the Japanese also created one of the greatest pop music entertainments of our age. Karaoke was developed in 1971 and is now a common pastime from Tokyo to Cape Town, Istanbul to Los Angeles, making it as good a place to start as any.

17. Karaoke!

Of all the forms of contemporary Japanese entertainment to have reached international audiences, surely the most ubiquitous is karaoke.

The word is a portmanteau of the words *kara* (empty) and *oke* (orchestra), creating *karaoke*, or "empty orchestra." This poetic phrase describes well what are simply music recordings shorn of their lead vocals. It is in those empty places that the magic—or, let's be honest, the occasional train wreck—happens. In those spaces, amateur singers of all levels are able to sing their favorite songs, with the full backing of that "empty orchestra."

Karaoke was introduced in 1971, when Daisuke Inoue, a professional drummer in Kobe (near Osaka), figured out a way to offer instrumental tracks without a vocal. He did this, he said, at the request of many of his clients, who wanted to be able to sing along to his music even when he wasn't performing.

Inoue did not do this to make money, and that's a good thing, because he never did. The musician/inventor never got a patent for his invention. Instead, the patent for the karaoke machine as we know it was registered by Filipino entrepreneur Roberto del Rosario in 1975. To be fair, many Filipinos had long enjoyed what they called "music-minus-one" singalongs and brought such innovations as immigrants to Japan in the mid-1960s. So the notion was in the air by the time Inoue "invented" karaoke.

But Inoue remains famous and honored in Japan, and karaoke has since become a standard global entertainment option in homes, in bars, even in cabs. Karaoke has been sung in remote truck stops and at birthday parties—even at music festivals such as Knebworth in Britain, where in 2003 singer Robbie Williams led what was dubbed "the biggest karaoke event in the world," with 120,000 singers taking the lead vocal, according to *Guinness World Records*.

Karaoke remains a crucial part of contemporary entertainment in its homeland. For a nation of people widely thought to be restrained and undemonstrative—and who certainly can be those things—the Japanese turn out to be passionate singers, and Japanese parties have traditionally featured singalongs.

Many Japanese are also quite happy to sing to themselves, and that inclination led to the next big development in the world of karaoke: the karaoke box. These commercial establishments introduced the concept of separate, small,

soundproof rooms—or "boxes"—where singers, alone or in small groups, could sing to their hearts' delight, without disturbing the neighbors. The boxes also accelerated the commercial development of karaoke, and today, karaoke boxes, usually rented by the hour, are the norm around the world.

As for the karaoke machines themselves, and the technology behind them, being launched in the 1970s meant that most early models used cassette tapes, an unsophisticated technology even at the time. Then, in the mid-1980s, karaoke tracks moved on to the new Laserdisc format. This development gave karaoke music producers the ability to add the lyrics to the coding on the discs so that the words played along with the music. This ability to read the lyrics is a crucial part of karaoke, since few amateur singers are able to remember all the words. But Laserdiscs, being digital, could carry this extra information and put it up on the video screen, vastly improving the memories of millions of singers and saving the ears of millions of listeners.

Since then, improvements in karaoke have included ongoing refinements to storage and delivery with the ensuing waves of CDs, DVDs, and now, hard-drive machines that can store thousands of songs, lyrics, and even videos to accompany the "empty orchestras." One form is known as *tsushin* karaoke ("communication karaoke"), which provides songs and videos from an offsite commercial content vendor that are delivered via the internet or cable. *Tsushin* karaoke greatly expands the number of songs available to singers, beyond disks or whatever limited collection one particular karaoke box may have.

Another form of karaoke that is growing in popularity is the *wankara*, or solo karaoke box (the word is a Japanese-English pun: "one-*kara*"). In this small "room"—with just enough space for one person to stand or sit—a shy singer can belt a song out to her heart's content, without the social

pressure that comes from singing karaoke in public. The verb *hitokara*—combining the Japanese words *hitori* (alone) and *kara* (from karaoke)—means to sing karaoke alone.

This is a development that all of us should be grateful for, whatever our level of vocal ability. Another is the relatively recent addition of pitch-correcting technology, similar to the software Auto-Tune used by many pop singers, which evens out even the wobbliest pitches.

Any trip to Japan will offer many opportunities to sing karaoke, and a visitor would be foolish to pass up the chance, as singing together is a common way for the Japanese to bond. If you do, be prepared to be asked to name your *juhachiban*— your favorite song to sing karaoke to. You'll enjoy karaoke more if you have one.

18. *Kawaii:* The Japanese Fascination with Cute

One need never even visit Japan to experience one of the best-known aspects of Japanese culture: the fascination with cuteness. Or as the Japanese call it, *kawaii*.

From Hello Kitty to J-Pop, from Pokémon to anime, Japanese pop culture is awash in *kawaii*. Cartoon characters with enormous eyes, animals anthropomorphized beyond any resemblance to the real thing, adorable schoolgirls used to sell every product imaginable ... Japan is in love with *kawaii*.

But once one gets to Japan itself, cuteness is even more ubiquitous: packaging, railroad trains, government offices, road signs, toilet seats, pornography—*kawaii* is literally

everywhere. The land of such elegant arts as ikebana and bonsai can feel at times as though the entire country is populated by eleven-year-olds, whose taste is stamped on everything. Even governments and government agencies such as the national postal service, and NHK, the public broadcasting system, use *kawaii* characters and design elements (stars, rainbows, candies) on their advertising and official pronouncements. Every prefecture in Japan has a *kawaii* mascot.

Given the seriousness with which the Japanese approach every art form—and especially considering how important naturalism is in traditional Japanese art forms—the candy colors and simplistic lines of *kawaii* can be jarring, at least until one becomes accustomed to them. But that will happen quickly, because *kawaii* is arguably Japan's dominant contemporary aesthetic. It is also one of its most successful exports.

Kawaii has even entered the fine arts, through the Superflat style of painter Takashi Murakami, whose paintings have adapted *kawaii* style to comment wryly on Japanese society and culture.

Although *kawaii* is now thoroughly commercialized—San Rio's Hello Kitty has grown into an $8 billion property, with the simple kitty emblazoned on an estimated fifty thousand products—it began as something of a folk art. During the 1970s, teenage girls began writing to each other in a style that eschewed traditional Japanese structure—top to bottom, right to left—and began inserting hearts and flowers and other simple symbols. Variously dubbed *koneko ji* (kitten writing) or *burikko ji* (fake-child writing), this was not an unusual thing in itself—dotting an "i" with a heart symbol is nothing new—but the extremes to which these girls took their decorations soon began evoking the Japanese genius for design, and *kawaii* took off.

The *kawaii* style has been compared by some to punk,

Kawaii *characters are cute, irresistibly appealing, and used to promote just about everything.*

which evolved in the West at the same time, in that it offered these kids a form of rebellion through a negation of mass-produced, mainstream culture. But instead of punk's black and neon colors, simplistic music, and anti-fashion fashion, *kawaii* embraced the fundamentals of childhood innocence as a soft revolt against the responsibilities of adulthood. In Japan's rigid social structure and demanding education system, *kawaii* was a relief for stressed-out children.

Like punk, *kawaii* is remarkably adaptable, because its basic elements are so simple. *Kawaii* figures have minimal facial features—big eyes, a small or almost non-existent mouth, blank expressions—and bodily proportions that emphasize the head, thus evoking infants and baby animals. They are usually outlined in black, like other cartoon characters, but beyond these basic parameters, they are infinitely varied.

It is no wonder that artists find them appealing. *Kawaii* characters can be virtually anything.

Perhaps not surprisingly, since the style was developed by girls and young women, and was initially used commercially to sell products to them, *kawaii* is largely associated with femininity. Women have long been symbolically infantilized in Japan, often making them subordinate to men as children are to adults.

These days, *kawaii* culture extends far beyond the graphic style where it began and has entered society in myriad ways, most notably in fashion. The famous "Harajuku Girls" of downtown Tokyo use this baby-doll aesthetic when they dress, and age is no object. One may occasionally see even mature women in their thirties, forties, and older adopting *kawaii* dress and makeup, a look that is very much at odds with their ages. Dubbed "Lolita fashion," probably after Vladimir Nabokov's novel about a thirteen-year-old girl, this style combines elements of cartoon characters and gothic, frilly accessories with a forbidden sexuality that is common in Japanese culture.

The "cuteness" of *kawaii* is also entering a new arena, which may at first seem surprising: Some Japanese robots are being given bodies and faces that are clearly inspired by *kawaii*, a move that is helping speed their acceptance by humans, a species programmed by nature to respond to cuteness in infants and small animals.

Kawaii is arguably Japan's most successful aesthetic export of recent decades. Certainly, its most famous products, from Pokémon to Hello Kitty, outsell Japanese movies and traditional arts, even manga. It is radically accessible, simple enough that a two-year-old understands it, and easily transcends language and other cultural barriers.

19. The Story of Manga

Manga are familiar to many around the world as Japan's version of comic books, but their bold and distinctly Japanese stylistic innovations have in turn changed the style of Western comic books themselves. With each frame advancing the action, sometimes quickly and sometimes in slow motion, sometimes from a distance and sometimes close up, cartoon-like manga are like a storyboard for anime, Japan's instantly recognizable brand of cartoon films.

Manga and anime share many of the same themes, even characters, and certainly a lot of the visual style. But if anime require production skills and the money to execute them, the *manga-ka* (manga writer) only needs a pen or pencil and some paper.

Paralleling the postwar development of anime and feeding that medium fresh stories all along, manga are anime's low-tech twin. Sold everywhere in Japan (and beyond), low cost, and open to every subject under the rising sun, manga are perhaps contemporary Japan's most ubiquitous art form.

These comic books are where new stories are told—and drawn—for a broad swath of Japanese readers, from young boys and girls to middle-aged men and women. These simple books, often printed on cheap newsprint and in plain black and white, are where many stories that might eventually become anime get their first shot at an audience.

Manga—the word comes from the words *man* (whimsical) and *ga* (picture)—are nothing really unusual. Comic books have been popular in the West since at least the 19th century, and during the U.S. Occupation after World War II American soldiers introduced them to Japan. Japan already had its own versions: One series was by the artist Hokusai, and a

magazine, *Eshinbun Nipponchi*, was modeled on the venerable British comic magazine *Punch*. But the postwar introduction of modern American superhero comics supercharged the Japanese, who immediately began making their own versions.

Primary among these *manga-ka* was Osamu Tezuka, an artist who soon developed a style he dubbed "cinematographic" in which each frame would unfold like the frames in a movie. He created a character called Astro Boy, an adventurous and daring boy who became instantly popular, even crossing back across the Pacific and becoming a huge hit in the United States.

Tezuka's visual dynamism was shared by another artist, Machiko Hasegawa, who came up with the manga series *Sazae-san*, which focused more on day-to-day life and issues that might be considered interesting to girls.

Together, these two artists laid a groundwork for what would become an explosion of creativity, initially aimed at boys (*shonen manga*) and girls (*shojo manga*). But that was just the beginning: For the next twenty years, through the 1950s and 1960s, various forms of manga—easy to produce, cheap to distribute, and fun to read, even if one didn't understand Japanese—would evolve.

Manga have, in the years since, become one of Japan's biggest cultural exports, subdividing into genres based on age, gender, and interests, and, like anime (many of which are based on various manga), into a myriad of genres, from sci-fi and fantasy to soft- and even hard-core porn.

Manga generally appear as serial installments within large weekly magazines that can be hundreds of pages long. Each installment will be twenty or thirty pages, and if a title catches on with an audience, those installments may eventually be collected into a smaller magazine or even a book of its own, called a *tankobon*.

Tezuka's early success led him into animation, where his

Astro Boy became an animated series and helped launch the anime industry. Thus, he is widely considered to be the father of not one, but two Japanese popular art forms.

Anime began to overtake manga during the 1990s, when the novelty of the latter wore off and anime grew in quality and reach. But the easy accessibility of manga to artists—to try new things, to reach an audience, and to do it with very little technology or financial assistance—kept it going, and it remains a large industry in Japan. When Japanese publishers pushed out into the American and European markets, manga were largely revived in export, and titles like *Sailor Moon* were imported into dozens of countries. At the turn of the 21st century, manga were more popular than ever—and now have a huge international audience.

The manga form itself appeals to artists in other countries as well, to the point where what are actually Japanese manga and what are "manga" in other counties and languages is unclear. But the impact of the form is undeniable, and it has fueled anime and other subsidiary arts around the world. It is now even taught in Japanese universities.

20. The Art of Anime

The first commercial Japanese animated film, entitled *Katsudo Shashin*, was created and shown in 1917. Its creator, who is unknown, would be amazed to see that, one hundred years later, the Japanese animation industry has grown to include nearly five hundred production companies, which together turn out thousands of films that have come to epitomize a distinctly Japanese art form: anime.

"Anime" is a shortened form of the Japanese word *ani-meeshon*, itself a Japanese borrowing of the English word. In Japan, all animated films are anime; outside of Japan, the word has come to denote those Japanese films that have developed into a distinctive style of animation, a style that shares much with the comic book styles of manga.

Anime developed during the post–World War II boom alongside the American animations of Walt Disney and other foreign production companies and have become a crucial part of the Japanese film industry. Despite the influence of Disney and others, anime developed a different style. Because some Japanese production companies were unable to match the time-consuming "cel" animation of Disney—in which each frame is drawn by hand, creating a remarkably lifelike movement of characters—anime artists focused instead on the quality of the art itself, in particular the backgrounds, which did not move, instead of the characters, which did.

The result was a very different look that became codified in anime, even when computer graphics and other time-and-cost-saving advances would have allowed the easier movement of characters. As in other Japanese arts, anime's limitations became its strengths, and a unique art form was born. In a way, Japanese anime can be seen as much more cinematic than much American animation, with panning "camera" movements rather than the more static, "stage-play" style long favored by American animators. (That said, anime has had reciprocal impacts on animators of all nationalities and tastes.)

Anime are often associated with the dynamic storyboards of manga, but their scope extends far beyond that. Depending on the audience—girls, boys, adolescents, and even adults are catered to by different segments of the anime industry—the subject matter changes. While many cartoons are all

childhood innocence, others address darker, adolescent, and young-adult themes. Some step over into adult themes, even pornography.

Because of this, anime are often classified by their target demographics, such as those for children (*kodomo*), girls (*shojo*), boys (*shonen*), and adult men looking for pornography (*hentai*). Science fiction, fantasy, romance, gay romance—anime cover as many subject areas as any other form of film or entertainment.

Body proportions of human anime characters tend to reflect real proportions of the human body, but not always. Sometimes, the exaggerated eyes of characters in manga and the *kawaii* genre are obvious; other times, the bodies are roughly proportional to actual humans. The hair in anime is often exaggerated, and what is known as "hair action" can be used to emphasize the movements and even emotions of the characters. The effect can be stunning.

This focus on not just visuals but emotions has also helped distinguish Japanese anime from its commercial equivalents in other countries, particularly the United States. Characters are allowed deep emotions, and the subject matter of much adult anime can be quite sophisticated.

The degree to which anime have come to dominate the Japanese film industry is in the numbers: Anime surpassed live-action films at the box office at the beginning of the 2000s. Emblematic of this is Hayao Miyazaki's 2001 film, *Spirited Away*, a dazzling work that explores Japan's spirit world in a contemporary setting and that became the highest-grossing Japanese film ever made. Nearly every year, at least half of the top-ten grosses in Japan are animated films.

Moreover, anime style films, inspired by Japanese forms, are increasingly being developed in other countries, especially the U.S. Thus, controversy has occasionally erupted over

what is uniquely Japanese about anime, or what is cultural versus what is a matter of style or technique. These debates are unlikely to be resolved soon, but one thing is clear: Japanese animation, having passed its hundredth anniversary, has become one of Japan's most important and global cultural exports. Its second century finds it expanding in unforeseen directions.

21. Nature in the Films of Hayao Miyazaki

Japan's film industry has produced a wealth of important films, from *The Seven Samurai* to *Tampopo*, from *Godzilla* to *In the Realm of the Senses*. The best Japanese filmmakers have delivered an unrivaled measure of craft, care, and artistic daring into their films.

But there is no contemporary Japanese filmmaker as successful or beloved, or perhaps as connected to such a deep well of quintessentially Japanese feeling, as the master Hayao Miyazaki. The animator, screenwriter, producer, director, manga artist, and studio head has created some of the greatest movies of Japan's century in film, among them *Princess Mononoke*, *The Wind Rises*, and, above all, *Spirited Away*, which matched the Japanese box office of the record-breaking *Titanic* and won Miyazaki the American Academy Award.

Miyazaki has written or directed eleven feature films, all of them animated. They span more than four decades, but all are unified by a vision that is coherent and complex, even as he approaches vastly different subjects. Whether crafting

a story about a boy's fascination with flight (*The Wind Rises*, 2013)—he himself grew up during World War II, the son of the owner of a factory that made airplane rudders—or telling tales of girls and young women who find themselves stepping beyond the bounds of the "normal" world into realms of spirits and demons, Miyazaki's films explore the human—and, specifically, the Japanese—relationship to nature.

Robots and fashion and electronic music and all manner of modern pop culture continue to fascinate the Japanese, but there remains a deep affinity with, and appreciation for, nature. And so it is that Miyazaki's animated films offer lush, powerful visions of nature, be they blue skies full of billowy white clouds, windswept grassy hills, or dark, forbidding caves.

Miyazaki's films have an almost tactile quality, as though you could touch those clouds or lie down in that grass. But these are not mere celebrations of what a beautiful world we live in. Having grown up during World War II—his affluent family barely escaped the firebombing of Utsunomiya in 1945—these experiences were imprinted on his artist's soul, even though he was only four years old at the time. His films capture a sense of imminent conflagration, of the danger and destruction caused by mankind, and of the ever-present threat to nature. His movies soar and sparkle, but there is always an awareness of the fragility of all natural phenomena—including humanity. Speaking out in recent years about the willingness of many Japanese to forget the legacy of 20th-century militarism, his films are also a meditation on the consequences of conflict.

At the same time, Miyazaki's films have magical, otherworldly qualities that transcend both nature and the national disaster that greeted his birth. In particular, the great *Spirited Away* (2001), which won him the Academy Award for Best

Animated Feature, delved deeply into nature's hidden mysteries, the spirits that inhabit it, and the vast reservoirs of unknown, but deeply felt, experience.

Interestingly, Miyazaki's protagonists are most often heroines, girls or young women who are in touch with nature, caught up in mystery, who often encounter spirits and demons in their many forms. The heroine's interactions with these beings are ambiguous and complex, often evoking the sense of wary respect that the Japanese have long given nature. It may not be clear to a non-Japanese at first, but these spirits— these sometimes fanciful, sometimes frightening entities— are depictions of the *kami* (Shinto gods or presences) that Japanese culture has long celebrated.

Miyazaki is a pacifist, a feminist, and an environmentalist, and those themes come out in many of his films. But he is rarely making a purely political statement; instead, he delves into the Japanese spirit—and spirits—evoking something enduring and universal.

The buoyant spirit of Miyazaki's films is grounded in a clear-eyed vision of the world, and especially at mankind's often destructive place in it. Still, despite this gloomy picture, his artistic vision is uplifting and inspiring, his work dazzlingly beautiful. His films consistently communicate a wonder at the mystery of life—in Japan, on the planet, and in the realms of spirit that underlie it all.

22. Eight Recent Japanese Films to See Before You Visit Japan

Well before the great contemporary success of Miyazaki, the Japanese film industry had a long and illustrious history, producing dozens of films that have had an impact on international filmmaking and audiences. Seminal directors such as Akira Kurosawa, Yasujiro Ozu, Masaki Kobayashi, and Kenji Mizoguchi made films that have not just been popular outside of Japan but have profoundly influenced the art of filmmaking.

The Seven Samurai, Tokyo Story, Rashomon, and *The Woman in the Dunes* are among the most familiar titles. Anyone who has taken a good film class is familiar with these classics. And then, of course, there's *Godzilla.*

Japan's film industry has had its ups and downs since the 1950s Golden Era, but it saw a resurgence in the late 1990s that continues to this day. As elsewhere, Japanese films include people-pleasing crime dramas, tear-jerking romances, anime, or martial arts extravaganzas aimed at the mass audience. But the finest Japanese films address contemporary issues with the veracity and heart of timeless cinema.

Just as one might read a guidebook or a novel before visiting a country, watching some of Japan's best recent films can give visitors insightful glimpses into the lives and ideas of contemporary Japan. Here are eight films of recent vintage that are widely considered to be worth seeing. This list is just a starting point. (As of late 2020 all eight of these films are available on Amazon Prime, Netflix and other streaming services.)

- *Okuribito* (*Departures*) (2008): Japan's first Academy Award winner in fifty years, *Departures* is a gorgeous

The classic film samurai pose is of a lone warrior, silhouetted against the sky.

film about a man whose dreams of being a concert cellist are shattered and who ends up taking a job as a mortician to survive. Shot over a ten-year period, the film is remarkably realistic and deeply moving, with light comic touches that ease the darkness. Its themes cross cultural borders with ease.

- *Tokyo Sonata* (2008): Director Kiyoshi Kurosawa shifted from making horror films to this realistic domestic story of unemployment and its impacts on a Japanese family, following the effects as they ripple through each familial relationship, leading to horrors more terrifying than buckets of blood. The director deftly crafts a metaphor equating loss of employment with loss of life.

- *Nobody Knows* (2004): Inspired by a true story, this

tells the tale of four children living in a small apartment, their mother absent and their four fathers long gone. Hiding from school and even their landlord, the four children live lives filled with danger. A film that must be seen to be understood. Yuya Yagira was just fourteen years old when he left the Cannes Film Festival with the Best Actor award for his work.

- *The Taste of Tea* (2004): This quirky, surprising, and visually riveting ensemble piece follows numerous intersecting lives and tangential plot lines in a small town outside of Tokyo. The thoughts and feelings of the characters appear onscreen in various forms, making the film a visual delight and expanding its emotional palate. It has been the recipient of numerous international film awards.

- *Battle Royale* (2000): Directed by Takeshi Kitano, an enormously popular and influential director, actor, and all-around performer, this controversial film about high school children turned loose as competitors in a life-or-death punishment is said by some to have inspired *The Hunger Games*. Melodramatic though it may be, the film's Japanese perspective on social relations and its dark-humored comment on government manipulation are fascinating.

- *All About Lily Chou-Chou* (2001): Based on an interactive internet novel, animated by on-screen internet posts that are sometimes difficult to follow, and climaxing in a rock concert, this tale of two high school boys unfolds in surprising ways. Characters develop slowly over the course of the film, as the friends go through some dramatic changes that keep the viewer guessing throughout. Utterly unique filmmaking.

- *Still Walking* (2008): If you are looking for action, keep walking past Hirokazu Kore-eda's family drama. But if you are a student of domestic relationships, this tale of a family reunited to honor a dead brother is almost painfully subtle and understated. But the emotions ring perfectly true, thanks to a remarkable cast that takes a minimal script and squeezes every bit of emotion out of the situations with few words spoken.

- *Spirited Away* (2002): Japan's highest-grossing movie of all time is not about contemporary life *per se*, but this animated dive into the Shinto spirit world is a breathtaking cinematic experience that captures the Japanese soul as well as any socially realistic drama. Director Hayao Miyazaki's animation manages to look utterly modern and yet evokes the most ancient of Japan's many spirits. Not to be missed.

23. Five Internationally Known Modern Japanese Artists

Unsurprisingly, Japan's fine art scene is one of the world's most important, with contemporary artists who have come to rival the greatest in their respective media.

There are dozens of top artists in Japan—many of whom live and work abroad for at least part of the year—and their work is widely accessible online and in books and publications, as well as in galleries and museums. The five listed here

are regarded both by the Japanese and the larger art world as being among the world's finest working artists.

- **Takashi Murakami** is Japan's most famous painter and is known to some as the "Andy Warhol of the East" for his fusing of high and commercial arts. He came of age in the postwar era and, like Warhol, he made little distinction between his work for galleries and his commercial work. Noting that much traditional Japanese painting—not to mention manga and anime—was visually two-dimensional, Murakami dubbed his work, with its "flat" planes of color, "Superflat," a word that now describes a style that has influenced many artists in Japan and beyond. Murakami's work is shown in museums and galleries, but he has also collaborated with fashion designers Louis Vuitton, Marc Jacobs, and Issey Miyake, and even created skateboard decks for the clothing company Supreme. His inclusive strategy has worked well: His provocative 1998 sculpture *My Lonesome Cowboy* sold for $13.5 million in 2008, the same year he was the only visual artist included in *Time* magazine's list of the 100 Most Influential People.

- **Yayoi Kusama** is almost as famous for her personal appearance as for her spectacular art. Sporting a scarlet wig and elfin affect, the ninety-two-year-old Kusama was Björk and Lady Gaga before those two were born. But it is her art (and writing) that has made her Japan's most-beloved artist. Kusama's art, born of her lifelong pixelated hallucinations, are explosive refractions of color and light, embodied in her quintessential form: the polka dot. Kusama began creating her polka-dot art at age ten, and what

began as a young girl's playfulness has expanded into a singular artistic vision in the subsequent seven decades, with painting, sculpture, and mirrored-room installations that aim continuously to capture her remarkable vision. Kusama, like Murakami, has also pursued her vision into commercial applications, and her artwork itself has sold for as much as $5.1 million—at the time the most money ever paid for a work by a female artist.

- **Yoko Ono** may be the most famous of these artists, in part for her marriage to the late John Lennon. But Ono was an important artist long before she met Lennon, and well into her eighties has continued to create in a variety of media. Ono's work was *avant garde* from the start, making her an early performance artist when that was still a barely recognized term, and a well-known conceptual artist who worked with music as well as installation art. A survivor of the allied fire-bombing of Tokyo at the end of World War II, Ono has made political action as important as her artwork, first as an early feminist and then in her effort to promote peace and understanding around the world.

- **Nobuyuki Araki** is often known simply by his last name, and that name has graced an astonishing number of works: He has published more than 350 different photography books in his career. Originally working in advertising, Araki moved on to create a diaristic study of his long marriage to writer Yoko Aoki, including graphic depictions from their honeymoon to her death. Sadomasochism, bondage, and prostitution—as well as scenes of great love and

intimacy—have informed his work and made him controversial as well as famous. In particular, his photos of works of Japanese rope tying—*kinbaku-bi,* or the "beauty of tight binding," particularly of traditionally-dressed Japanese women—are known around the world. He has worked with fashion designers as well.

· **Mariko Mori** began her career working in photography but has moved far beyond its limitations. Many of her early works had her creating fanciful, futuristic costumes that made points about gender roles, sometimes posing herself in specific public places. In some pieces, she would insert herself into existing photos to create surprising juxtapositions; in others, she interacted with passersby in ways that were more performance art than mere photography. A near-death experience in her early twenties deepened her art, and she began to consider consciousness and mortality in her work. Mori's enormous sculptural installations have been shown in museums around the world, and she has situated her work in natural settings, such as her recent, multi-location work *Rebirth*, in which clean forms are set amid the unpredictable elements of nature. In 2011, a survey of her life's work, entitled "Oneness," toured the world, becoming the most-visited contemporary art exhibition ever.

24. How Art Transformed the Island of Naoshima

There are a number of open-air art museums in the world, places where large works stand amid the elements, often situated harmoniously in the environment so that each is elevated by the other. And then there is the island of Naoshima.

One of the roughly three thousand islands located in the Seto Inland Sea between southern Honshu and the islands of Shikoku and Kyushu, Naoshima has long stood in obscurity. It was known, if at all, for the Mitsubishi plant that employed many of the island's nearly nine thousand residents.

But time and industrialization—and nearly two-thirds of the island's residents—moved on. It was then, just thirty years ago, that Soichiro Fukutake, head of the language arts and test-prep publisher Benesse Corporation, decided he wanted to share his extensive art collection with the world. In doing so, Fukutake began the transformation of this region from post-industrial decline to a vibrant arts-based economy.

Choosing Naoshima, Fukutake hired the internationally-known Japanese architect Tadao Ando, winner of the 1995 Pritzker Prize, to design a museum, and a hotel, and then another museum—and another, and another. Over the subsequent thirty years, Naoshima itself has become one of the great museums of the world, indoor and outdoor, an entire island devoted to contemporary art in its many forms.

Even some of the original homes, in the tiny village of Honmura—one of only two villages on the small island—have been converted into the Art House Project, a brilliant blend of old and new, of function and form, by some of the world's top artists. Among the names represented here is Japan's

beloved matriarch of modern art, Yayoi Kusama, whose giant, polka-dot "pumpkins" are the island's icons.

But there are many other artists represented here. Luminaries such as Andy Warhol, Cy Twombly, Jean-Michel Basquiat, Jasper Johns, David Hockney, Bruce Nauman, Walter de Maria, Lee Ufan, and Richard Long are found in this tiny island's museums.

Dominating the island is the Chichu Art Museum. Entirely underground, and thus named *chichu* (literally, "in the ground"), it nevertheless uses natural light to illuminate its works. These include some by the artists above, as well as by an artist who is not contemporary but whose epic, quasi-environmental works have inspired generations of artists and art lovers. One of French Impressionist Claude Monet's large-scale "Water Lilies," as well as four smaller pieces, are displayed in minimalist settings that make them appear almost to float in the air.

Ando's Chichu Art Museum, opened in 2004, is situated above the sea and was built adjacent to Benesse House, opened in 1992, a luxury hotel of only ten rooms in which one can stay surrounded by monumental environmental art. The galleries are open after closing hours to those who stay in the hotel, giving greater space to view the art.

Another Japanese architect who has contributed greatly to the look of the island is the late Kazuhiro Ishii, who designed all of the municipal buildings on the island, including the local schools and town hall. All can be visited during normal business hours. Kazuhiro's style has come to be known as Naoshima Style.

There are other recent additions to the island, including the relatively new public bath house, or *sento*, established in 2009, cleverly called I Love Yu (a Japanese/English pun that plays with the sound and double meaning of *yu*, the word for

"hot water" in Japanese). Like everywhere else on Naoshima, I Love Yu also integrates contemporary art. This fusion of utilitarian spaces with art means that visitors are more likely to come into contact with local residents.

All of these many options sit on an island that is only 8 square kilometers, so it is possible to walk the entire island to take in the many works scattered about. Shuttle buses also make their way around the island at regular intervals.

In the village of Honmura, on the east side of the island, a number of artists have taken seven distinctive local buildings—including one that used to be a parlor for playing the popular Japanese strategy game of *go*—and turned each one into a unique environmental art experience. These "art houses" can easily charm visitors, while some of the larger works tend to dwarf them. Honmura was built to evoke the castle towns of the Warring States period of civil war in Japan, during the 15th and 16th centuries, and is thus a special place to visit even without the art and art houses.

The success of Naoshima, which celebrates its thirty-fifth anniversary in 2021, has begun spreading to other islands in the Seto Inland Sea. The Setouchi International Art Festival, an annual event, has expanded to include six nearby islands.

The island of Teshima, population 920, is a half hour's ferry ride from Naoshima and in 2010 saw the opening of the Teshima Art Museum. That museum, shaped like a drop of water, inspired the local restoration of terraced rice paddies, which surround the museum in yet another example of the merging of architecture, art, and landscape—and another example of how art can transform, even revive, postindustrial areas.

25. Eight Crucial Postwar Japanese Architects

Japan's postwar period has produced an abundance of world-renowned contemporary architects, including eight recent winners of the Pritzker Prize. There are so many important Japanese architects that we cannot hope to list them all here, but it is still worth noting a few of the most influential.

Though their creations may be quite different, Japanese architects share certain cultural perspectives. For example, the Japanese sense of space, especially the awareness of emptiness, or "negative space," as well as a tendency toward minimalism, is evident in the work of all of the major Japanese architects . The Japanese appreciation of nature and attention to materials, ancient and modern, synthetic and natural, are other common themes.

The following six men (and one woman) are a good group with which to start exploring the wonderful world of modern Japanese architecture. Just ask the Pritzker committee.

- **Kenzo Tange** is arguably the definitive postwar Japanese architect, having literally helped rebuild Japan after the war. Tasked with rebuilding Hiroshima after the atomic bombing, Tange's modernist design is reflected in the world-famous Hiroshima Peace Center and Memorial Park in the devastated city. Tange won the Pritzker in 1987, making him the first Japanese to win the coveted award.

- **Fumihiko Maki** was Japan's second Pritzker Prize winner, in 1993. He was one of the foremost exponents of the style known as Metabolism of the 1960s and 1970s, but his subsequent work moved

far beyond that label. Recent works include the Aga Khan Museum in Toronto, Canada, and a new building beside the United Nations headquarters in Manhattan, as well as many around Japan.

- **Tadao Ando**, a former boxer who taught himself architecture through his explorations in interior design, is a master in the use of empty space and natural light, combining simple materials—concrete and wood among them—to construct remarkably evocative settings. His Church of the Light, a Christian church in a suburb of Osaka, was built for only $250,000, but its effect is priceless; the exquisite structure of nearly solid concrete seems to melt away, much as stone European Gothic cathedrals did hundreds of years ago. Speaking of Europe, Ando's 2009 restoration and expansion of the Punta Della Dogana museum in Venice brought his work to the very heart of the Western art world. Ando has won the Pritzker as well, in 1995, making him the third Japanese architect to be so honored.

- **Kazuyo Sejima** is the only woman on this list, and her work, in collaboration with **Ryue Nishizawa**—working together as SANAA—led the pair to be the fourth and fifth Japanese to win the Pritzker, in 2010. The duo's work is characterized by its situation in, and harmony with, the surrounding environment, as in Nishizawa's masterful Teshima Art Museum in Takamatsu, Japan. Sejima's bold 2007 "stack of boxes" building for the New Museum of Contemporary Art in downtown Manhattan was designated one of the "Seven New Wonders of the World" in *Condé Nast Traveler* magazine.

The Art Tower Mito in Ibaraki Prefecture was designed by Arata Isozaki.

- Sejima and Nishizawa got their start working for the great conceptual architect **Toyo Ito**, a thought leader whose ideas have affected countless architects. Ito created the Sendai Mediatheque, a building that epitomized his concept of "plate, tube, and skin" in which the three main elements of the structure (floors, supporting vertical structures, and walls) seem to blend effortlessly. He won the Pritzker in 2013.

- **Shigeru Ban** won the Pritzker in 2014, but his fame was well established before that. His innovative use of common materials—he has incorporated

discarded cardboard tubes and other forms of paper into many of his designs—has allowed him to produce not just impressive structures for the global elite but temporary, urgently needed buildings for disaster victims, including those in Japan itself. In addition to designing quick, sustainable housing for disaster victims in Nepal in 2015—where he used rubble to fill in the walls—Ban created a temporary cathedral for Christchurch, New Zealand, after a 2011 earthquake destroyed the original. One of his main materials was cardboard.

- **Arata Isozaki** became the eighth Japanese architect to win the Pritzker in 2019, when he was eighty-seven. Isozaki's work has been built all over the world, with renowned examples in Los Angeles (The Museum of Contemporary Art); Gallicia, Spain (The Domus, a science museum); in Doha, Qatar (the breathtaking National Convention Center); and perhaps most spectacularly, in his home country, where he designed the Art Tower Mito, in Ibaraki Prefecture. As those examples demonstrate, Isozaki's work ranges broadly in style, though his roots in Brutalism remain clear. Such roots make sense. Isozaki grew up not far from Hiroshima in postwar Japan, and he describes himself as having grown up in ruins: "My first experience of architecture was the void of architecture."

Together, these are just some of Japan's many celebrated architects who are making a mark on the cities of the world. There are many more, and it seems likely that Japan will continue to have a profound effect on global architecture for years to come.

26. A Compact History of the Capsule Hotel

Simplicity, efficiency, elegance, and comfort: These are four characteristic Japanese obsessions that find unique expression in a Japanese innovation just beginning to take root around the world—the capsule hotel.

Capsule hotels—*kapuseru hoteru* in Japanese—began in the 1970s as a way to provide a safe, clean, and relatively inexpensive place to sleep for tired (or drunk) office workers who weren't able to get themselves all the way from work back home to the suburbs in the early morning hours. They have since become more common throughout Japan, and the last decade has seen the opening of capsule or, more commonly, "pod" hotels in cities around the world.

The first structure built around the idea of capsules opened in 1972, becoming iconic in its own right: The Nakagin Capsule Tower in the Ginza area of Tokyo, with its distinctive round windows, bespeaks the pod-like construction of the whole. The building, by architect Kisho Kurokawa (1934–2007), is widely considered the epitome of what became known as the Metabolism style, a brief theoretical movement that conceived buildings based on notions of "the biological function of the building to grow." Perhaps if buildings could appear to "grow," then the "pods" were almost analogous to cells.

But the rooms in Kurokawa's Nakagin Capsule Tower were not truly capsules, though they were of course small (this is Tokyo) and featured all-white, built-in furnishings. The first true capsule hotel opened in Osaka in 1979. Also designed by Kurokawa, the Capsule Inn, which still operates, boiled down the essentials of Kurokawa's earlier design into something

Capsule hotels may not be spacious, but they are cheap and convenient.

functional and inexpensive while continuing his fascination with an almost Space Age use of space.

In the ensuing decades, capsule hotels have sprouted all over Japan, serving locals—and, increasingly, tourists—with their sleek design and relatively low cost in an expensive country. Some are as barebones as the name would imply, but the Japanese are experts at making even the simplest experience enjoyable and even beautiful, and capsule hotels are no exception.

At their best, the individual rooms—some call them pods, since one can't really do anything in them but crawl in and lie down—are arranged in long rows, usually two high. Simple

as they are, they can have the feel of what it must be like to take a long trip to Saturn. Often made of molded, white fiberglass, each pod will contain a futon, bedding, a light, a place to charge one's electronic gear, and even a source of "fresh" air. Some even have sound generators (waves, rain, white noise) to cover the sounds of the other guests whose heads are, most likely, just a meter away, in the next capsule.

But the pods are not the entire experience. At the best-run capsule hotels, when you enter the lobby, you are given a bag with slippers, a towel, perhaps even toiletries, as well as a key to a locker where you can store your valuables and small luggage (there is absolutely no room in the capsule for anything but your body and a small handbag). You then file into a gym-like bathhouse where you can shower, shave (or do makeup), towel off, and slip on a *yukata* (a light cotton robe) in order to shuffle off to your pod, crawl in, and pull down the light sliding door at your feet.

Many capsule hotels are male-only, as they were originally designed for salarymen; it was generally assumed that "nice" women would do no such thing. Now, with capsule hotels used by both genders, some are coed. But men's and women's "pods" are still strictly separated, even to the point that some establishments have separate entrances, floors, or even elevators for men and women.

Capsule hotels are numerous in Japan, and one of life's greatest travel experiences can be had at an airport like Tokyo's Narita, where capsules can be rented by the hour. Thus, a six-hour international layover can be spent taking a shower and crawling into a pod to sleep comfortably, rather than slouching over a few seats in the departure lounge—and all for a fraction of the price of a hotel room.

After decades of being limited to Japan, the concept of the capsule hotel has begun catching on around the world,

from Moscow to Malaysia, New York to Mumbai, and from London's Heathrow to Naples' Capodichino Airport. Although these sleeping spaces are somewhat larger than capsules, and are often called "pods" to capitalize on their Space Age feel, their roots are clearly in what may yet turn out to be one of Japan's many contributions to worldwide hospitality.

27. *Bujutsu*: Six Contemporary Martial Arts

Although the popular imagination tends to focus on judo, karate, and perhaps sumo as Japan's key martial arts, the country is home to a staggering variety of these ritualized combat skills. Developed for the battlefield over the centuries by samurai and ninja, these days Japanese martial arts—known by the umbrella term *bujutsu*, or "martial way"—have become both art and sport with practitioners around the world.

Japanese martial arts began as skills for life-or-death situations. Employed in battle, most warriors were expected to have mastered many skills, including *iaido* (swordsmanship), *kyudo* (archery), and even just basic survival skills such as swimming, climbing, wrestling ... anything one might need to live to fight another day. (Sumo is covered in chapter 29.)

But with the relative peace of the nearly three centuries of the Tokugawa shogunate (1603–1867), during which the country was cut off from the outside world and united under one ruler, internecine war was largely a thing of the past, and many of the martial skills developed as "arts" rather than survival skills. With the Meiji period's modernization of

the country (and the military), other martial arts arose that had never been intended for actual use in battle. These more modern arts became known as *gendai budo*, literally "modern martial arts." These arts are concerned less with self-defense or use in battle and more with self-improvement and competition. They are distinguished from *koryu* arts, which are modern evolutions of older skills (archery, swordsmanship) that were once used in war.

There are dozens of forms of *bujutsu*, but here are six that were considered essential and have been developed over the centuries (including quite recently) into highly stylized and codified arts.

- *Iaido*, or swordsmanship, is the quintessential martial art, since swords are one of the oldest and most essential weapons of war, particularly in close quarters. Battles during the Tokugawa shogunate were often fought less by massed armies (who were more likely to use archers) and more hand-to-hand. To this day, there are many modern martial artists who consider *iaido* to be paramount, as it is the martial art most closely associated with that romantic national figure, the samurai.

- *Kendo* is a modernized version of *iaido*, using bamboo "swords" and wooden shields so that competitors are able to use full force without hurting—that is to say, killing—their adversaries.

- *Kyudo*, or archery, is still considered a crucial martial art, as it has been across all cultures and epochs of world history, from the Trojan War to the wars of conquest in the Americas two thousand years later. But as firearms became the dominant long-distance weapons starting in the 16th century, the samurai's

"art of the bow," or *kyujutsu*, became the basis for a martial art, *kyudo*, which has increasingly become associated with contemplative practices. The "Zen archer" is by now a familiar figure.

- **Karate**, literally "the way of the hand," is an almost balletic martial art that originated in Okinawa and only came to Honshu roughly a century ago. Its rapid movements of the hands and feet were quickly incorporated into the regimens of public education in the 1920s.

- *Jujutsu* is another grappling art, distinguished by locking one's opponent's joints and throwing him. Judo, developed from *jujutsu* in the early 20th century, is perhaps the best-known of the *gendai budo* arts, so it is ironic that the word translates as the very un-martial phrase, "the gentle way," or "way of softness." As its name implies, the art is a form of physical challenge and self-improvement, using the technique of yielding to force in order to manipulate that force to your own ends.

- **Aikido**, literally "the way to harmony with *ki*," is one of the *gendai budo* arts that are practiced without any weapons at all. Like judo, aikido focuses on mental and spiritual preparation and on learning how to use your opponent's movement and energy to literally throw him off.

Regardless of their differences of form, all of these arts combine "hard" (*goho*) and "soft" (*juho*) approaches, depending on the need of the moment. "Hard" thrusts, blocks, and other applications of force against force alternate with "soft" skills of yielding and redirecting force.

Taken together, this balance of soft and hard corresponds with the larger Chinese concept of *yin* and *yang* (in Japanese, *in* and *yo*), as combatants learn to vary their technique depending on what their opponent is doing. Thus, most distinctions of "hard-style" or "soft-style" techniques are purely conceptual; the best martial artists will understand both themselves and their opponents on instinctive, even spiritual, levels.

28. How Baseball Came to Japan (and Became Japanese)

Though one might naturally assume that baseball came to Japan during the U.S. Occupation after World War II, this quintessentially American sport was actually one of Japan's earliest Western imports, arriving in the archipelago at the start of the Meiji period, in 1872. Brought by an American, the sport was quickly adopted, and adapted, by the Japanese, and thus has a history in Japan nearly as long as its history in its home country.

That is not to say the Japanese play the sport the same way as Americans—or at least, with the same attitude. While Americans celebrate the home run hitters and fastball pitchers who rise above their peers to become baseball stars, the Japanese, true to form, make team cohesion and harmony the focus. As with many other imports, the Japanese have made baseball—now *besuboru (bay-sue-boe-rue)*—into something distinctly Japanese.

The Japanese National Tourism Organization once noted

that *besuboru* (also known in Japan as *yakyu,* or field ball) is so familiar to the Japanese that some are surprised when they hear that it started in the United States.

Interaction between Japanese and American teams has been a feature of *besuboru* from the start, culminating in 1934, when an American All-Star team that included Lou Gehrig, Babe Ruth, and Lefty Gomez visited Japan to play sixteen exhibition games against the All-Nippon Stars, a largely amateur assembly. The Americans won every game—Ruth alone homered thirteen times in sixteen games—but the Japanese were inspired by several close games, and by the characteristic Japanese confidence that, were they to stick to it, they could challenge the Americans. Soon enough, the Japanese turned pro.

The first Japanese pro team, the Yomiuri Giants, was formed in 1936, but an actual league didn't come together until 1950, when Nippon Professional Baseball (NPB) became the overarching professional organization, similar to Major League Baseball in the U.S. Divided into two leagues (Pacific and Central) of six teams each, NPB isn't a big league, but what the Japanese lack in numbers, they make up for in intensity.

In *besuboru,* everything from the ball to the strike zone to the dimensions of the field is smaller than in U.S. baseball, but the differences go much deeper. Originally conceptualized by the Japanese as a form of martial art, akin to *kendo* (a form of swordsmanship), *besuboru* is subject to all the same considerations of form, face-saving, and group harmony that rule most Japanese undertakings.

These differences show up starkly when foreign players hired by Japanese teams assume that what works in American (or Cuban or Dominican) baseball will work in *besuboru.* The difference lies in the importance of the group, or in this case, the team. A great player who draws too much attention to

himself, even if it's by hitting well or striking out a string of opposing batters, risks alienating his own teammates, or even embarrassing them. More than once has a player who has hit too many big hits or struck out too many opposing batters found himself benched until he cools off. In this way, no one stands out too much, and no one loses face—even if it means losing the game.

Needless to say, this would be anathema to most competitive players in sports the world around. But this is *besuboru*, not baseball, and for the Japanese, it works.

That said, over sixty Japanese players have proven themselves, sometimes brilliantly, in American baseball. The player who really paved the way was Hideo Nomo, who joined the Dodgers in 1995. And of course there is the All-Star Ichiro Suzuki, who played for nearly eighteen years beginning in 2001. More recently, in 2018, pitcher/slugger Shohei Ohtani, in his rookie year with the California Angels, and despite significant injuries, tied a record set by Babe Ruth in 1919.

For the visitor, attending a *besuboru* game in Japan is generally overlooked by all but the most rabid baseball fans, but visitors ought to consider trying a game, which is not expensive and can be a cultural experience as well as an athletic one. Especially fun are the cheering sections, where fans, divided by team loyalties, passionately call out fight songs and bang on drums for the length of the game, once again showing that team spirit and group organization are among the highest values of the Japanese—even when enjoying an imported game.

And then there's this: Even if you're a dedicated fan of the American hot dog, you'll probably never regard it with quite the same affection after spending a game enjoying Japanese bento boxes and fresh sushi. This is one area where Japanese *besuboru* markedly improves on American baseball.

29. Sumo Wrestlers: The Life of a True Warrior

Along with the samurai and the geisha, one of Japan's iconic character types is the massive sumo wrestler, a figure of great cultural—as well as physical—weight.

In Japanese, of course, this sport is not called "sumo wrestling"; it is simply *sumo*, which literally means "striking one another." But unlike various forms of boxing around the world, the goal of sumo is not to hit one another. Instead, the goal of each wrestler is to push the other wrestler out of the round ring known as the *dohyo*. Failing that, his goal is to get the other wrestler to touch the clay floor of the ring with anything other than the soles of his feet.

Thus, sumo is a very simple sport, at least at first glance: A typical bout lasts only three or four seconds. One enormous, almost-naked man pushes the other out of the ring. But as with so many other things in Japan, the subtleties that have developed over the centuries give every aspect of sumo a complexity and nuance that take time to appreciate.

Sumo is thought to have begun many centuries ago as a Shinto purification ritual. To this day, sumo matches are filled with precise ritualistic elements, which make them more than just the few seconds of physical confrontation. From the tossing of salt to purify the ring to the confrontation itself—in which a human is said to be wrestling with a *kami*, or spirit—sumo's ritual and imagery are deeply entwined with Shinto, all the way up to the ceiling above the *dohyo*, which resembles the roof of a Shinto shrine.

Sumo wrestlers are, of course, best known for their tremendous weight and girth, cultivated through tremendous caloric intake. Some wrestlers are said to consume as much

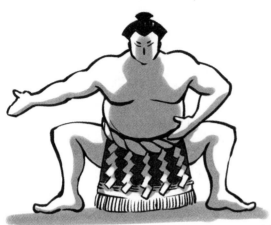

Much of the time in a sumo match is devoted to ritual and ceremony.

as ten thousand calories a day. With their top knot of hair and enormous bodies, it is easy for the uninitiated to regard them as a combination of freakish and comical. But were one ever to face a wrestler in the *dohyo*, the result would likely be anything but funny.

Because of their great size—remarkable anywhere, but particularly in a country of such relatively thin people as the healthy-eating Japanese—sumo wrestlers loom large in Japan, literally and figuratively. While their actual time in the ring per year is minimal—there are only six tournaments a year, with each tournament featuring two or three short bouts of three to four seconds each—Japan's roughly 650 professional sumo wrestlers are nevertheless famous throughout Japan, and their tournaments are extensively covered in the media.

The details of the actual lives of the wrestlers may explain something of their mystique as well, for these men are subject to restrictions and a lack of control over their lives that few other athletes would willingly tolerate. It is perhaps indicative of these restrictions that the name of the communal

buildings where active wrestlers live and train are called *heya*: stables.

The life of a sumo wrestler may be glamorous at moments, but for the most part it is hard work, akin to a monk's but with one goal: to get the wrestler as bulked up as possible and ready to push another huge man out of a small clay ring.

The tremendous size for which most (but not all) sumo wrestlers are known is a relatively recent development. Because there are no size or weight divisions the way there are for boxers or other one-on-one competitors, sumo wrestlers are involved in a sort of weight-gain arms race, each competing to see how much weight he can put on through eating massive amounts of *chankonabe*, a stew of meats and vegetables, eaten with rice and beer.

Everything is done to realize that weight-gain goal, from denying the wrestler a breakfast to then forcing him to nap after the huge lunch. This works to get him big, but the long-term consequences of fattening athletes this way are what you'd expect: Former wrestlers die, on average, more than ten years earlier than the average Japanese male.

Each wrestler's level of accomplishment also determines how he lives his day. The younger, less accomplished ones live lives of service to the more accomplished members of their stable, acting as virtual servants, and a rigid hierarchy enforces nearly every moment of their lives. Their behavior is severely restricted—wrestlers are not allowed to drive cars—and even their dress while in public is tightly monitored and controlled.

On the plus side, they are generally paid well, if not spectacularly so by the standards of international athletes. Even the lowest-level professional will make in the low six figures over the course of a year, and the top champions, the *yokozuna*, can make as much as several hundred thousand dollars a year.

But their real reward, gained at the cost of their health and their freedom, is knowing that they are the latest of a long line of Japanese wrestlers who represent Japan to the world in the way few of their countrymen can claim.

30. Japan's 20th-Century Literary Titans

Japan may not be the first country one thinks of when contemplating the novel, but the country has a thriving and influential literary scene, especially when it comes to modern fiction. Radically different authors such as Banana Yoshimoto, Kenzaburo Oe, and especially Haruki Murakami, the literary world's current Japanese darling, sit on bookshelves around the world.

The Japanese have a legitimate claim to having *created* that literary form a thousand years ago. *The Tale of Genji*, written in the first decade of the 11th century, was a fictional account of the adventures of a young prince in the Imperial Palace in Kyoto. Written by Murasaki Shikibu, a noble woman of the Imperial Court, the book is an insider's look at the courtly manners (and romantic shenanigans) of Japan's classical Heian period. It is arguably the first example of what we know as the novel.

But the novel didn't really catch on until European and American novels that were brought to Japan in the late 19th century inspired the Japanese to try their hand at this "new" form. These days there are hundreds of popular Japanese writers writing novels, in everything from historical fiction to

erotica to a recent form, the manga-inspired "light novels" for young adults.

A handful of writers from the 20th century are regarded as the giants who created modern Japanese fiction, much as Americans honor Hemingway, Faulkner, and Fitzgerald. That these writers led similarly dramatic lives only adds to their mystique. Below are six Japanese writers whose works form the basis for Japanese fiction, and whose lives, often tragic, influenced how the Japanese see their literary artists.

- **Soseki Natsume** (né Kinnosuke Natsume, 1867–1916) launched the modern Japanese novel with his satirical book *I am a Cat*, published in 1905. He is widely regarded as Japan's greatest writer. Since Haruki Murakami called him his favorite writer in 2014, Soseki has gained new readers around the world. His explorations of the tensions between desire and duty, the group and the individual, and Japan's place in the world make him quintessentially Japanese.

- **Jun'ichiro Tanizaki** (1886–1965) is the author considered closest in stature to Soseki. Tackling then-taboo subjects such as sexuality and violence, Tanizaki was early on a controversial writer and bohemian who was fascinated by the West and Japan's place in the world. But his works also explored the psychology of marriage and all manner of personal relations. He was shortlisted for the Nobel Prize in Literature the year before he died. Two novels to start with are *The Makioka Sisters* and his early *Naomi*.

- **Ryunosuke Akutagawa** (1892–1927) wrote numerous novels, but he is known to literary history as "the father of the Japanese short story," a form favored by many Japanese writers. His story "In a Grove" was

the basis for Akira Kurosawa's classic 1950 movie
Rashomon. His name has been given to Japan's highest
literary honor, the Akutagawa Prize. Beset with phys-
ical problems and anxieties about his mental health,
Akutagawa committed suicide at the age of thirty-
-five. Sadly, few of his books are currently available
in translation; the best bet is the collection *Rashomon
and Seventeen Other Stories*.

- **Yasunari Kawabata** (1899–1972) was one of several
 writers who helped explain the inner lives of the
 Japanese, individually and as a people, as the country
 moved into and through the disaster of World War
 II. He was the first Japanese to win the Nobel Prize in
 Literature, in 1968, for work that includes his novels
 Snow Country (originally published in installments)
 and *Thousand Cranes* (1958). His books are widely
 available in English.

- **Osamu Dazai** (né Shuji Tsushima, 1909–48) was born
 into an upper-class family but rebelled ceaselessly
 against life itself. His story is a long, lurid tale of
 suicide attempts, addiction (to morphine), and gen-
 eral psychological distress, and his books are auto-
 biographical fictions about life before, during, and
 after World War II. A young fan of Akutagawa, Dazai
 made his own suicide attempt in 1929. Fortunately,
 he was unsuccessful, for he went on to write some
 of Japan's greatest novels, including *The Setting Sun*
 (about the loss of standing of the aristocracy under
 the American Occupation) and *No Longer Human* (or
 A Shameful Life), a searing self-portrait. But the sui-
 cide attempts continued, and he was finally success-
 ful in 1948.

· **Yukio Mishima** (né Kimitake Hiraoka, 1925–70) was a controversial figure in Japan (and abroad) during the postwar period for his haunting (and haunted) avant-garde novels such as *The Temple of the Golden Pavilion* and *The Sailor Who Fell From Grace with the Sea*, as well as for his nationalistic bearings (he founded a right-wing militia, the Tatenokai) during the American Occupation. Mishima, a direct descendant of the shogun Tokugawa Ieyasu, wasn't just a writer: He and the Tatenokai attempted a military coup in 1970, taking over an office on a Japanese military base; when the "coup" failed, Mishima committed ritual *seppuku* (also called *hara-kiri*). His books are widely available in English and include his semi-autobiographical novels *Confessions of a Mask* and *Forbidden Colors,* both of which take up themes of hidden homosexuality.

三

TRADITIONAL ARTS

AND CULTURE

It is perhaps fitting that the longest section in this book focuses on traditional Japanese arts and culture, because these, along with the food, are what most people come to Japan for. The artistry of the people of this island nation can be even more mind-bogglingly beautiful than the spectacular scenery—and in many cases is actually an outgrowth of it.

Although modern visual arts are captivating, it is still the rare Japanese who doesn't consider nature to be the truest source of beauty. Thus, this section begins with Japan's four distinct seasons and the most beloved, spring, and the annual tradition of *hanami,* a quintessential Japanese entertainment that even anime and manga are unlikely to dislodge, at least for the Japanese.

The arts you will see at temples, museums, shrines, and many of Japan's numerous cultural heritage sites are rooted in a much older group of traditions that are united in particular by the Japanese people's abiding love of nature. Notice how open traditional Japanese spaces, whether temples or homes, feel. Notice how a particular window might look out on a garden, often a garden designed to be seen through that very window. Notice how a trail in a garden curves around a bush; follow it and you'll find it ends abruptly behind that very bush. For this is not a trail for the feet to walk, but for the eye to wander—and the mind to contemplate.

Nature is of utmost importance to the Japanese, and judging from their art, it always has been. Of course, all cultures began at some point ensconced in nature, and many works of art have landscapes as their subject. But look at European art five hundred years ago, and what one sees are people: characters, usually distinct individuals, often in religious situations, sometimes nudes, sometimes enjoying more quotidian pursuits as in a Bruegel. But always, Western art has traditionally been about people.

By contrast, while the Japanese certainly did paint portraits, their art has tended to less humanistic forms—be they birds, animals, plants, or mountains—or more abstract forms, as simple as a

circle but always practiced to perfection. Or, to *near* perfection, for part of the Japanese aesthetic is to resist the urge to perfect. Life just isn't like that.

Likewise, traditional Japanese architecture is designed to incorporate as much of nature into itself as possible. Rather than the grand, beautiful, but hard surfaces of European architecture—which did, of course, often feature central gardens, or at least courtyards—Japanese architecture is almost porous. Built primarily from wood, the structures flow freely from indoor to outdoor.

The incorporation of nature into art and architecture is joined by a complementary Japanese pride in placing limitations on their art, resulting in the ability to create art out of seemingly anything. Sure, many cultures around the world have come up with great painters and sculptors, singers and writers, but where else are there whole artistic disciplines created out of such simple acts as the folding of paper or the arranging of flowers?

The irony here is that this love of nature is matched by an aspiration to control it, arrange it, guide it, and even master it. The Japanese artist will go to great pains to make everything look as natural as possible, as though a human hand had never touched the scene and the elements of the piece had just fallen into place. This is one of the great, guiding concepts of Japanese art: artful artlessness.

The love of nature, especially as it changes through the four seasons, each bringing in its turn new life, growth, decay, and death—the eternal cycle—is where we begin.

31. The Four Seasons in Japan

Ah, to be in Japan, now that spring is there … or fall … or winter …

The Japanese are fond of their four distinct seasons. Each is regarded as a step in an endless cycle, each one bringing its own food, festivals, and sights. From the *hanami* picnics of spring to the ski-and-*onsen* trips of the frigid winters, or the summer beach parties found all over the archipelago, Japan's seasonal attractions are yet another reason for the Japanese— and for visitors—to explore the many seasonal facets of Japan.

The Japanese insist that their four seasons are particularly unique, and while that may smack of chauvinism to some— and fair enough—it's also a fact that, like everything else, the seasons *are* a bit different in Japan. After all, there are cherry trees blooming every spring all over the temperate world, from northern Spain to Washington, DC, but there is nothing quite like the cherry blossoms in Kyoto or other parts of Japan.

So let's start with spring (*haru*), when the Japanese love of nature is repaid in kind by a natural display of color that is hard to match. The cherry (*sakura*) trees sprouting their famous and much-beloved colors are tracked by TV stations as the bloom moves northeast across Japan, as though it were a hurricane. The other flowering trees so beloved of the Japanese—including plums (*ume*) and dogwood (*hanamizuki no ki*)—are also blooming this time of year, and a walk around Kyoto in particular is almost dizzying in its delightful mass of colors. Cherry petals collect in the city's small canals, pile up in drifts against buildings, and float through the air like snowflakes, leading to the phrase *sakura fubuki*, literally "cherry blossom snowstorm."

The *sakura* blossom underlines how the Japanese see the passing of seasons as a metaphor, not just a meteorological event. The fleeting beauty of the *sakura* blossoms is widely considered a metaphor for our own, human insignificance and temporary existence. It's not a heavy thing, but the Japanese acknowledge this in their celebrations.

The Japanese celebrate with *hanami*, a picnic under the blooming trees (discussed in chapter 32). When visiting Japan in the spring, be sure to be prepared for any weather, including wind, rain, and cold. Japan is, for the most part, a northern country, and a rainy one at that. Spring can bring just about any weather.

Summer (*natsu*) in Japan is hot and humid, with the exception of far-northern Hokkaido island, so be prepared to sweat. Tokyo in particular can be oppressive simply because of the massive number of cars and people, all of which create even more heat. In addition, June, most of which is still technically spring, is also the rainy season (*tsuyu*), so be prepared with an umbrella at least.

But the Japanese make the most of their humid summers, and for many, summer boils down to fireworks (*hanabi*). The Chinese may have invented them, but the Japanese have a passion for fireworks that can result in some of the most spectacular and artistic fireworks displays possible. The annual fireworks (*hanabi taikai*), held on the Sumida River since 1733, draws more than a million Tokyoites every summer! Then there's the beach, a plentiful commodity in an island nation. One popular game in summer is *suikawari* (literally, "split the watermelon"), a game that turns even the most timid office worker into a sword-wielding samurai. Summer in Japan also means baseball, and rice fields so green they seem almost electric.

Autumn (*aki*) comes to Japan the way spring comes in, with

The pine, cherry, and morning glory are beloved in Japan and infused with seasonal meaning.

winds, foliage changes, and the added element of typhoons (what the Western hemisphere calls hurricanes), which can cause considerable damage in the archipelago. The landscape is sheathed in a riot of colors, this time the dying leaves, particularly of Japan's ubiquitous and renowned maples and their *koyo* (red leaves). The hills around the country are seemingly draped in color. But there are also chestnuts (*kuri*) and persimmons (*kaki*). As the weather cools, if it's clear, the tradition of moonviewing (*tsukimi*) lingers, though it's nowhere near as popular as *hanami*. One popular place to see fall colors is Kiyomizudera temple in Kyoto, but you need do no more than be in nature to be overwhelmed by the beauty of Japan in the autumn.

One other thing about Japanese autumn: It is when many

vegetables, mushrooms, and fish come into season. A phrase often used is *shokuyoku no aki,* which literally means "appetizing autumn" or "autumn is the season for eating." Indeed it is.

Finally, winter (*fuyu*) in mountainous Japan means, among other things, skiing in the Japanese Alps and plenty of action for the numerous *onsen* (hot springs) that are dotted around the archipelago. Nagano and the surrounding mountains are world-class ski areas, but the prices aren't: ¥3,000–¥5,000 ($30–$50) will get you a lift ticket for the day, a fraction of what skiing in the U.S. costs. And then there are those *onsen* afterward.

There's also the Yuki Matsuri (Snow Festival) in Sapporo every February, which draws thousands of tourists to Hokkaido to see its magnificent ice sculptures. And of course, Fuji-san never looks quite so majestic as when it has a mantle of snow and the air is clear and crisp. The village of Shirakawa-go, along the Sho River in Gifu, draws crowds with its beautifully lit, snow-covered houses.

Ultimately, the marking of the four seasons in Japan is just another part of an overall sensitivity to the environment, an appreciation of nature, and a will to celebrate the good fortune of being born in this beautiful country.

32. Enjoying *Hanami*, Japan's Most Iconic Scenery

Life is beautiful, fragile, and fleeting: This is one of the central understandings that underpins much Japanese art and culture, from ikebana to calligraphy to fresh *uni* sushi. Nature

and its seasonal, ever-changing beauty is crucial to Japanese life and culture, and one of the events in Japanese life where that is most apparent is in the spring tradition known as *hanami*.

Hanami—its literal meaning is "viewing the flowers"—is the annual celebration of one of Japan's most indelible images: the cherry blossoms of early spring. During the brief period in late March and April, when the country's millions of cherry trees (and dogwoods) bloom, one sees the national love of nature in its most popular expression.

Hanami parties are a primary social event for much of this time. The Japanese put together elaborate picnics, complete with fine clothes and adult beverages, to picnic with friends and family under the branches of cherry trees in public parks and on the grounds of temples, shrines, and even royal palaces.

These *hanami* picnics are so popular with so many Japanese that there is a specific "blossom forecast" on TV, radio, and the internet in the weeks leading up to the bloom, so that the Japanese can plan ahead for a *hanami* at the highest peak of the bloom.

But the tradition existed long before blossom forecasts were broadcast. *Hanami* are recorded as far back as the Nara period of the 8th century, when the tradition was more often focused on plum blossoms, which bloom a week or two before the cherry blossoms. The focus shifted to cherry blossoms during the 9th century.

Hanami brings together several threads of Japanese culture, focused above all on the love of nature and beauty, the delight in simple things, the joy of eating and drinking together, and the opportunity to take a break from those seemingly endless Japanese workdays.

Hana yori dango is an idiom that pops up this time of year,

a gently mocking phrase that translates to "dumplings rather than flowers." The saying recognizes that for many Japanese, the food and drink that come with the *hanami* celebrations are the focus of their revelry more than the blossoms themselves.

But the flowers remain the focus of *hanami*, and a significant variation on *hanami* is the popular night version, which has been dubbed *yozakura*—"night *sakura*." Paper lanterns may be hung in the park to help people navigate the dark and, more importantly, to illuminate the blossoms.

Another version, even older, is *umemi*, or "plum viewing," which is generally a bit more reserved than *hanami* and thus often enjoyed by older people for whom drinking and occasionally boisterous partying is not "true *hanami*."

There are a variety of ways in which Japanese enjoy *hanami* parties, from a simple blanket on the ground under the trees to fully equipped grills, tables, chairs, and coolers. Sake is widely drunk, and bento boxes are popular. Some have even been known to bring karaoke machines for singing under the blossoms.

Some of the major department stores or food chains offer special *hanami* bento boxes or other prepackaged picnics for *hanami*-goers. It is not required to even eat Japanese food; the Japanese themselves are big fans of wine, cheese, and bread and may well bring whatever food they like to a *hanami*.

Note that even though cherry trees are everywhere in Japan, some groves are not open for *hanami*, and some that are open may not allow alcohol. It is best to ask a Japanese friend or acquaintance about the places where *hanami* will be happening, and under what conditions.

The cherry blossoms start as early as mid-January in southern Okinawa and then gradually move north with the warming spring. By mid-March, southern parts of Japan start getting their *hanami*, and the movement up the archipelago

can go as late as early May in Sapporo on the northernmost island of Hokkaido.

Some of the major spots for *hanami* include Ueno Park in Tokyo, which is said to host as many as 2 million people over the course of the roughly two-week *hanami* season, as well as Shinjuku Gyoen National Garden, also in Tokyo. The latter is one of the city's favorites, since the garden is home to a number of different cherry tree varieties, making the viewing particularly rich.

Kyoto is spectacular during the *hanami* season, with its many parks, gardens, temples, and shrine complexes floating in clouds of pink flowers. Be aware that *hanami* season will find every hotel in town booked, so plan ahead if you want to visit during this special time of the year.

But wherever you go, and whatever you bring to eat and drink, the annual *hanami* celebrations are some of the most vibrant parties of the year in the Japanese archipelago. If your trip to Japan coincides with cherry blossom season, *hanami* is a sight you will not easily forget.

33. Elements of Japanese Garden Design

Japanese garden design aims for a naturalism in which nothing is left to chance and everything has meaning. If there are leaves scattered on the ground, they were left there to simulate nature's processes; if a moss garden looks parched and fading, it has been left that way because it is the height of summer; and if there is a mound toward the center of things

Many Japanese gardens are designed for strolling.

that seems to be the same shape as Fuji-san, well, that's supposed to represent Japan's most famous and revered mountain.

Japanese garden design has evolved over more than a thousand years into a number of different kinds of gardens, each one suited to a very particular purpose: *karesansui*, Zen or rock gardens, for contemplation; *kaiyushiki-teien* for strolling; *roji*, to enjoy while participating in a tea ceremony or *kaiseki* feast; and *tsubo-niwa*, small courtyard gardens that may be designed to suggest Japan's grand vistas—or even the celestial vistas of heaven.

To achieve each of those effects, there are techniques and guidelines of great detail. Nothing about a Japanese garden is by accident. In that way, Japanese gardens are like three-dimensional, living symbolist paintings or sculptures in which one thing represents another, or sometimes even its

opposite. For instance, a foreign viewer's first impression of a Zen rock garden may be of something dry and austere. But look at those carefully raked, curving rows of gravel, snaking along in parallel. As they flow around a carefully placed, upright rock, they suddenly are revealed as waves lapping against the bases of the enormous rock formations, such as those seen on the coasts of Japan.

Suddenly, the vast white expanse of raked gravel is revealed for what it "really" is: the vast, rippling ocean. Scale disappears, or is reordered. The space in front of the viewer suddenly expands and you are no longer looking at a small, fenced garden; you are instead transported into a much larger reality. With more contemplation, the rows of rocks undulate, turning from solid rock to endlessly changing water. Your vision expands.

None of this happens by chance. Japanese gardens, many of them hundreds of years old, are the product of countless hours of thought, deliberation, and painstaking care.

Zen gardens, which use rocks large and small to such remarkable effect, are just one style. Water also plays a crucial role in most Japanese gardens, which are, above all, meant to be evocations of Japan's natural beauty and geography, its mountains and waterfalls, its lush forests and dense undergrowth. Watching a crane poised motionless in a garden, one imagines he is a statue until, suddenly, he dives beak first into a pond, spearing a koi fish. Japan's gardens are alive.

But Japanese gardens are also meant to transcend nature, to acknowledge that the spirits—*kami* in Shinto—that inhabit nature are to be worshiped through nature. Japanese gardens—one word for which is *niwa*, a place that has been purified for the arrival of the *kami*—are temples of the natural world.

Japanese gardens can be—consciously and

deliberately—spiritual places, temples created not just from natural materials, but from the very elements of nature: water, rock, plants, space, whose presence in the garden is often represented by a stone lantern or tower built in five levels. Japanese gardens are, of course, exceptionally pretty, and one need not be a practitioner of Shinto or obsessed with symbolism to enjoy them.

Some gardens now open to the public were for centuries the exclusive property of the Imperial Family or rich warlords and merchants. You may need to reserve a time for your visit, but once inside you can explore along their paths and enjoy their views and details. They still display elements of older, imported Chinese design, such as arching bridges, water features, little islands, and anchoring rocks, but the more naturalistic tastes of the Japanese dominate, and many of these large stroll gardens have outbuildings with separate *tsuboniwa* and *karesansui* garden types.

Nature is what these beautiful gardens evoke for foreigners visiting them for the first time. But knowing that ancient Japanese cosmology was based on the legend of a perfect central mountain—Mount Horai, where the gods reigned in a misty past—makes those rocks and that mound rising in the center of the garden take on a deeper meaning. Sitting quietly in a Japanese garden is one of the great pleasures of life in Japan, as it was many centuries ago.

34. The Art of Ikebana

Flowers are valued throughout the world as gifts of life, thanks, and as offerings to the spirits of the dead. In Japan,

what were once devotional offerings have grown over the centuries into one of Japan's most recognizable art forms, one that has spread all over the world and continues to develop to the present day: ikebana, the art of flower arranging.

Although the earliest origins of ikebana ("flowers kept alive") are lost to history, the art dates back to at least 1462, when a monk at Kyoto's Rokkakudo temple, Ikenobo Senkei, became the first known master of flower arranging. His followers continued his work, spreading his ideas from the priestly caste into the samurai class, where the practice became a sign of refinement.

A later priestly ikebana master, Ikenobo Senno, wrote in the mid-16th-century compilation of ikebana teachings, *Senno kuden,* "Not only beautiful flowers but also buds and withered flowers have life, and each has its own beauty. By arranging flowers with reverence, one refines oneself."

This idea is familiar to anyone who understands the reverent Japanese relationship with nature and the deep Buddhist understanding of the impermanence of all things, as summed up in the elegant notion of *wabi-sabi* (see chapter 85). Ikebana is an enduring expression of that ideal.

During the past six centuries, ikebana's place in Japan has waxed and waned in popularity and shifted from the province of monks and samurai to that of housewives and artists. But its formal standards have continued to evolve in surprising, and always artful, ways. As the practice of the art has moved from Japan into dozens of countries around the world, it has taken on international flavor.

Ikebana as we know it began in the Muromachi/Ashikaga period, during the late 14th to mid-16th centuries, a chaotic era in which warlords battled for supremacy before the establishment of the Tokugawa shogunate in the early 1600s in Edo (modern Tokyo). This was the period when many of Japan's

most representative art forms blossomed. In addition to ike-
bana, the tea ceremony was refined during this time, as were
theories of garden design and the structure of Noh plays.

As Japan moved on from the Muromachi period, ikebana
became the province of the emerging merchant culture, and
the original arrangement style of *tatebana*, developed for tea
rooms, evolved into the new, more decorative *rikka* ("stand-
ing flowers") style, which in turn became the more austere,
symbolic *seika* (or *shoka*) style. The symbolism was expressed
through a triangular structure that aimed to evoke heaven-
earth-mankind through various arrangements.

No matter the era, the structure of ikebana has always
been its essential element. Ikebana masters teach based on
sophisticated diagrams that show the precise angles of the
branches, flowers, and other elements, as seen from eye level
and from above. An ikebana arrangement aims to look almost
natural—the upright *nageire* style literally means "thrown
in"—but it is in fact a stylized, deeply prescribed form that
takes many years to master.

Two keys to ikebana are the use of asymmetry and an
allowance for space in the arrangements. Ikebana arrange-
ments do not burst with flowers; instead, each branch, each
stem, each bud, is placed deliberately and balanced with
every other element.

The Moribana style is still the basis for ikebana, in both
its basic "upright" and more complex "slanting" forms. Each
individual element has a name (*shin*, *soe*, and *hikae*) and the
relative lengths of each piece are determined by complex
formulae.

In the latter half of the 19th century, Japan opened to the
West and began its process of modernization. The govern-
ment began allowing women to study ikebana as part of the
necessary movement to educate them for the modern world.

In barely a generation, at the dawn of the 20th century, ikebana had gone from an art form meant for the refinement of men to one used for the education of women. Today there are more than 3,000 ikebana schools in Japan, and it is estimated that as many as 15 million Japanese, most of them women, practice the art.

The spread of ikebana worldwide means that many new elements have been introduced to the tradition, with all the creativity, passion, and respect appropriate for a form that is now more than 550 years old. As an example, one of the most important modern schools today began relatively recently, in 1912, after Unshin Ohara broke with the Ikenobo school and started using Western plants, creating the Ohara School.

Visitors to Kyoto are especially lucky because the development of ikebana began there, at the temple Rokkakudo. Ikenobo, the oldest school of ikebana, continues to thrive here under the forty-fifth head of the school, Sen'ei Ikenobo. In 1977, he began developing yet another new form of ikebana, *shoka shinputai,* a modern, three-part style that has dazzled the ikebana community and continues to carry the ikebana tradition into the future.

35. The Art of Bonsai: Creating Little Green Worlds

Bonsai, which literally means "plantings in a tray" (*bon,* a tray or shallow pot, and *sai,* a plant or planting), doesn't sound impressive—until you see a small, 30-centimeter tree in a small ceramic dish. Then as you admire it, you find out that

this tiny tree—which looks like a hundred-year-old tree, standing stately, despite its size—actually *is* a hundred-year-old tree.

Bonsai is perhaps the most widely practiced Japanese art on the planet—there are more than fifteen hundred bonsai societies in ninety countries, and hundreds of bonsai books and magazines have been published in dozens of languages. It successfully combines all the fundamental Japanese sensibilities into one art form: The love of nature combines with the deep attention to form; the fascination with asymmetry comes into harmony with the concept of *wabi-sabi*; and the reverence for life—and the joy in its tending—itself becomes subject to the artist's slow, precise manipulation. The Japanese desire to improve on nature, and yet to hide any trace of those improvements, finds its fullest expression in bonsai.

Like many Japanese arts, bonsai goes back more than a thousand years and has been strongly influenced by the Chinese, whose art of *penjing* does much of what bonsai does. Although there is evidence of bonsai as far back as 1200 CE, the art grew popular during the Edo period (1603–1867), under the rule of the shogun Tokugawa Iemitsu, who loved the art of what was then called *hachi-no-ki* and practiced it himself. One bonsai that the shogun created more than four hundred years ago is still alive and in the collection of the Tokyo Imperial Palace. Bonsai is the very ideal of enduring, not to mention living, art.

Bonsai are created from various sources. Some are grown from cuttings of a favorite plant; others are small trees that have been found in nature or in a garden and deemed worthy of the time required to turn them into a bonsai. Any number of species respond well to this patient, painstaking treatment. Favorites include Japanese natives that have been cultivated for centuries. Juniper, Japanese maple, birch, magnolia,

various pines, dwarf pomegranate, Chinese elm, and even oak trees are regularly turned into bonsai.

The goal of creating a proper bonsai is to manage the growth of a small plant so that, over the course of many years, it becomes a mature tree that has the look and proportion of a full-grown tree in miniature. The techniques employed to do this are many, time-consuming, and intricate.

Leaf trimming manages the size and distribution of the leaves. Careful pruning of the trunks, branches and, especially, the roots, of the tree control its growth. The wiring of branches forces them to grow in a particular fashion to achieve the desired effect. As with a painting, most bonsai are also meant to be seen only from the front, so all the trimming and cutting aims to create an illusion of fullness—but only from one side.

Attention is also paid to the texture of the bark, which ideally will develop the rougher, aged surface of a mature tree. Likewise, higher branches are pruned to keep them smaller at the top and thicker at the lower reaches, so that as the trunk tapers, the optical illusion created is of a much taller, correctly proportioned tree, with the same sense of mass and gravity.

In this way, bonsai are shaped into a variety of established forms, whether it be the formal upright style, the cascade style in which plants bend partly or even all the way over, the slant style where plants come out of the ground at an angle, the style where tree roots wrap around a rock, or even the forest style with several trees in one pot (in a separate art known as *saikei*). Some trees even incorporate dead trunks to mimic the "snags" that are found in nature. Whatever form is chosen, concerns for balance, asymmetry, the correct use of "empty space" between the branches, and the sense of movement in the tree are all foremost in the artist's mind.

As in other forms of Japanese art, great care is given to

creating the illusion that this highly manipulated form is actually completely natural; the artist's hand, though it is clearly in charge of every aspect of the bonsai, must not appear to have been involved at all. The illusion of natural beauty must be total. Even the pot must be carefully chosen to "frame" the tree properly, just as a frame would be chosen for a painting. After all, this living art has the potential to literally outlive the person who created it.

36. *Irezumi,* the Art of Japanese Tattooing

Of its many artistic traditions, perhaps the one the Japanese are most conflicted about is *irezumi,* or the art of tattooing. Dating back to the prehistoric Jomon period (roughly 10,500–300 BCE), the art of *irezumi*—which literally means "injecting ink (*sumi*)"—has a long and complicated evolution.

Irezumi, also called *horimono,* has gone in and out of cultural favor in Japan, and even its legality has ebbed and flowed. It was illegal from the Meiji Restoration in 1868 until after World War II, but only if you were Japanese. It is currently legal and experiencing a bit of a renaissance as in the rest of the modern world. But tattoos are still considered distasteful by the majority of Japanese. Many establishments, particularly *onsen* (hot springs) and *sento* (public baths), still don't allow those with visible tattoos.

But attitudes are changing as younger Japanese adopt Western styles and attitudes, and Japan's unique contributions to this art form are showcased everywhere from Ed

Spectacular tattoo designs in Japan often feature dragons and Kabuki actors.

Hardy's down-market merchandise to museums in the United States and Europe. Like it or not, tattooing is a cultural phenomenon, and Japan, despite its conflicting attitudes, is a crucial part of the story.

Tattooing was originally done by the proto Japanese in the prehistoric Jomon period and survived into the first millennium CE as decoration of warriors and various craftspeople. Some women were also thought to have worn tattoos as talismans against evil. But as Buddhism and Confucianism entered Japan from China in the 600s and 700s CE, Chinese cultural prejudices against such body decoration infiltrated Japan, and tattoos fell out of favor. Soon, they were used mostly to mark criminals and other undesirables.

Nevertheless, the art of *irezumi* continued to grow, and by the beginning of the Edo period (1603), it was an established

decoration for firefighters in particular, indicating their courage and strength, though coal miners, samurai, gamblers, and others adopted them as well. Some of the patterns typical of *irezumi* even now—dragons, tigers, flowing water, koi fish, and cherry blossoms—were already well established.

At the time, the tattooing technique was a slow, painful process using a special ink from Nara that turned blue-green when poked into the skin. Association with the *ukiyo-e* woodcuts of the early Edo period—which used many of the same images—also lent Japanese tattooing its other name: *horimono*, based on the word *hori*, meaning "to engrave."

During the mid-Edo period in the 18th century, the translation of the ancient Chinese book *Shui-hi-chuan* (in Japanese, *Suikoden*) created a craze for tattooing, as the Robin Hood–like outlaw-heroes of the book were heavily tattooed. An illustrated edition in the late 1700s displayed new tattoo designs of the book's heroes, and body tattoos became popular—but still mostly among the lower classes.

Criminals, who had originally been forced into tattoos—a well-placed *kanji* character warned anyone with eyes that the tattooed man was a thief, or worse—soon added more, bigger tattoos to cover the original branding. This ultimately led to their use by the modern era's gangsters, the infamous *yakuza,* which further heightened the association of tattoos with criminality. (Today's yakuza reportedly don't have as many tattoos, as they are a sure giveaway.)

When Japan opened to the West with the Meiji Restoration in 1868, tattoos were quickly banned, since the leaders of the rapidly modernizing country didn't want the Western world to see their nation as primitive and ripe for colonizing. This only further reinforced the image of tattooing among the Japanese as criminal, low class, and generally undesirable.

Tattoos didn't carry the same negative baggage for

foreigners arriving in Japan, and in addition to sailors and merchant seamen, several prominent Western figures got these indelible souvenirs of a visit to Japan: Britain's Prince Alfred (Queen Victoria's son) got two large dragon tattoos on his arms, and Russia's last tsar, Nicholas II, also got inked. Another early tattoo fan was reportedly the Archduke Franz Ferdinand, whose 1914 assassination would plunge Europe into World War I.

During World War II, young Japanese men got tattoos because they thought the stigma might keep them out of the military. But after the war, the American occupiers who wrote Japan's modern constitution allowed tattooing as a form of freedom of speech—and as a practical matter, since many American troops sported tattoos already. But tattooing's low-brow image was fixed in the Japanese imagination. While acceptance is growing, a 2018 survey by the Japan Tourism Association found that a majority of Japanese associate it with criminality and say that tattoos scare them. Workers are still docked pay for exposed tattoos, and students disciplined. A majority of *onsen* owners still have policies against tattoos in their pools, though many visitors flout those rules. Old attitudes and associations continue to dog tattoos.

Nevertheless, the number of tattoo parlors, while small, is growing, and the art form—characterized by whole arm, leg, or even torso designs of dragons, tigers, and cherry blossoms—has spread worldwide. There's even the Yokohama Tattoo Museum south of Tokyo, and expectations are that with increasing tourism, and growing numbers of tattooed tourists, discrimination against tattooed people will slowly disappear.

After all, cultural attitudes change; tattoos are forever.

37. From Food to Flooring: The Many Uses of Bamboo

There are many crucial plants in Japan: Rice and rice straw are ubiquitous and fundamental, tea has been bred and processed to create a huge variety of flavors, and sea kelp is processed and cooked in a variety of ways. Some of these food products even show up in non-edible forms, such as rice paper and tatami mats (see chapter 5).

But nothing in Japan—even the wood of pine trees or the archipelago's abundant stone—shows up in so many forms, providing so many uses, as bamboo. From tools to food, building materials to fabrics, tea whisks to musical instruments—from the quotidian to the sublime—bamboo has been manipulated and processed and transformed in dozens of ways and into hundreds, even thousands, of objects that help make Japan the country and culture it is.

Even Japan's language and culture benefit from this simple plant: Bamboo provides some of Japan's most durable and elastic metaphors, its very presence offering lessons in character and behavior that resonate with the Japanese on a fundamental level. In Japan, everything is connected to bamboo.

Bamboo grows all over the world (except for Europe and much of the Middle East) and appears in as many as fourteen hundred different varieties of the subfamily *Bambusoideae* of the family *Poaceae*. It grows everywhere from the humid tropics to the frigid north of Japan and China, a dazzlingly well-adapted plant that only looks like a tree. It is, in fact, a member of the grass family.

Bamboo is used all over Asia for construction, whether as the elements of the structure itself, or as scaffolding. Its

tensile strength, which approaches that of steel, as well as its flexibility, makes it ideal for many uses. In Japan, it is not used so much for construction, as the archipelago's extensive mountain forests contain a wealth of hardwoods. But turn to food, decorative items, architectural details, religious artifacts, musical instruments such as the *shakuhachi* (bamboo flute), flooring, furniture, and even fabrics, and you will see bamboo everywhere.

The Japanese word for bamboo is *take*. Once you know that word, you will hear it popping up everywhere, for bamboo is often used in Japanese metaphors. An example is *take ni ki o tsugu*, which means, literally, "putting wood and bamboo together," which is meant to convey disharmony.

Even more common is the use of bamboo as a symbol of prosperity, since it has so many uses for the Japanese. You will see *take* pictured in many paintings and religious artifacts; at New Year, the entrances of homes, business, and shrines feature the *kadomatsu*, three wide bamboo shoots (or "culms") tied together for good fortune.

Take is also the second of the Three Friends of Winter (*saikan sanyu*), the three hardy plants that the Japanese admire for their perseverance and durability during Japan's harsh winters. These three plants—pine, bamboo, and plum—have become metaphors for relative levels of quality, in much the way Westerners might use gold, silver, and bronze.

As in much of Asia, diners in Japan may also be served bamboo. This is a seasonal favorite of the Japanese, who prefer to pick the bamboo shoots in late winter, before they even break the surface of the soil, as they are considered most tender and delicious at this point and can be eaten raw.

Another common springtime treat is *takenoko* (literally, "bamboo child") bamboo shoots that have been boiled and cooked in *dashi* broth, or grilled, or fried tempura style, or

pickled. The Japanese magic with food extends easily to bamboo shoots.

Furniture and decorations; the ladle for ritual handwashing at temples; cooking tools from chopsticks to the *takebera* (a flat scoop for serving cooked rice) and the *chasen* (the whisk used in the tea ceremony); the water pipe in *tsukubai* (a Japanese garden "fountain"); baskets; swords and bows and arrows; even the *shippei*, which Zen priests might use to smack a dozing monk during meditation practice—these are just some of the uses of bamboo in Japanese life. You will see many, many more as you travel the country.

But just as important as its many physical uses are the characteristics that the Japanese most admire in people as well as in bamboo: flexibility as well as rootedness; the ability to bend without breaking; internal strength that isn't obvious; a remarkable capacity for growth; and simplicity and the lack of anything superfluous.

Finally, there is the plant itself, varieties of which are fast growing and invasive in the extreme, but which are beautiful to look at—as well as to hear. Standing in the midst of a bamboo forest such as the grove at the temple Tenryuji in Kyoto's Arashyama district—perhaps the most photographed bamboo grove in the world—is one of the highlights of any visit to the old capital. Surrounded by the many-colored, hollow culms gently knocking against one another while the leaves flutter in the wind is one of the great delights of life in Japan.

38. Kyoto and the Template of Japanese Architecture

As of 2020, eight Japanese architects have been honored with the Pritzker Architecture Prize, rivaling American architects. Tellingly, four Japanese architects have won the Pritzker since the last American won in 2005.

But for all the sleek, dazzling, modern designs of contemporary masters Shigeru Ban and Toyo Ito, the buildings that most impress visitors and Japanese alike are those built during Japan's 7th and 8th and 9th centuries, when Buddhism, written language, and Chinese architecture first came to Honshu.

Elegant and timeless, these buildings remain Japan's classic architectural creations, many of them having survived earthquakes, wars, typhoons, and dynastic changes for over thirteen hundred years. In 2003, Japan's government designated 3,844 buildings and other structures in the country as either National Treasures or Important Cultural Properties.

Perhaps most remarkably, 90% of those buildings were constructed of wood, making the twenty-eight from the 7th and 8th centuries the oldest wooden buildings on the planet. Had volcanic Japan been blessed with stronger, less-porous stone, Japanese architecture might have been considerably different.

Many of these structures stand in or near Kyoto, Nara, and other parts of the area where Chinese civilization first took root in Japan. Together, they comprise perhaps the most significant cultural sights in the country. These buildings—temples, farmhouses, rice stores, pagodas, tea rooms, castles, and palaces—were built to last, and it is no accident that many of them are still standing after more than a millennium. Their construction was adapted from both local traditional styles

Traditional Japanese architecture features tatami, shoji, *and minimal furnishing.*

in the 6th and 7th centuries and also profoundly influenced by the imperial style of Chinese architecture—with its huge, sloping roofs—in the 9th century. The structures were built with local materials, positioned within their environment for maximum impact, and topped with roofs that could handle centuries of snow and rain.

The roof is the dominant element of many of these buildings, with its distinctive curving eaves, constructed to sit atop deceptively simple post-and-beam structures of almost unimaginable strength. As with much Japanese art, these often enormous buildings—the floor area of the Todaiji Daibutsuden temple in Nara is 2,880 square meters, its roof held 47 meters above the floor—are also marvels of light and

space. Their interiors are often open to a remarkable degree, reflecting the Japanese desire to include nature in every creation. It is difficult to imagine a traditional Japanese building without a garden drawing the eye from the interior to the outside world.

Contrast this with 8th-century European structures such as Aachen Cathedral, the oldest in northern Europe. Such Carolingian structures are beautiful indeed, but they are often dark, imposing places, with necessarily small windows. And while their interiors, too, rise dazzlingly high in places, the outside world is effectively shut out.

Because of the post-and-beam structure, which does not depend on structural walls for support, there is an openness to Japanese designs that is part of their great appeal. These classic buildings exhibit their skeleton, as it were, for all to see. However, this simplicity of design and use of commonplace materials should not be confused with fragility. That these structures around Kyoto in particular have survived so long is a testament not just to their durability but to their flexibility. Wood is a material far more flexible than stone, a useful quality to have in an area that has experienced countless earthquakes. The post-and-beam framing structure is constructed to distribute shocks and sway gently rather than break.

But there's another reason these buildings have survived so long, and it is built into the structures themselves. Many were put together so that they could be taken apart and rebuilt. Instead of being nailed, the planks and pillars and other elements were joined together, and because they are joined, they can be disassembled to be repaired. Likewise, their relative lack of walls means that sections of the structure can be dismantled without unnecessarily disturbing other parts of the structure or compromising its integrity.

It is this integrity—of the structure, of the materials, and of the relationship between the building and the environment—that allows classical Japanese architecture to display itself so beautifully. It is here that the many elements of Japanese culture, from the sense of proportion and grandeur to the spiritual nuance and integration with the natural world, shine brightest. That these qualities are expressed in such a public and functional artform is a daily benefit for the Japanese, and to those visitors from abroad who are lucky enough to walk among them, if only for a brief time.

39. Modern Japanese Design and Aesthetics

A chapter on Japanese aesthetics may seem somewhat redundant here, since other chapters in this book go into depth on concepts like *wabi-sabi* and *kawaii*. Other chapters focus on traditional arts such as garden design and flower arranging that reflect timeless Japanese design principles.

But as those aesthetic principles have spread out over the globe, they continue to influence modern style from Scandinavia to London, from New York to Sydney. So it is perhaps worthwhile to isolate some of the basic notions behind Japanese design. In that way, visitors can see what unites, for example, Japanese buildings, whether centuries-old wooden or modern concrete structures, with everything from rice cookers to graphic design.

As with many things in Japan, no matter how old or new, the design aesthetic begins and ends with the example of

nature: its seasons, its resistance to human senses of order, and its indications of time passing, of decay, of death. Nature, in the Japanese mind, is about impermanence, imperfection—and proper spatial relationships. The Japanese like a good straight line as much as anyone, but they are also humble and aware enough to break or bend or otherwise alter it just enough to call its reality into question.

The Japanese are surrounded by oceans, their landscape awash in water, and they are well aware, sometimes painfully so, of the slow, corrosive, inevitable impact of water on everything. The Japanese know, watching all this water, that even those things that are so real for a moment soon pass away. It is perhaps no accident that one of the most iconic visions in Japanese art and culture is of the huge ocean wave, breaking at the shore, all-powerful, a monumental thing, a mountain of water ... and then, *gone*.

Similarly, the beauty of plants in Japanese aesthetics is not in their full bloom; that is understood to be but a moment, and perhaps the most transient of, say, a flower's life. Instead, the Japanese focus on buds, all potential, or dying leaves, their prime fading behind them. This evokes in the Japanese an understanding that everything is passing; the moon is either waxing or waning, in its fullness only for a moment.

Various lists have been compiled of the elements of Japanese design: five aspects, seven aspects, nine aspects. Various overlapping words have come to be descriptive, broadly, of Japanese aesthetics: Simplicity, a lack of extraneous decoration, essence ... this quality is described in subtly different ways by words such as *koko*, *shibumi* (and *shibui*), and *kanso*. The awareness of impermanence is codified as *mono no aware*. Other aesthetic principles include *seijaku* (tranquility, stillness, solitude), *datsuzoku* (freedom from habit or the conventional), and *yugen* (the preference for suggestion over

representation). *Ma* is the sense of open space. And let's not forget *fukinsei*, all-important asymmetry.

Each informs not just design, but also the performance of one's duties, one's behavior in social situations, and even the contours of one's character. Aesthetics in Japan are far more than what looks good; as with the quality called *iki* (a sense of being genuine, direct, unabashed, unpretentious), aesthetics address what is good, what is natural, what is meant to be, in art, in performance—in the person herself.

Japanese design is increasingly international. But perhaps the sharpest expression of Japanese design, particularly in a modern context, is the symbol of Japan: the national flag. Is there a flag more identifiable, more perfect, in the world? Why is that? The U.S. and British flags are certainly ubiquitous, and hugely influential; the Italian and French flags are nearly as familiar, and evocative. But most other world's national flags look either derivative of those or are just trying too hard.

By contrast, no flag is quite as simple, or says as much, as the Japanese flag. It influenced the cover design of this book, and you probably caught that at first glance. If you know it, you recognize it, no matter how far away, or how abstracted.

The flag references Japan's place as "land of the rising sun" and incorporates several Japanese design elements: It uses space in a way that makes it seem bigger; it evokes Japan's historic isolation and uniqueness; it uses color as boldly as possible while remaining utterly simple. It evokes nature. It looks static yet radiates vitality. It is austere but also vibrant. It is powerful yet inviting. It is literal but makes its point by suggestion. It is natural, and yet looks proudly artful at the same time. A three-year-old child would not only understand it; she could draw it.

It is, above all, the very soul of simplicity, with absolutely no excess, no decoration, no pretense.

When walking around Japanese towns—Kyoto in particular, with its low, wooden buildings, where even new construction evokes traditional materials and designs—one gets a sense of how easily classic Japanese tastes meld with even the most modern functions. Other design aesthetics in the world share qualities with Japan's: Germany's Bauhaus design and Italy's modernist styles are similarly clean and minimalistic, while being wildly creative.

But Japan has the edge, and it says a lot about the quality of Japanese design, and the aesthetics behind it, that every passing day the design of the future looks more and more Japanese.

40. Japan's Delightful, Traditional *Ryokan*

The traditional Japanese lodging known as the *ryokan* is often described as a country inn, or as Japan's version of a bed and breakfast. But many *ryokan* are much more. These beautiful, elegant places offer an unrivaled hospitality experience and a classic Japanese cultural experience for any visitor to Japan.

Less common in big cities like Tokyo and Osaka, *ryokan* are typically found in the scenic countryside, and often near or accompanied by an *onsen* (hot springs). They are not uncommon: There are an estimated 58,000 *ryokan* in Japan, 1,400 of which are members of the quality-assuring Japan Ryokan Association.

Ryokan are generally traditional Japanese structures, with rooms that often feel like small suites, complete with sliding

doors and tatami flooring. The *ryokan* experience usually includes a substantial breakfast and a *kaiseki* dinner. Often, *ryokan* include *onsen* as part of the accommodations, either as a shared bathing area or, in the most elegant places, a private bath.

The average cost is usually between ¥15,000 and ¥25,000 ($140–$240) per person, including dinner and breakfast, though there are budget *ryokan* as low as ¥8,000 ($75) and luxury *ryokan* for which the sky is the limit. But considering that it's easy to spend ¥20,000 ($190) or more for a fine hotel, the *ryokan* is a wonderful way to experience all the pampering that traditional Japanese hospitality can offer.

No two *ryokan* are alike, and many are still owned locally by people who take great pride in providing an enjoyable experience for their visitors. Stepping into a *ryokan* is more than renting a room; it is giving yourself up to the host—the *nakai*, your personal room attendant, often a women who has a wealth of experience in hospitality. This might at first feel strange to have someone directing you as you're getting settled in your room, but allowing your *nakai* to manage your stay is one of the great pleasures of the *ryokan*.

That experience begins with a formal welcome before you are brought to your room. Despite the typically dark hallways, rooms are often large and well-lit, with walls constructed of natural wood, tatami floors, and comfortable chairs, often facing a large window or even opening out onto a balcony.

The *nakai* sets the table for tea or brings a beer if that is preferred, and you are encouraged to change out of your travel clothes into a comfortable traditional cotton robe known as a *yukata*.

Depending on the time of one's arrival, this may be time for a before-dinner trip to the *onsen*, a delightful way to soak off the rigors of travel. While one is soaking, the *nakai* and

her assistant may be setting your table for the highlight of the evening: an elaborate *kaiseki*, Japan's haute cuisine, which will be served at the table in your room. Simpler *ryokan* will probably not serve a full *kaiseki*, which can feature as many as a dozen courses, but many will serve hearty, delicious dinners of local and seasonal fare and of dependably high quality. *Ryokan* owners and employees, like all Japanese, take hospitality seriously.

Such hospitality is rooted in the concept of *omotenashi*, the idea of something being given without expectation of reward. *Omotenashi* underpins everything from the warm towels offered at the start of a meal to the tip-free conclusion: Service is offered in the spirit of giving, not giving-to-receive.

After dinner, the *nakai-san* will move the table and chairs out of the way, put down futon, and dress them with bedding. Sleeping on the floor has never been so luxurious! Once the bedding is set, guests will be encouraged to go use the shared bathing facilities. Higher-end places will have the bath right in the room.

In the morning, the ladies will come in, put away your bedding and futon, and put the dining table back together. Soon after, they will bring in a traditional Japanese breakfast, which will consist, once again, of local and seasonal items, usually all served at once.

Modern variations on the *ryokan* include the *ryokan* hotel, which looks very much like a contemporary hotel—less traditional in form, perhaps even Western in style—but which may feature some of the same elements of a *ryokan*, especially the meals served in your room and the attention to orchestrated, personal service. Some *ryokan* hotels may offer Western food in addition to traditional Japanese fare. A *ryokan* hotel may also have features that more traditional *ryokan* don't; for example a bar, restaurant, or even a karaoke room.

Another variation on the *ryokan* is the *minshuku*, a more modest form of *ryokan* that often features Japanese-style tatami rooms that are comfortable but less roomy and elegant than those in traditional *ryokan*. The meals are unlikely to be *kaiseki*, but they will certainly offer delicious homestyle Japanese cooking. They may not feature the views or larger bathing facilities of *ryokan*, but they will give visitors a sense of traditional Japanese hospitality absent in most modern hotels.

Whatever form and price range you choose, staying in a *ryokan* is almost guaranteed to be a highlight of any trip to Japan.

41. The Pleasures of the Traditional *Onsen*

Japan's geographic position atop a volcanic archipelago clearly has its downsides, so it's important to remember one of its great benefits: Japan is home to literally thousands of hot springs, or *onsen*, and the Japanese have a long and storied tradition of enjoying this natural resource.

The word *onsen* refers to the hot springs themselves and also to the many clusters of resorts, retreats, and services that have sprung up around these mineral-rich, volcanic springs. The Japanese have, as with the making of tea or the eating of noodles, turned the act of taking a bath into a deliberate, conscious, often communal, and occasionally even spiritual experience. Going to Japan without enjoying at least one visit to an *onsen*, preferably in the countryside, is to miss an essential part of living in Japan.

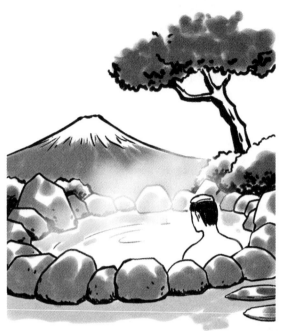

Onsen *often feature outdoor hot spring baths with beautiful views.*

Most *onsen* are located in the countryside and take full advantage of their locations, with many laid out next to rivers or with views of mountains or the ocean or even just a beautiful garden. As the practice draws more tourists, *onsen* are springing up within cities as well. But these are really more like *sento*, or public baths, since they are not natural hot springs but use piped-in water that is then heated. *Sento* are rarely as luxurious as a good *onsen* but may be appealing for that very reason: These public baths preceded private baths in homes, so they are a good look at Japanese bathing culture. See chapter 42 for a fuller description of *sento*.

Communal bathing is a tradition in Japan, born partly of necessity from the time when few had their own baths.

But it is also a strong expression of the manners and relaxed ambience of the communal Japanese character. Although the traditional *onsen* (and *sento*) were "mixed" (women and men bathing together), that changed during the Meiji period in the 19th century, and in most public baths, the sexes bathe apart.

One reason for this is that, with few exceptions, the Japanese prefer, quite sensibly, to bathe naked. Most *onsen* owners and bathers will look at you askance if you enter a pool wearing a bathing suit.

The word "bath" is misleading here, for one is expected to thoroughly bathe using the separate showers or water spigots before entering the baths. *Onsen* are for soaking and relaxing, not washing up.

The water in the various *onsen* varies as well—this is, after all, "wild" water that bubbles up from the earth. Different *onsen* might have water rich in various minerals, including ions of calcium chloride, sodium chloride, calcium, or magnesium, to name a few. To be called an *onsen*, at least one of these minerals must be present, and the water must come out of the ground at a minimum of 25 degrees Celsius.

The health benefits of mineral baths are well known around the world, from classical Rome and Turkey to modern California and Germany, and a rich culture has grown up around them over the centuries. Benefits claimed for mineral baths include increasing blood circulation, deep cleansing of the skin and even internal organs, reducing hypertension, and promoting relaxation. *Onsen* fans (and owners) are known for making extravagant, or at least colorful, claims for their waters—one advertisement mentions the "forty thousand ailments" their *onsen* can cure—but when one sinks down into a steamy bath, even the most outlandish claim may seem plausible.

Onsen are scattered all over Japan, with the greatest concentration in central Honshu, particularly west and north of Tokyo. The area around Kyoto features fewer popular *onsen*, but these are said to be among the best in the country.

Perhaps best known is the seaside *onsen* town of Kinosaki, which boasts seven traditional *onsen* in its delightful old town center. One regularly sees bathers shuffling between the public baths and along the town's picturesque, tree-lined canals. The baths here offer great variety, with themed baths, garden and cave baths, and even a walk-in freezer for when the heat gets to be too much. A three-hour trip from Kyoto, Kinosaki's position on the coast means that, in addition to the *onsen*, the hunger that many feel upon exiting the baths is easily sated with fresh seafood, including (during winter) some of the best fresh crab in Japan.

Many guides to the country's *onsen* exist and can be easily found online, but wherever you end up soaking, the variety and richness of the *onsen* culture, as well as the towns that have grown up around them, are not to be missed.

42. *Sento* Baths: Japan's Everyday *Onsen*

The love of a hot bath has been a part of Japanese culture for centuries, in part because of the volcanic nature of the archipelago, making it dotted with hot springs, and also because of the Japanese love of communal activities. But mostly, what's not to like? It's a hot bath!

But as with many things, the Japanese have refined the

activity of bathing into something approaching a ritual, and visiting Japan without visiting an *onsen*, a natural hot spring, is to leave your visit incomplete. We look at *onsen* in chapter 41, but there is another option, more common and more accessible—and considerably cheaper—than the traditional rustic hot spring.

Akin to the *hammam*, or Turkish bath, the *sento* is a public bath where local people can go for a reasonable price, usually around ¥450 ($4.25), and less for children. And although they have been decreasing in number since the 1970s, as more and more homes have their own baths, a visit to a *sento* is still enjoyable for its communal aspects, and a visitor would be wise to search out this simple, everyday pleasure.

There are more than a thousand *sento* in Tokyo alone, with the typical one tucked away in a residential district or small commercial area and as simple and utilitarian as you'd expect. Their layouts are often similar, with high ceilings, an entry area with an attendant's desk known as a *bandai*, and two areas, separated by a relatively low (1.5 meters) wall, for men and for women. *Sento* feature many of the same items seen in a typical gym or bathhouse anywhere: a scale, toilet, changing area with lockers, some beverages, and, in many cases, beds for babies (but only on the women's side). There are also typically Japanese items such as short stools and wooden buckets for washing yourself off before entering the bath itself.

This last point is an important aspect of any visit to a Japanese *sento*, *onsen*, or even private home: Bathe first! This makes sense in any public bath, but the Japanese are adamant about it, even at home. One must already be clean when one enters the bath, which is for relaxation, not washing.

The roots of the *sento* are in religious ritual bathing, which goes back as far as India, where bathing in Hindu temples was a rite of spiritual purification as much as a hygienic activity.

As with much Asian culture, the practice migrated with Buddhism to China, Korea, and then Japan, though surely anyone lucky enough to have a hot spring nearby didn't need Chinese Buddhists to tell them that bathing in it was a good idea!

It was mainly through Buddhist temples that bathing got a foothold in Japan, more than a thousand years ago, during the Nara period, where they were first used only by monks and priests. But as time passed, more and more people were allowed to use them, and the first commercial *sento* is said to have been opened in the 13th century in Kamakura. But it wasn't until the Edo period in the 19th century that *yuya* (hot water shops) became common.

These days, most *sento* are chlorinated for health reasons, another way they are distinguished from *onsen*, which feature natural hot springs of mineral-infused water and where additional chemicals are generally frowned upon. But *sento* are more practical institutions, and keeping out bacteria is a high priority when so many people use the water.

As with *onsen*, people with tattoos are generally barred from using the facilities because of the long association by the Japanese of tattoos with yakuza gangsters. Visitors are often cut some slack in Japan, however, and those with subtle tattoos will probably have no problem. But if your tattoos can easily be covered with a bandage of some sort, doing so may help you feel less self-conscious about breaking this cultural taboo.

Because the genders are separated, most *sento* are entered naked; wearing a bathing suit may strike the Japanese as odd. Children are allowed into the opposite sex's bathing area generally until the age of eight, though some places still allow girls into the men's until they are thirteen.

Women were long employed by *sento* to scrub men's backs and otherwise serve them, and many *sento* were for a time

associated with prostitution, though laws have long been established to discourage the commercial interaction of male customers and what were long called *yuna* (hot water women). This practice was gradually shut down after the opening of Japan to the West in the late 1800s and has continued to be discouraged into modern times.

Most *sento* are neighborhood establishments, casual, inexpensive, utilitarian, and made for the whole family, and should not be missed.

43. Gifts, *Giri* and Japan's Obsession with Packaging

Visitors who spend any amount of time in Japan quickly become aware of the importance, even the primacy, of presentation: A nice meal or a gift, or even an everyday object, is always appreciated in itself—but just as important is how it is wrapped or otherwise packaged.

Go to a shop, even to buy a T-shirt or a package of breath mints, and then watch as the clerk carefully wraps the item in paper, affixes a printed sticker to hold it, puts it into a bag, then folds over the top of the bag and affixes another sticker to close it. This focus on presentation comes right down to the receipt, which isn't just handed over; it is presented, with both hands, the eyes of the clerk fixed on the customer—with a smile.

Once one notices this—and it is difficult not to—one sees it everywhere, from hotels with their beautifully laid-out personal items and perhaps individually wrapped biscuits or

chocolates, to grocery stores with their individually wrapped fruit, to the way a shirt comes back from the dry cleaner wrapped in plastic with a tiny paper bowtie affixed to the collar.

Wrapping (*tsutsumu*) and tying or binding (*musubu*) are ways of showing that something is important or precious—of separating mundane things from the mundane world—and thus they are signs of respect. Properly wrapped and properly presented, anything can be made special.

Westerners, particularly in the hyper-efficient modern world, with its casual indifference to appearances, may find this pretentious or even false. But to the Japanese, who rigorously observe the division between *tatemae* (the public face or "official position") and *honne* (the "true voice"), presentation isn't just pretense—it is everything.

Wrapping is important, as it is in all cultures, in the presentation of gifts. But Japanese gift-giving, while often "from the heart," is just as often a prescribed action that represents a complex social code with multiple hierarchies and responsibilities. Gift-giving is just one of many forms of *giri* (obligation, or duty) in Japanese culture: A gift is an obligation, and it is often one that comes with an obligation to reciprocate. Gifts may be given freely and with sincerity, but a sense of *giri* may not be far behind.

This puts even more pressure on the wrapping. Because of this, it is important to give as much attention and praise to the wrapping as to the gift itself. Considering the Japanese skill in wrapping and packaging, this isn't hard to do.

Elegant presentation goes far beyond mere gift-giving in Japan. Take lunch, for instance: Even the cheapest *bento* boxes display their modest lunch items with great care, and the boxes are often quite beautiful themselves. If they are not lacquerware, they are plastic painted to look like it. A recent

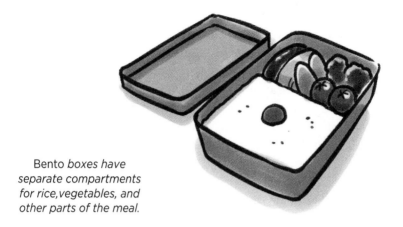

Bento *boxes have separate compartments for rice, vegetables, and other parts of the meal.*

trend among Japanese mothers was a competitive approach to *kyara-ben,* or bento boxes "with character"—in which case the humble rice ball may be decorated to look like an adorable panda bear. Even the mundane school lunch was an area to demonstrate mastery of presentation.

Sake bottles come wrapped in beautiful paper, and the simplest cookies and biscuits are sometimes hidden behind two or three layers of beautiful packaging. If you think this may have a larger cultural implication—well, what doesn't? The word meaning "to wrap" (*tsutsumu*) has an analogue in *tsutsushimu,* which means to be chaste or discreet, or to be careful. It has also been used to express the need to suppress one's feelings—to keep one's feelings wrapped.

Even the Japanese themselves can be wrapped, as any geisha can tell you. Traditional kimono and *yukata* can be seen, especially when compared to more functional Western clothes, as beautiful body wrappings, with a carefully tied *obi* being the bow.

Japanese, a context-sensitive language, is on some fundamental levels distrustful of speech—the English phrase "talk is cheap" may well express a core belief of the Japanese.

Another is "actions speak louder than words," and in this respect, the wrapping culture may well be an expression of a wariness of mere verbiage. In that way, the presentation of a gift or even the wrapping of a recent purchase may say something more profound than the most effusive thank you.

As with much Japanese culture, what is external is not just about hiding something, though it may do that as well. Instead, fine presentation is about honoring the act of giving itself. The Japanese believe that it *matters* whether something is done beautifully. Wrapping isn't just about making something prettier; it is about honoring other people, even the world, by presenting one's best, and doing it as beautifully as possible.

44. Haiku and the Japanese Love of Brevity

The haiku may be the ultimate literary form for the Japanese, a culture that prizes efficiency and clean, simple aesthetics.

Familiar all over the world, these almost impossibly brief, elegant glimpses of life and spirit have grown in popularity in many languages. In Japan itself, the form has changed from the strict structure of the past but retains the simplicity and clarity of the original. Perhaps the most famous haiku written in Japanese was from the national saint of Japanese poetry, Matsuo Basho:

> *old pond*
> *a frog leaps in*
> *water's sound*

Basho, who lived from 1644 to 1694, wrote his poems long before what we now call haiku existed as a form. What we know as the haiku's structure evolved from an earlier form, the *hokku*, which was a short opening stanza to a longer poem called a *haikai* or *renku*. It wasn't until the Meiji Restoration that the poet Masaoka Shiki (1867–1902) would cut the *haikai*'s opening lines free, thus bringing the haiku itself into being.

Since then, the haiku has changed its form over the centuries and grown in popularity, thanks to the talents of writers like Kobayashi Issa and Masaoka Shiki. In Japanese, the haiku has traditionally consisted of one long vertical line down the page (Japanese is generally written top to bottom), its rhythm implicit in the sounds and sense of the words used.

Haiku first entered English via Japanese poets, who tried their hand at creating original *hokku* in English at the beginning of the 20th century. Yone Noguchi even wrote "A Proposal to American Poets," suggesting that they try their hand at this economical form. Haiku itself was introduced into French in 1906 by the poet Paul-Louis Couchoud and into Spanish not long thereafter. The style, if not the name, was adopted by the expatriate American poet Ezra Pound in 1913, with his "In a Station of the Metro":

The apparition of these faces in the crowd:
Petals on a wet, black bough.

Pound's poem was considered to be an Imagist work, a modernist form of the time, but the influence of haiku was clear to many. Still, full recognition in the West of the Japanese form would not come until Reginald Horace Blyth, an Englishman living in Japan, produced a four-volume collection of Japanese haiku in 1949, followed by Japanese-American translator Kenneth Yasuda's 1957 collection and interpretation of haiku in both Japanese and English.

In English, we think of haiku as consisting of seventeen syllables, arranged in three horizontal lines of five, seven, and five syllables. That tradition has changed in the one hundred years since Pound introduced an approximation of that form to English literature, but most writers of haiku still don't stray far from this limitation, which imposes a discipline and structure on what could otherwise be a very insubstantial form.

But in Japanese, the structure is quite different. The mora is a unit of sound roughly similar to a syllable, thus the Western style of the seventeen-syllable haiku. But haiku structure isn't just a matter of counting syllables, or morae; it is about how elements that might not otherwise fit together are juxtaposed to create an effect akin to a kind of revelation. Haiku allows the reader or listener to make an imaginative leap simply by hearing two phrases or images bump up against each other in a compelling, insight-inducing way.

the first morning of autumn: the mirror I investigate reflects my father's face

(Masaoka Shiki)

Besides the number of syllables, or morae, the essential element in most haiku is something less precise but equally important: the *kireji*, or "cutting" word, that comes at the end of one of the three lines and separates the two thoughts in a way that unifies them, or ends a haiku in a way that signifies closure or emphasizes an emotion. English doesn't have an equivalent, save perhaps in classical poetry's caesura; instead, Western poets use punctuation to pause the flow, change the poem's direction, or end it all together.

Another element of haiku that has remained relatively consistent is the *kigo*, or seasonal reference, which places the poem in the proper seasonal context. It does this through

the use of specific words that have long been understood by the Japanese to signal specific seasons. This is an important aspect of much Japanese art in general, which has long been connected to the changing of the four seasons. Haiku written in other languages, by poets of other cultures, often lack this seasonal element, but it is still considered essential by most Japanese lovers of the form.

Japanese haiku may strike some Westerners as insubstantial or overly simple, and the limits of translation work against a full understanding of the form outside of its native language. Still, some time spent reading haiku, even in translation, can draw even the less poetically inclined into its spell, making haiku yet another way in which Japanese art can illuminate the mind and soul.

45. The Strange Story of Japan's "Alphabet(s)"

As difficult as learning to speak Japanese might be, the written form of the language—the Japanese "alphabet," although it's not really an alphabet—is even more complicated. That's because, given the external influences on Japanese culture, from China to Europe, many non-Japanese words, and scripts, have entered the language from its earliest history.

That is how Japan has ended up with not one, not two, not even three, but four different sets of written characters, making every Japanese sentence a jumble of symbols that take many years to learn to decipher. Most Japanese writing will make some use of three of these four sets, which has led to

the suggestion that Japanese is possibly the most complicated written language in the world.

How complicated? These four different sets of characters or letters—*kanji, hiragana, katakana,* and *romaji*—are used according to what kind of word it is, its grammatical function, how it is used in the sentence, and where it came from. Thus, for example, words that originally came from Chinese are represented in *kanji,* the Japanese version of specific Chinese characters. There are reportedly as many as forty thousand *kanji* extant, and Japanese primary and secondary school students are required to know more than two thousand by graduation. The majority of characters in any sentence written for adults will most likely be *kanji.*

Hiragana and *katakana* characters—there are forty-six of each—comprise two separate syllabaries with identical sounds and are historically based on original Chinese *kanji* that have been simplified and stylized into characteristically Japanese forms. *Hiragana* characters are used to represent native or naturalized Japanese words as well as verb endings and other grammatical elements and are the written forms one is most likely to encounter when first learning Japanese. *Katakana* characters are used for emphasis and to represent imported "loan" words and proper names from other languages, as well as scientific words.

A fourth alphabet, *romaji,* is not as often used in typical writing, but a visitor will encounter it frequently in train and subway stations. It is basically the English or Latin alphabet, used to represent non-Japanese words or acronyms and logos, and in some cases, to communicate with non-Japanese. Romaji can also be used to give words a foreign flavor or cachet in advertising or fashion, for example.

This jumble of symbols represents Japan's position as a country deeply influenced by radically different cultures. As

The same syllable in the
four writing systems
used in Japan, clockwise
from top left: hiragana,
katakana, romaji, kanji.

confusing as the writing system may be to outsiders, it could hardly be any other way, and this complication only multiplies when one considers that Japanese, though traditionally written like Chinese—in columns from top to bottom, and from right to left—can also be written horizontally and from left to right, as in English. Throw in the fact that written Japanese doesn't require spaces between words and you have a written language that may serve the Japanese well but can be difficult to learn.

For English speakers, it might be tempting to think that *romaji* (literally, "Roman characters") is the easiest way to communicate, since it uses the twenty-six-character script from the Latin alphabet. It's true that if you're communicating with a Japanese person via a computer or text, you will begin with *romaji*. The problem is that, despite appearances, Japanese doesn't really have four alphabets, it has three: *kanji*, *katakana*, and *hiragana*. *Romaji* is primarily for foreign names and words in advertising and signage, so using it to communicate with the Japanese is a short-term solution.

This only touches the surface of the infinite complexities of Japanese writing; there are many other subtle elements, exceptions, rules, and nuances in translating sound to the page. If you want to learn it, you will need to learn all three sets of characters, the two syllabaries and the *kanji*—there is simply no way around it. This adds an additional burden, but learning the writing system can help deepen your experience of the language and, in turn, your appreciation for the country and its culture.

46. The Timeless Art of Japanese Woodblock Prints

Even those unfamiliar with woodblock printing—and Japanese woodblock printing in particular—are still likely to be familiar with what is perhaps the most famous woodblock print in the world: *The Great Wave Off Kanagawa*, by *ukiyo-e* artist Katsushika Hokusai.

Created sometime between 1829 and 1833, the print depicts what is thought to have been a rogue wave off of Kanagawa, near present-day Yokohama in Tokyo Bay. The massive wave has since become nearly as familiar, and as often satirized, as iconic Western paintings like da Vinci's *Mona Lisa* or Munch's *The Scream*.

But beyond the worldwide fame of that particular image, the piece is an exemplar of *ukiyo-e* woodblock printing, which flourished in Japan for nearly three centuries. Although woodblock printing goes back to the earliest days of Chinese influence on Japan—printed books are recorded as early as

the 8th century CE—woodblock printing came into its own after the invention of movable type and the introduction of mass printing in the 16th century.

The first hero of the story of printing in Japan is Tokugawa Ieyasu, just a few years before he founded the Tokugawa shogunate, which ruled Japan during its two and a half centuries of isolation. Ieyasu was the first to create a native printing system using movable type that could work with thousands of Japanese characters—the German Gutenberg press, by contrast, only needed to create twenty-six letters and ten numbers.

The best-known style of woodblock printing in Japan was *ukiyo-e*—literally "pictures of the floating world"—the hedonistic world of merchants and artisans that grew up during the 18th and 19th centuries of the Edo period. Although the lowest of the four social classes were by decree the merchants (the highest were the samurai), these merchants thrived under the relative calm of the shogunate, and with their newfound wealth they discovered the pleasures of the "floating world" and paid good money for representations of it. Woodblock prints of geisha, courtesans, Kabuki actors, and nature were highly prized and widely disseminated.

The next to influence Japanese woodblock printing was the artist Hishikawa Moronobu (1618–94), who in 1670 began to create monochromatic prints. He was also the first to produce prints that were not illustrations in books but rather works of visual art that stood on their own as single prints.

Color was gradually added over the next century, and by 1760 the artist Harunobu was creating so-called brocade prints with numerous blocks that added different colors, making him the dominant artist of the period. Later in the 18th century, a number of artists had perfected this complex process, and the great masters of the art were producing some of

their classic works, including Hiroshige and Hokusai, whose above-mentioned *Great Wave Off Kanagawa* was the ultimate expression of the form. Their landscapes and the focus on the details of everyday life were exemplary of the *ukiyo-e* style.

The printmaking process was complex, requiring four people, including the artist. The publisher was first, financing the production and hiring the three master artisans who would actually produce the work; a painter, who created the original artwork; a carver, who carved the lines of the painting into cured white cherry wood for printing; and the printer, who applied the paints to the woodblock and rolled out the prints. With this process, artists were able to mass produce copies of a print while at the same time making something that was utterly unique, as each print differed slightly in how the ink was applied.

After that, with the rapid social and technological modernization of the Meiji period, *ukiyo-e* went into a steep decline from which it never recovered, though color-block printing is still practiced by a dwindling number of masters. Still, Japan's subsequent period of modernization led *ukiyo-e* to be exported, particularly to Europe, where "Japonism" became a hot trend and artists such as the French Impressionists and Post-Impressionists (particularly Manet, Cassatt, and Whistler) adopted some of the *ukiyo-e* style and techniques. Vincent Van Gogh went so far as to paint copies of some Japanese originals. Subsequent artists such as the Art Nouveau master Toulouse-Lautrec made their debt to *ukiyo-e* apparent in their prints (and in many cases, choice of subject matter).

The vogue for Japanese woodblock prints may have surprised some Japanese, who considered the form to be a mass medium, not a high art. Funny, then, that the cover of composer Claude Debussy's pivotal work *La Mer* would be published with a woodblock print variation on Hokusai's *Great*

Wave as its cover. In keeping with the growing appreciation of the form in the West, an American, Ernest Fenollosa, curated the first exhibition of *ukiyo-e* work in Japan itself, in 1898.

47. Folded Form: Origami and Kirigami

The traditional Japanese arts are, generally speaking, all about making things with natural materials and as little "processing" as possible. Human creations should look natural. Thus, the ideal ikebana flower arrangement should appear not to be arranged at all, but rather to have just fallen into place naturally.

Few Japanese arts are as simple and unprocessed as kirigami (paper cutting) and origami (paper folding). All that is required is the paper itself, along with a knife, or some small implements such as tweezers and a piece of bone for folding the paper.

Kirigami—from the words *kiru* (to cut) and *kami* (paper)—is lesser known than origami outside of Japan, though schoolchildren around the world cut out a snowflake or a chain of paper dolls at some point. But kirigami takes such cut-paper creations to a different level. Intricate card designs, three-dimensional pop-up "architectural" kirigami, and even entire dresses made of cut paper are among the creations that have blossomed in this unassuming art.

The basics of kirigami are in the folds and in the precision and care with which the cuts are made. Most often paper is folded once, then twice, and even sometimes a third time.

The folded crane is a staple of origami around the world.

Each fold adds layers of difficulty, but also adds to the subtlety of the final design. For this reason, very thin paper is needed, and the Japanese, who absolutely love paper—think about the rice paper *shoji* screens in homes, or the wrappings so often lavished on packages, and Japan's ongoing love affair with books—are happy to oblige. Like everything else in Japan, the varieties of paper are mind-boggling.

Kirigami allows not just folding and cutting, but even gluing and taping, expanding the creative possibilities.

By contrast, origami does not allow anything but folding. There is no gluing or taping, and there are no holes in the paper when origami is done. The resulting grace and beauty of origami creations is one of the wonders of Japanese culture. Still, while most visitors may be aware of the simple folded cranes that pop up everywhere in Japan—from table settings to *ryokan* pillows to the "thousand cranes" hangings that are traditional wedding gifts—origami creations can be remarkably elaborate.

The secret is in the folds, of which there are nine basic forms, from the "mountain" folds to the "pleat" and "crimp" folds, as well as the "bases" upon which those folds are made.

Another technique that has arisen is the "wet fold," which allows the creation of more organic, less angular shapes that can be rounded to achieve a more natural look. Other variations are based on the different papers used: plain or colored or even foil. The paper used is called *washi* and is made using pulp from the *ganpi* shrub, but everything from bamboo to hemp papers are often used as well.

Japan is not the only place where the paper-cutting art is practiced, and paper-folding traditions from China to as far away as Germany have influenced Japanese design. In fact, it was from the German paper-cutting art known as *Scherenschnitte* that the conventions on cutting were introduced into Japan in the late 19th century.

In modern times, the precision of computers has allowed cuts of such detail that even a medieval artisan would be impressed. The machine-made, pop-up creations sold for a pittance on the streets of China, Vietnam, and even New York City are not considered true kirigami, but they are the latest combination of this traditional paper-cutting and -folding craft with computer technology. These cheap souvenirs are as impressive as they are increasingly common.

The artistic exploration made possible by kirigami and origami—people are constantly creating new forms—has allowed these crafts occasionally to attain the status of fine art. Akira Yoshizawa (d. 2005), whose work led him to be called Japan's origami master, is reckoned to have created tens of thousands of unique designs that have been shown in Europe and elsewhere.

Both kirigami and origami designs are widely available to beginners in books and on the internet. If the patterns are closely followed, even a novice can create beautiful designs almost immediately, making these two of the most enjoyable and widely practiced of Japan's many arts and crafts.

48. Three Kinds of Classic Japanese Theater

There is a long tradition of theater in Japan. Classic works of the Western canon, as well as contemporary drama and even musicals are popular, but three forms of traditional Japanese theater are still widely performed.

Noh, Kyogen, and Kabuki have deep roots in Japanese culture and are directly related to each other. Noh is classic Japanese drama, and remains the most traditional form. Kyogen is a short, comic theater that first appeared as comic relief during Noh performances. Kabuki arose in part from Kyogen, with a bawdy, less-rarefied content that some have called Japan's first popular culture.

All are accompanied by musicians, sometimes a chorus, who serve to heighten the scenes in otherwise relatively spare, even minimalist, staging. Even the music itself comes and goes, with the spaces in between as important as the music itself.

Noh is the father of the others and has seen its ups and downs over the centuries, almost disappearing during the Meiji period. But it has since reestablished itself as one of Japan's most distinctive and serious cultural expressions. Noh began in the 13th century as dramas based on traditional stories from Japanese literature; there are more than two thousand Noh plays in the repertoire—though just a fraction of them are still performed.

Noh is especially known for its iconic masks, which form a repertoire of more than four hundred different faces, allowing actors to play several different characters. The ways in which actors use those masks—tilting their heads to catch the light in ways that express different emotions—are some

of the wonders of Noh. Body movement, highly stylized, is employed to further express emotion and ideas.

But Noh is not, strictly speaking, theater as it is known in the West. Instead, it is more akin to storytelling, in which the actors illustrate the tale rather than try to convince the audience—who know the stories and their characters, which are classic—that they are the character him- or herself. The language, which largely comes from the 14th–16th centuries, when it developed as a court entertainment, is very formal; much of it is alien even to contemporary Japanese, just as Shakespeare's verbal style is to most contemporary English speakers. Noh is similarly not naturalistic; this is part of its great appeal. Lovers of Noh have little desire for it to be contemporary; its great power is in its unchanging forms and traditions.

Kyogen plays—shorter (few are longer than ten minutes) and less serious than Noh plays—are more fluid. They developed alongside the latter form as comic or at least emotional relief, sometimes improvised. They became a distinct form in the 15th and 16th centuries. Kyogen were performed on Noh stages in between plays, and still are; but these days, exclusively Kyogen performances, assembled from a handful of the 260 plays extant, are not uncommon.

Kabuki arose much later and from a much different source. In contrast to the serious, moralistic Noh, and the fable-like, simple Kyogen, Kabuki is about dancing and singing, and its very name suggests that it has always been about bizarre and off-kilter performance. The word comes from the verb *kabuku*, meaning "to lean" or "to be out of the ordinary." Yes, Kabuki is weird even to the Japanese.

Kabuki arose from the fringes of society, more precisely from the dry riverbed of Kyoto's Kamo River, where in 1603, Izumo no Okuni began performing her radically different,

often ribald, plays, songs, and dance dramas with large ensemble casts. They were an instant sensation among nobles as well as commoners.

Kabuki could not have contrasted more with Noh. Among other things, it was performed entirely by women, unusual in 17th-century Japan, and many of those women were also prostitutes. By 1629, the shogunate had banned such women from performing and men took over the roles. Kabuki continues to be all-male, though it has retained its edginess over the centuries.

The fortunes of each of these theater arts have risen and fallen over the centuries, almost nearly disappearing at points: especially at the time of the Meiji Restoration in 1868, when Noh lost the government support it had during the Tokugawa shogunate, and after World War II, when Kabuki, which had been performed in support of the country's imperialist expansion of the 1920s and 1930s, lost favor under the Occupation. But since the 1960s, both Noh and Kabuki have become enshrined as classic Japanese theater, widely supported and worth exploring on any visit to Japan.

49. The Kimono, Japan's Traditional Garment

The kimono may be a cultural marker as familiar as the baseball cap, a simple visual shorthand that says "Japan" as strongly as sushi does. Despite changing fashion, it has been adapted for continued use in a country that long ago adopted Western clothing by imperial edict.

The kimono, whether casual or formal, silk or polyester, for summer or winter, is a complicated thing, with an array of precise rules for wearing, storing, and cleaning, as well as a millennium's worth of history behind it. The kimono is anything but simple.

A kimono—the word means simply "a thing to wear"—is also anything but cheap. One can buy an inexpensive kimono in any number of different fabrics, but a real kimono—made with hand-painted silk and painstakingly sewn together by hand—can cost upward of $10,000, meaning a formal kimono is one of the larger investments a Japanese woman or man is likely to make in a lifetime.

That's just for the kimono itself. To properly wear a kimono is also to have a beautiful, wide belt (*obi*), the traditional footwear (*zori* or *geta*), with special, split-toe socks (*tabi*), as well as a dozen other undergarments and accessories that can easily double the price.

On top of that, the actual upkeep of a fine kimono is an ongoing investment: Traditional silk kimono must be completely disassembled into their constituent parts—large panels cut from one original bolt of cloth—then cleaned by hand (a process called *arai hari*) and then resewn in a process that can take days.

Kimono are disassembled not just to be cleaned but to repair a damaged panel or to add material from another, older kimono. Each part, whether the *eri* (collar) or a *sode* (sleeve) or a *maemigoro* (front panel) can be removed and repaired or replaced. Thus, a kimono can be maintained for many years, even down through generations.

The styles of women's kimono vary widely and offer very specific clues to the wearer's position. Those in the know can tell a woman's social status and even marital status by the cut of her kimono. For example, a *furisode* kimono features long,

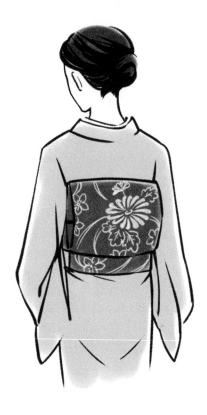

The traditional kimono is still a fashionable, festive, and ceremonial garment.

swinging sleeves that denote an unmarried young woman, while a *susohiki* kimono is usually worn by geisha or other performers. The *junihitoe* is an elegant kimono worn by ladies of the Imperial Court, and the *uchikake* kimono is a bridal costume. Another kimono, the *homongi*, is meant for semiformal events.

Men's kimono—in contrast to the varied and elaborate women's styles—are much simpler, composed of more modest fabrics and muted colors, and are considerably easier to coordinate and care for.

Kimono are distinguished not just by function, but also by the materials used. The *komon* style features delicately patterned material, while the *iromuji* is a solid-colored kimono

worn mainly to tea ceremonies. The *edo komon* features tiny dots that create sweeping, pixelated patterns.

The kimono goes far back in Japan's history, a thousand years or more, but it came to be what it is now during the Edo period (1603-1867) and was commonly worn well into the 20th century. The transition to Western dress that began in the late 19th century, during the Meiji period, with its conscious embrace of modernity in the form of Western styles, began the kimono's long decline. But subsequent attempts to preserve traditional Japanese culture, and the kimono's place in such ceremonial traditions as weddings, funerals, and various religious events have assured that a kimono is still a standard part of any Japanese woman's (or man's) wardrobe.

Even during a walk around Kyoto, a visitor will likely see many young women sporting kimono with traditional wigs and makeup. However, the observant visitor will quickly discover that these are, in fact, other tourists who have paid to play at being Japanese ladies. Any well-educated Japanese will be able to point out a half dozen flaws in their costumes.

Wearing the proper kimono—made of the right fabric, in the right cut, for the right occasion—can be a daunting prospect even for Japanese women. But it also makes getting it right such an impressive accomplishment. The famous Japanese attention to detail, as well as a conscious desire to perpetuate timeless Japanese style, finds full expression in the kimono.

50. Elements of a Traditional Japanese Wedding

Weddings are important events all around the world, and like everyone else the Japanese take the wedding ceremony very seriously. The amount of money spent on clothes, decorations, food, and venue can match a year's wages, all with an attention to detail that is typically Japanese.

Marriage itself has changed much over the centuries in many cultures and countries, and in Japan it is no different. While the Japanese have retained many of their own cultural traditions, they've also incorporated many other cultures' practices—especially those of the West.

Both of the main forms of Japanese weddings—the traditional Shinto wedding and the "white" wedding, a version of Protestant Christian wedding traditions—are popular in Japan. Both are relatively recent innovations, but the "white wedding" appears to be winning the hearts of the Japanese: In recent years, an estimated 80% of Japanese weddings have been done in the "white" wedding style.

This blurring of cultural lines, or combining of different traditions, is common in Japan, and a common Japanese saying sums it up: "Born Shinto, marry Christian, die Buddhist."

Both Shinto and "white" weddings—the phrase originated in Victorian England—came into vogue after important public weddings. The first Shinto wedding was only held in 1900, when the Crown Prince Yoshihito (later, Emperor Taisho) took a bride, and the "white wedding" became popular with the 1981 worldwide television broadcast of the wedding of Great Britain's Prince Charles and Lady Diana.

Whichever type of ceremony is chosen, the actual wedding is usually held for only a small group of family and close

friends. This is particularly true of Shinto weddings, which take place at Shinto shrines, with an attending priest who purifies the couple and offers their union to the *kami* (gods) of the temple. Sake is drunk ceremonially, the bride and groom each taking three sips from each of three special cups, with their parents also partaking.

By contrast, "white" weddings are more often held in Western-style wedding halls and, to complete the illusion, are often presided over by an American or European male who may not be an ordained priest at all. This is, after all, not a Christian ceremony per se, but a more secular event in the Western style.

Perhaps the greatest difference between the two styles is in the clothing (and makeup for the bride), which is elaborate and traditional in the Shinto style and much simpler in the Western style. For Shinto weddings, the bride and groom are dressed in elegant, traditional vestments: the bride in a white kimono known as *shiromuku* and the groom in a black kimono with kimono pants and jacket. In addition to the kimono, the bride often wears some spectacular headdresses, *tsuno-kakushi* and *wataboshi*, that date back to the 14th century. She may also be made up in white makeup, much like a geisha's, to indicate her purity.

After the wedding ceremony itself, the bride and groom and their families move to a banquet hall, where they are celebrated by a much larger group with food and drinks, toasts and speeches. Guests generally pay a fee to join the festivities and should also give *goshugi* ("gift money," as much as ¥30,000, about $300) for the newlyweds. The giving of actual wedding gifts is not common, as money is easier for everyone, but there is one exception to this rule: The bride and groom are the ones who give small gifts, *hikidemono*, to their guests.

Dancing is one Western tradition that has not caught on at Japanese weddings, but at the conclusion of the main reception, younger guests are often offered the opportunity to go to a second reception at a bar or even a karaoke club, where they have more opportunities to be away from their elders, and perhaps make a marriage match of their own.

Such moments are important in a country that is seeing declining marriage rates and, since the economic bubble burst, a rise in the age at marriage. The number of people over fifty who have never married has risen fourfold for men, from 5 to 20%, while the number of women who have never married has doubled, from 5 to 10%. The average age at which women and men marry has risen to roughly thirty and continues to increase each year.

Still, the amount of care and money that the Japanese put into weddings remains consistent, reflecting the culture's ongoing emphasis on marriage as a social good. Shinto or "white," the style of marriage in Japan may change, but its importance to the Japanese does not.

51. Introduction to the Japanese Tea Ceremony

Its name in Japanese is simple—*chakai* (tea gathering)—but what is often referred to in English as a Japanese tea ceremony is one of Japan's most sophisticated, yet fundamental rituals.

The *chakai* (or more formal *chaji*) is not just about tea, nor is it simply a ceremony, something to be learned, performed,

and added to one's list of accomplishments. Chado, the study of tea, is more than that; it is a way of life.

While this may sound pretentious, it is actually the opposite. Chado is a way of living—the Way of Tea—that focuses both the practitioner, who can spend an entire life exploring the action of making and serving tea, and the guest, who will learn something new every time, on life's fundamentals: sitting down with friends, boiling water, and drinking tea.

In English, we sometimes say that someone is "going through the motions" to indicate that they are just performing rote, routine actions but are not engaged. In a *chakai*, the motions are prescribed down to the slightest movement, but within this ritualized movement is a world of presence, and of understanding.

A *chakai* is not a religious ritual, and drinking tea is not the point. Instead, it is a gift that raises both the giver and the receiver's awareness of every moment in its fullness.

The actual ritual tea ceremony and all its variations— called *temae* in Japanese—would take a book to describe. Such books exist, and they describe every detail, every movement prescribed by tradition, by practicality, by design, by aesthetics. The *chakai* is endlessly simple, and endlessly sophisticated. But it is not taught by books, nor is it experienced through them. The tea ceremony is all about the direct experience.

Tea has been drunk and revered in Japan since it came from China in the 6th century. The bowls and utensils used in a tea ceremony are an ancient art form that, in some cases, preceded even the connection to China. But the *chakai* as it is now practiced arose sometime in the 15th century, during the great cultural flowering of the Muromachi period, which also saw the rise of Noh theater and ikebana, the art of flower arranging.

Like ikebana, the tea ceremony was first practiced by

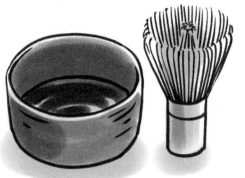

Green tea is whipped with a whisk before being served in a ceremonial teabowl.

Buddhist monks, then was adopted as a sign of reverence by the samurai and by the nobility and rich merchants as a sign of sophistication. It reached the general public slowly and is still practiced mostly by those with the time and resources to study weekly, as developing even a fundamental understanding of the proper way of serving tea can take many years of practice.

All that is done with the student's understanding that, as with life, learning the "right way" to do it is a never-ending process; the trick is to immerse oneself in that process, without attachment to a goal, and to see the lessons embedded in the study.

The tea ceremony takes two forms, the shorter being the *chakai*, in which tea is served with a small meal, akin to afternoon tea; it may take less time and be somewhat less involved, but it would be wrong to say it is informal.

The longer version is the *chaji*, which can take as long as four hours and will include *kaiseki*, the multicourse meal that is Japan's haute cuisine.

Whether *chakai* or *chaji*, the ceremony takes place in a small room or tea house that is specially designed for the purpose. Laid out on a square of exactly four and a half tatami

mats, around a sunken brazier on which the water is boiled, the elegant choreography of the *chakai* or *chaji* proceeds at a pace that allows host and guests alike to savor the moment.

The whole ceremony is designed to focus the attendees' attention on the process itself, on the utensils and tea bowls, which are admired and even passed around carefully, as they are objects of great reverence. Special, elegant cloths are used to clean each one, and in some cases, even to hold them.

Bowls of tea are shared—beginning with thin (*usucha*) tea, then with the thicker (*koicha*) tea, ritually whipped into a gorgeous green froth, then passed from one guest to another. The tea and its qualities are discussed as the tea itself is deeply enjoyed. Presence is focused to a degree that can only be called meditative.

Likewise, although this is a friendly gathering, a tea ceremony is not the place for idle chit-chat or gossip; tea and the ceremony, as well as the other art in the room, are the topic. Special scrolls of calligraphy may be hung on the wall in a place of honor, often with the four *kanji* characters that express the focus of the day's *chakai*. Those four *kanji* are *wa* (harmony), *kei* (respect), *sei* (purity), and *jaku* (tranquility). The host wants to be sure that these are not only discussed but experienced by each guest. The tea ceremony is a meditation, but it is also a gift from the host to the guests, as the tea, and life itself, are gifts to everyone present.

Thus, the *chakai* and *chaji* are ways to honor friends, but also ways to honor life and to make oneself humble before it. As elaborate as its rules and rituals may seem, the essence of the Japanese tea ceremony—and tea itself—is simple, humble, and beautiful. As is life itself.

HISTORY AND ARCHETYPES

What we identify as Japanese culture really came into its own with the introduction of Chinese culture in the 6th century. What follows are brief looks into particular periods in Japanese history that helped create contemporary Japan. This section also glances at some of the basics of Japan's fascinating spiritual and religious practices, from the Shinto pantheon to Zen Buddhism. Whole libraries of books have been written about each, so this is just a starting point.

History and myth blend in most cultures, and that is certainly true in Japan. The first thousand years of the Japanese Imperial Family is understood by historians to be the intentional creations of a royal family eager to cement its legitimacy in the distant past, much like King Arthur in Britain.

Then there is the more recent history of the Tokugawa shogunate, which ruled for two and a half centuries; of the American naval Commodore Matthew Perry's invasion of Japan in the mid-1800s; and of the Japanese invasions of Asia in the early 20th century. Each has been a turning point in Japan's long, complex history that I hope will anchor readers in a framework that makes Japanese arts and culture easier to grasp.

Along the way, we'll explore a few of Japanese culture's most colorful and best-known icons, like the geisha or the samurai or the Imperial Family that has "ruled" Japan for its entire history. But we'll start with the mythological characters who first gave the inhabitants of the islands a sense of what being Japanese means: the gods of the ancient land of Wa.

52. Amaterasu and the Gods of Ancient Japan

The early myths of Japan were first compiled beginning in the period between the 5th and 8th centuries CE in chronicles known as the *Kojiki* and the *Nihongi*. This is rather late compared to the myths of nearby China, not to mention those of Greece and Rome. These myths still resonate strongly with modern Japanese, who have recycled them in contemporary manga and animated films.

The stories of the ancient gods, or *kami*, are a crucial part of Shinto, Japan's indigenous religion, which despite the subsequent adoption of Buddhism and its various sects remains at the heart of Japanese culture. One important aspect of the myths was political and supported the divine rights claimed by the Japanese Imperial Family, which was held to be divine until forced to renounce its claims to divinity after World War II.

The primary Japanese myths concern a celestial family and its creation, and ultimately center on one key *kami*, Amaterasu-omikami, the Goddess of the Sun. That this sun deity is female, when most sun gods are traditionally male (and the moon, female) is a distinguishing feature of Japanese cosmology.

When these stories first began being told is unknown, and various myths in the *Kojiki*, *Nihongi*, and other sources tell different stories, or different versions of stories, about the sun goddess Amaterasu and the other gods. But the most popular version, fundamental to the Shinto view of the world, takes the familiar form of the family drama.

Amaterasu, the supreme Japanese deity, was said to have been created by the divine couple Izanagi (He-who-invites)

190 ■ JAPAN FROM ANIME TO ZEN

and Izanami (She-who-is-invited), who were themselves cre-
ated by, or grew from, the originator of the Universe, Ameno-
minakanushi (All-Father of the Originating Hub or Heavenly
Ancestral God of the Originating Heart of the Universe). This
divine couple created the Japanese archipelago, the islands of
which are considered to be their first children.

Next came the creation of their divine offspring, which
began badly: Izanami gave birth to Kagu-Tsuchi, the god of
fire; Izanami was horribly burned, died, and was sent to the
underworld, known as Yomi-no-kuni. Izanagi tried to rescue
her, but when he found her, she was disfigured and consumed
by maggots, and he retreated in horror to the archipelago they
had created.

As Izanagi returned to the world, he spontaneously gave
birth to three deities: Amaterasu, born from his left eye; her
younger brother, Tsukiyomi, the moon deity, from his right
eye; and the troublesome baby boy of the family, Susanoo, the
storm deity, the product of his nostrils.

The first of these offspring, Amaterasu, was primary,
all-powerful, and beloved, for she was said to bring nothing
but goodness to the land her parents created. But her younger
brothers would give her—and the Japanese people—prob-
lems for the rest of eternity.

The main illustrative story about Amaterasu is one famil-
iar to world mythology, for it describes the importance of the
sun and the fear of its loss, which is experienced in cultures
around the planet. The story involves Amaterasu and her bois-
terous youngest brother, Susanoo, who is jealous of his older
sister's beauty and power and just can't help creating trouble.
At one point, he upsets his sister so much—his crimes are
legion and colorful—that she runs away and shuts herself in
a cave, plunging the land into darkness.

Many attempts to draw her out of the cave fail, until

Uzume, the goddess of joy and revelry, conceives a plan: Placing the large mirror (the Yata no Kagami) facing the cave's opening, Uzume does a comical, sensual dance that entertains the other *kami* and the people so much that Amaterasu peeks out to see what all the fuss is about. When she catches sight of herself, shining in the mirror, she is drawn out of the cave by her own beauty and is caught by the god Ama no Tajikara-wo no Kami, who uses the Yasakani-no-Magatama (Curved Jewel) to hook her. He then strings a *shimenawa* (the braided rope that is common at Shinto shrines) across the cave entrance to keep her from reentering it.

Thus, Amaterasu is returned to the world for good, and the sun shines on the Japanese archipelago. The three items used in this story—the mirror, the curved jewel, and a third, the Kusanagi no Tsurugi sword, which her brother Susanoo later gave to her to apologize for his bad behavior—are the Three Sacred Regalia that are emblematic of the Imperial Family and play ongoing roles in Shinto ritual to this day.

Amaterasu herself is today honored most prominently at the Grand Shrine of Ise, in Mie Prefecture, central Honshu, southeast of Kyoto, where the temple in her honor has been rebuilt every twenty years since 690 CE in order to keep her memory pure.

53. Koi, Cranes, and Other Symbolic (but Real) Animals

Like most cultures around the world, the Japanese see animals not merely as fellow creatures but as symbols of a variety of

qualities they would like to express or benefit from. No, we're not talking about Hello Kitty and Godzilla, though their popularity could be a new wrinkle in this old theme; nor are we going to address the mythical beasts of religious iconography such as the dragon and phoenix.

Instead, the animals in question are those that have long been a part of life in Japan's mountains and surrounding oceans, as well as in the nation's painting, sculpture, and religious imagery. Japanese carp (koi), cranes, monkeys, tigers, deer, and raccoon dogs—an actual beast called the *tanuki*, unique to the Japanese archipelago—are depicted not just for their beauty, but for their meaning.

The meanings attached to these symbolic animals originally came from China. But in the case of the koi, a species of carp, the fish itself was actually imported from China, where they have been bred to produce different colors for more than a thousand years. The Japanese have more than twenty different names for breeds of koi, which are considered to symbolize and bring good luck and success in life and business. Schoolchildren often fly koi kites.

Cranes, with their long legs and necks, natural poise, and elegant movements, are abundant in Japan and are regarded as symbols of good fortune. Because of their natural grace and beauty, they have long been a favorite subject of Japanese artists; and their images are especially popular at the New Year's and at weddings, when origami cranes are offered. Cranes are also a symbol of longevity, since they were thought to have a lifespan of a thousand years.

Monkeys are still extant in the Japanese archipelago and have long had the reputation they hold in many cultures: clever, tricky, playful creatures, whose obvious physical resemblances to humans have not gone unnoticed by the Japanese. Monkeys were worshiped in early Shinto and even

The tanuki *is a beloved creature with strange powers and a love for sake.*

Buddhism, and the social and familial aspects of monkeys have been a favorite subject of Japanese artists—the Three Monkeys of the Toshogu shrine in Nikko is a prime example of the depth of meaning that the Japanese find in humanity's close genetic cousins.

Tigers are a popular animal motif in everything from Edo-period screens to modern tattoos in Japan, but their meanings—strength, ferocity, courage—are consistent through time (and for that matter, across cultures).

Cats are popular in Japan, occupying, as they do all over the world, that borderland between the wild and the domestic. Cats are never quite to be trusted, and many Japanese folk tales concern cats that shapeshift and may even possess humans. They are ubiquitous in Japanese arts both ancient and modern.

The *tanuki*, or "raccoon dog," is an indigenous mammal that is not a kind of raccoon, despite its dark-eyed "mask." It is a distant relative to the dog, but with an edge: In Japanese

folklore and arts (including a lot of small statuary often encountered outside of Japanese homes, public places, and even shrines), the *tanuki* is assigned supernatural powers. Those are said to include shapeshifting and the ability to bring good fortune to whoever honors them with well-placed statuary called *bake-danuki*. The statues are distinguished by, among other features, the *tanuki*'s large testicles—and are also known for their taste for sake, which they are often depicted drinking.

Another small mammal that has been assigned supernatural powers is the *kitsune*, the fox. Like foxes the world over, they are admired for their intelligence and cunning. *Kitsune* can be good or bad for humans, however. The good ones are the guardians of the Shinto shrines of the god of rice, Inari; statues of these beasts often guard those shrines. But the bad ones, again, like sneaky foxes around the world, are the *kitsune* who raid chicken coops, steal small farm animals, and otherwise make life difficult for Japanese farmers.

This menagerie of beasts shows up everywhere in traditional art, as well as in the modern mythologies of manga and anime. Because of its roots in Chinese culture, which has an entire zodiac built around animals, Japanese culture has long had a fascination with turtles, snakes, eagles, dogs, rats, rams, and many other animals that most urban Japanese are highly unlikely to ever actually encounter. But the power of their many meanings lives on.

54. Japan's Beloved Heretic-Saint, Ikkyu

Although Japan is a country suffused with rules and traditions meant to instill group harmony, the Japanese have a fascination with outlaws, rule breakers, and other iconoclasts. Historically speaking, perhaps the most famous and beloved of these is the 15th-century Zen monk Ikkyu Sojun, known popularly as Ikkyu or Ikkyu-san.

A poet, painter, musician, wandering monk, and eventually abbot of one of Kyoto's most important temples, Ikkyu is best known in contemporary Japan for his rebellious spirit and wanton ways, as well as for his impact on Japanese literature and Zen Buddhism itself. From his books of poetry to a popular anime television series based loosely on stories about his childhood, Ikkyu-san is beloved by children and adults, rebels and religious Japanese alike.

Ikkyu was born in 1394, the illegitimate son of Emperor Go-Matsu and a low-ranking woman of the Imperial Court. When he was five, Ikkyu's mother sent him to the monastery of Ankokuji. There he was raised by the monks, who gave him the name Shuken. Smart and talented, at thirteen he was sent to Kyoto's Kenninji temple, where he studied poetry. Many of his poems are still in print:

Like vanishing dew, a passing apparition or the sudden flash of lightning—already gone—thus should one regard one's self.

But with a few exceptions, Shuken was not impressed by his fellow monks. Rebellious and opinionated, he was irritated by the political nature of the Zen temples and the lack of Zen practice. His young poems mocked all of this and led to his moving from one temple to another, until he ended up

with a teacher on the shores of Lake Biwa, north of Kyoto. His beloved teacher Ken-o died when Shuken was twenty-one, and, deeply aggrieved, he moved to a new teacher, Kaso, who recognized his understanding of Zen *koan* (see chapter 83) and gave him the name Ikkyu.

At twenty-six, while meditating, Ikkyu heard the sound of a crow, which sparked his achievement of *satori*, or enlightenment. Despite being recognized by the Zen establishment, Ikkyu had earned a reputation as a drinker and troublemaker, so it was perhaps fitting that when he turned thirty-three, his goal achieved, he began his wanderings. He would not have a home for the next thirty years.

During that violent and unsettled time in Japanese history, which culminated in the Onin War, Ikkyu drew many admirers, especially poets, musicians, and other artists who wanted to accompany this kindred spirit. Indeed, he is known in Japan as a crucial contributor to Japanese arts as significant as *sumi-e* painting, calligraphy, music (he was a master flautist), and even the tea ceremony.

A keen admirer of women as well as drink, many of Ikkyu's poems reference brothels and the joys of sex, which he considered to be as fine a path to enlightenment as any, if done with perfect presence and awareness. He would, in fact, wear his monk's black robes to brothels, since he considered sex a sacrament. In one poem, he wrote:

> *The narrow path of asceticism is not for me:*
> *My mind runs in the opposite direction.*
> *It is easy to be glib about Zen*
> *I'll just keep my mouth shut*
> *And rely on love play all the day long*

> (From *Wild Ways: Zen Poems of Ikkyu*,
> translated by John Stevens)

During his wanderings Ikkyu earned yet another name, Crazy Cloud, and one of the musicians he spent time with, a blind singer called Mori, became the love of his life. His many odes to her are among Japan's greatest love poems.

Legends about Ikkyu's travels abound. One says that once, when out begging door-to-door in his mendicant's rough clothes, a wealthy man gave him a small coin. When he returned later to the same house, wearing his Zen master robes, the rich man invited him in for dinner. But before sitting down at the table, Ikkyu stripped off his robes and left, saying that it was not he who had been invited to eat, but his fine clothes.

Such a delightfully authentic and amusing character was destined to live on. In addition to the many books of his poems still in print, the animated program *Ikkyu-san* ran on Japanese TV from 1975 to 1982 and is still how many Japanese visualize him. In the show, a young Ikkyu cavorts in cartoon colors, more adorable scamp than rebel, outwitting grownups with glee. There have also been manga, movies, and more recently, a video from the popular J-Pop trio Wednesday Campanella, as well as a brand of instant miso soup and even a walker for the elderly named after him.

Despite his lifelong disdain for the Zen hierarchy, Ikkyu spent his eighties as the forty-seventh abbot of the Daitokuji temple in Kyoto, from which he oversaw the restoration of the war-damaged temple Myoshoji, located between Kyoto and Nara. The temple has since been renamed Shuon'an Ikkyuji, and it is the location of Ikkyu's mausoleum. The temple happily claims Ikkyu as its own and draws many visitors every year. Ikkyu died in 1481, at the age of eighty-seven, but his stories, his poems, his music, his temples, and especially his rebellious spirit live on.

55. The Heian Period, Japan's Classical Era

The Heian period—named for the original name of present-day Kyoto, Heian-kyo, to where Japan moved its capital from nearby Nara in 794 CE—was the era during which Japan first distinguished itself from the imported Chinese culture that had dominated the early Japanese. Four hundred years later, Japan would enter into its feudal era, under the military rule of a shogun. But the essentials of what we know as classical Japanese culture, which were established during the Heian period, would prove to be enduring.

This transformation affected nearly every aspect of life but was particularly pronounced in evolving forms of language, writing, and literature; in the structure, manners, and fashions of the Imperial Court; and especially in Japan's relationship to Buddhism, which would diverge from the form that had been imported from China.

During this time, China's Tang Dynasty was in crisis, and Japan's small government was being shaken by the troubles of its big brother to the west. China had given Japan much of its culture, but Japan was now ready to strike out on its own, and to do that, it officially disengaged from China and began what would be one of its periods of distance from the rest of the world.

This was to become a recurring theme in Japanese history, as the country vacillated between absorbing foreign influences and then withdrawing into itself. Japan had long had a distinctive culture. Artifacts of its early Yayoi and Jomon cultures show hints of what was to come, particularly in the arts. But it was in language and writing that Japan would first establish its cultural independence.

While the new capital at Heian-kyo was laid out on the Chinese grid model, and the Japanese language continued to use Chinese characters in its writing—as it continues to do to this day—the aristocracy that controlled early Japan developed a new script, called *kana*, that facilitated the writing of a distinctive Japanese literature.

The Japanese Imperial Court was at the center of it all. Only the aristocracy, which some historians number as few as five thousand people in an archipelago with as many as five million, had the time and education to pursue writing and other arts. Nobles also had the time for the endless machinations required to acquire and maintain their positions.

Several practitioners of the newly important literary arts were aristocratic women, members of the Imperial Court, who in the early 11th century would write two of the most important books in Japanese, and world, literature: *The Pillow Book of Sei Shōnagon* and *The Tale of Genji* by Murasaki Shikibu.

Buddhism, which had been imported from China and was taught using Chinese texts, developed a more decidedly Japanese character during the Heian period, producing the first two of what would become numerous Japanese sects: Tendai and Shingon Buddhism, both of which aimed at uniting the growing religion with the developing state. The designs of the religious buildings in Kyoto were less Chinese influenced, as contrasted with those in Nara.

But many significant changes during the Heian period were of a political nature, and that is reflected in the period's name itself: Heian means "peace," and the four hundred years from 794 to 1185 were, in fact, largely peaceful. But Japanese history would again become very violent.

Part of the reason the Heian period was peaceful is that one family, the Fujiwara clan, was able to gain almost total control over the government. The means by which they did

this were complex but boil down to the strategic use of mar-
riage—Fujiwara women were married to successive emperors,
thereby making the emperor beholden to the Fujiwara clan.

Despite the relative peace of the period—there were fre-
quent, if small, conflicts between the Fujiwara clan and two
other major families of the time, the Taira and Minamoto—
the Heian period ended with much of the island nation in
poverty.

The result was political upheaval and Japan's descent, by
the end of the 12th century, into civil war. When the victor of
the five-year Genpei War gave himself a new title, Shogun, a
new era was born. Variations on the shogunate he founded
would last for the next seven hundred years, from 1192 to
1867; the first two periods of the shogunate, the Kamakura
and Muromachi periods, are collectively known to historians
as Japan's medieval period.

This ensuing period would take Japan even deeper into
itself, away from the rest of the world. Japan's isolation would
not end until Commodore Matthew Perry's American gun-
ships sailed into Tokyo Bay in 1853.

56. The Samurai Class: More Than Warriors

Warriors, nobles, scholars, and ultimately outcasts, the samu-
rai, or as the Japanese are more apt to call them, *bushi* ("mar-
tial men") were crucial figures in Japanese history for nearly
a thousand years. For a third of that time, they ruled much
of the country, but they all but disappeared with Japan's

modernization. To understand why, we must know where they came from.

The first mentions of the word "samurai" appear in the 8th century, at a time when Japanese culture was in its early stages of development. These samurai were not warriors; rather, they were bureaucrats in the Imperial Court—and in the lower half of the bureaucracy at that.

Samurai as warriors developed as Japan shifted away from the imperial structure that had dominated the country from its founding in the 7th century until the end of the 12th century. When the Taira, one of the three clans in perpetual conflict, emerged victorious in 1160 and established the first shogunate, the emperor became little more than a figurehead. Just a few decades later, power shifted to the rival Minamoto clan, whose leader, Minamoto no Yoritomo, moved the capital from its traditional home in Kyoto to coastal Kamakura.

Victorious through arms, the Kamakura shogunate was ruled by warriors. Known as the Bakufu ("tent government," for the military's tendency to live in tents), the militaristic government allowed the samurai to gain increasing power, and the old imperial aristocracy became a secondary force. This period of time was also associated with the spread of Zen Buddhism, which the samurai studied for its focus on austerity and indifference to death.

Half a century later, in 1272, the Mongol armies of Kublai Khan, having already conquered China and established the Yuan dynasty, attacked Japan in Kyushu—and then again in 1281. Both times, the much larger invading navies were defeated by greatly outnumbered samurai. Both times, they were aided by fierce and fortuitous storms, which only added to their legend—and gave Japan the phrase "the wind of the gods": *kami-no-kaze*.

The next several hundred years were marked by military

rule, the last of which was the Tokugawa shogunate, also known as the Edo period for its establishment at the city of Edo (modern Tokyo). From the early 17th century on, internal conflicts during the Tokugawa shogunate were greatly reduced, and the samurai ceased to engage in wars and became a ruling administrative class again.

Nevertheless, the samurai's weapons remained an important part of their social stature. In 1586 when samurai status was ruled to be hereditary rather than earned, samurai gained even greater power. They were allowed to carry their curved swords (*katana*) and even allowed to kill, at their whim, anyone who they felt had disrespected them. One effect of this new hereditary status was to freeze social mobility and lock Japan into a structure that became increasingly rigid through the 16th to 19th centuries.

Another result was that the samurai occasionally became a social problem, as underemployed men with weapons tend to be. Whenever one of their masters, usually a daimyo (feudal lord), was required by the government to reduce his number of samurai, these unemployed warriors—known as *ronin*, literally "wave men," for their wandering, unproductive ways—were set loose on a defenseless populace. The *ronin*, though subsequently romanticized in fiction and film, were loose cannons and caused considerable problems for the shogunate.

Still, over the centuries, the samurai or *bushi*—among the best educated group in Japan—had developed complex and rigorous discipline into a samurai code, known as *bushido*, or the Way of the Warrior. Based in part on Zen and in part on Confucianism, *bushido*, with its emphasis on honor even in the face of death, as well as loyalty to a master, has remained an essential part of the image of the samurai.

The samurai were warriors until the end, but when the

end came, they disappeared relatively quickly. In 1873, an edict from the new Emperor Meiji shifted the country to a Western-style conscripted military and ended the samurai's hereditary status. Former samurai would continue to play a role in the transformed Japanese military and government, as well as in fields such as journalism, education, and business, as their education and loyalty were more transferable skills than their fighting abilities.

But the role of the samurai as swashbuckling soldiers was officially obsolete, and today they live on only as the stuff of adventure movies, business books, and history lessons.

57. The Shogunate

For the country's entire recorded history, the official supreme ruler of Japan has been the hereditary head of the Imperial Family, usually the emperor (or, rarely, empress). But for most of that time, the men wielding actual political and military power in Japan were not royals. The most famous leaders of Japan were the shogun—a shortened version of the title Sei-i Taishogun, which translates as "Commander-in-Chief of the Expeditionary Force Against the Barbarians."

The title first appeared sometime during the classical Heian period, 794–1185, when the Imperial Court in Kyoto was still attempting to assert control over the archipelago, some of whose inhabitants were considered barbarians. The first dominant shogun was Minamoto Yoritomo, who established the Bakufu "tent government" in 1192. The Bakufu also elevated the warrior, or samurai, class above all but the top nobility.

As the title Commander-in-Chief indicates, the shogun

was a military dictator with supreme power. The basic governmental structure of the Bakufu endured for an epic stretch of Japanese history, ultimately lasting nearly seven centuries, from 1192 to 1867. The emperor wasn't restored to head of government until what is known as the Meiji Restoration. During this time, the Imperial Family served as a unifying but impotent symbol; the real power was wielded by the shogun.

The first ruling shogunate arose with the 150-year Kamakura period, 1192–1333, and was followed by the Muromachi period, 1338–1573. Japan was not yet a truly unified country, and this feudal period was characterized by competing warlords (or daimyo) fighting for control.

Growing trade between the various regions of the country led many daimyo to rebel against centralized control from Kyoto. In 1467 the Onin War launched the period known to Japanese as the Sengoku, or Warring States period. For the next 150 years there was nearly constant warfare between regional warlords; numerous clans fought for control of the country over the decades, handing it back and forth amid much chaos and destruction.

Finally one clan, the Tokugawa, arose victorious, uniting the country under one government. The Tokugawa shoguns would rule a relatively peaceful Japan for more than 250 years, from 1603 to 1867. It was during this time that Japan became the country that we recognize today.

The Tokugawa shogunate was named for the victorious warrior Tokugawa Ieyasu, who was appointed to his rank by the Emperor Go-Yozei in 1603. But after only two years in power, Ieyasu abdicated the throne, handing it to his son, Tokugawa Hidetada. Ieyasu maintained actual control until his death eleven years later, but this maneuver established the hereditary nature of the shogunate, which would be maintained through fifteen Tokugawa shoguns, until 1867.

The Tokugawa shogunate was, by and large, a peaceful period, but it was not exactly easy. The intrigues of the Tokugawa clan down through the centuries were very much the match of the European dynasties of the same era in their courtly plots, betrayals, and violence, not to mention the repression of their subjects. For most Japanese living in one of the four social classes—the samurai, peasants, artisans, and merchants—life under the rigid hierarchy of the shogunate was hardly carefree.

The shogunate was based in a new city—Edo, the site of today's Tokyo—established far to the northeast of Kyoto, the longtime capital. The period of Tokugawa rule is thus known as the Edo period and was marked by stability. But this stability came at a cost: Minority Christians were persecuted, social mobility was impossible, and the policy of isolationism known as *sakoku* meant that Japanese culture was a closed system. The laws enforcing the isolation policy were strict: Leaving the country was punishable by death, should one return; even receiving a letter from abroad could get an entire family killed.

When a rebel group of daimyo united to support the restoration of the Imperial Family to power, the shogunate collapsed. In 1868, the young Emperor Meiji became the country's ruler, and immediately instituted a dizzying array of reforms to a society that was suddenly no longer feudal. With a jolt, the Tokugawa shogunate was gone, and Japan had entered the modern world.

58. Commodore Perry and the Opening of Japan

Along with the Meiji Restoration and World War II, few historical events have contributed to the shape of modern Japan more than the "opening" of the country by American naval commander Matthew Perry in 1853–54. Of those three epochal events, Perry's mission was the first, and it led in large part to the subsequent two.

Commodore Perry's mission, though military in nature, was driven by Western commercial expansion in East Asia, as American and European interests sought to open markets heretofore closed to their goods.

Since Japan had long been isolated from the outside world, the country was still essentially medieval at a time when Europe and the United States had developed into international industrial powers with military and commercial empires of various sizes. Colonialism had swept the non-European world, and British, Dutch, French, Russian, German, and American power was felt around the globe.

Everywhere, that is, except in Japan. Since 1797, more than two dozen ships, including a few warships, had approached Japan, only to be turned away by the archipelago's defenders, the samurai of the shogunate. Nevertheless, the Western powers were operating freely in the waters around Japan, whaling, fishing, and trading with other countries, gaining power in China, Indochina, Indonesia, and, of course, in Britain's largest colony, India.

The Japanese were well aware of this closing circle of commercial and military activity, and the country's elite debated for decades about allowing outsiders to even set foot on the islands, let alone do business. There was one exception, the

tiny island of Dejima, in Nagasaki Bay. This mere two acres of land had been established by the Portuguese and had for more than two hundred years been the sole place where foreigners, now mainly the Dutch, had been allowed access to Japan. But it was the exception that proved the rule and was meant to constrain trade rather than encourage it. Dejima's name translates, tellingly, as "exit island."

So when Commodore Perry and his four gunships steamed into Edo (now Tokyo) Bay on July 8, 1853, it was a moment of reckoning the Japanese had long known was coming. Perry's landing, a week later, came with cannons blazing in a "salute" that was a clear show of force. The threat of military action was made explicit in the written "proposal" given to the Japanese.

Unfortunately for the Japanese, nearly three centuries of isolation, and a military that was unprepared for conflict, made them no match for the Americans. When Perry arrived at what is present-day Yokosuka, the shogun himself was in poor health and would die just days after the Americans departed. His sickly young son inherited power, and the decision was put into the hands of the shogunal council, which was riven with factions.

Meanwhile, the competition between the great European powers—especially Russia, Britain, and France—was fierce, and all were concerned that the Americans would get exclusive access to Japan.

When Perry returned for an answer to his proposal on February 13, 1854, he brought with him an even larger force of ten ships, manned by sixteen hundred sailors, many of whom had just recently served in the Mexican-American War, in which the U.S. had conquered enormous territories. The Japanese response was a foregone conclusion. On March 31, the Convention of Kanagawa was signed, and the Americans were

soon surveying the harbors of Hakodate and Shimoda, where they had been given access to the country. Shimoda, located a considerable distance from Edo, was also to be the site of the first American Consulate in Japan. Hakodate was even further away, on the very southern edge of the far northern island of Hokkaido. The Japanese were determined to keep the foreign interlopers as far away as possible.

But however much they might try to quarantine this assault on their treasured isolation, the Japanese could not avoid what was to be a momentous shift in the country's sense of itself and its role in the world. Thus began a cascade of changes that ended the rule of the shoguns, brought about the restoration of the Imperial Family, spurred rapid industrialization and modernization, and turned, in only a couple of decades, an isolated, xenophobic, and largely agrarian country into a cultural, industrial, and military power that would soon bring enormous changes to the entire world.

59. How the Meiji Restoration Shaped Modern Japan

While Westerners talk of Commodore Perry's visit as the "opening" of Japan, it was opened much the same way an oyster is opened, and for much the same reasons: The Western colonial and mercantile powers wanted what Japan had, and forced it open. The conflict that arose in response to the push and pull with the United States, Great Britain, and Russia forced Japan to come out of its isolation and enter the modern world.

That required a virtual revolution in Japan. The word "restoration" sounds much more peaceful and orderly than what was actually an epochal shift of power within the Japanese political structure, when a group of young men essentially overthrew the Tokugawa shogunate that had run the country for nearly three hundred years and installed—"restored"—the emperor as the head of the government.

Restoring the Imperial Family was a way of gaining legitimacy for what was actually a group of young revolutionaries (the oldest was forty-one) overthrowing the government. They chose an exceptionally young figurehead for their coup: The Emperor Meiji himself was only seventeen when he was put on the throne. Nevertheless, though born in conflict, the Meiji Restoration did indeed open up Japan in myriad ways, and the country developed at a pace that had it turn, in two short decades, into one of the world's great modern powers. Japan's encounters with the U.S. and other colonial powers spurred the country to develop its own military to match those of the colonizers. Within a short time, Japan became one of the world's most formidable military powers and even a colonial power itself, as it seized parts of the Korean Peninsula, Manchuria, and even the island of Formosa (now Taiwan).

The changes unleashed were deep, comprehensive, and complex, but for simplicity's sake, here are a few ways in which the Meiji Restoration shaped modern Japan.

The Meiji government—Meiji was the name the young emperor took, meaning "enlightened ruler"—introduced compulsory, free education for both boys and girls and sent students, many of them former samurai, abroad in search of education in the sciences and arts; these students returned to Japan with many new ideas from the United States and Western Europe. Employing those ideas, the Japanese government built infrastructure—railroads, shipyards, mines, telephones

In the Meiji period, samurai adopted their dress to Western fashion while retaining some of their traditions.

and telegraphs, electrical grids—at a remarkably rapid pace. The country began industrializing within a couple of years of the Restoration—and has, of course, never stopped.

The Meiji government quickly broke down the rigid social structure of the Tokugawa shogunate, which had split society into four separate and unchanging social classes. Henceforth, education and merit would determine an individual's success. The samurai class was disarmed and essentially eliminated, though former samurai, who were well educated, were encouraged to go into business and government. After developing the infrastructure industries, the government spread industrialization by selling many of them off to private entities, including many run by former samurai.

With the restoration of the imperial line for the first time since the 12th century, the divinity of the emperor was reasserted, and to that end, the indigenous Shinto religion was

elevated above Buddhism as a way of reinforcing the emperor's potency as a political and religious symbol for the still-fractious Japanese population to rally around. In this way, the Meiji Restoration was a return to a previous era, which would ultimately prove disastrous to Japan, until the monarchy was permanently removed from politics after World War II.

The Meiji government managed to eventually corral all the original daimyo domains—nearly 300 of them—and combine them into civil prefectures under the central government, 47 of which survive to this day. That restructuring included significant land reform and the redesign of the country's entire legal system, modeled on the French and German systems, in order to gain a more equal footing with the colonial powers.

The Meiji period introduced a modern constitutional government in 1889, with an elected parliament called the Diet, one that recognized, modeled as it was on the Prussian and British constitutions, the rights of freedom of speech, privacy in communications, private property, due process, and freedom of religion—though it should be said that the emperor was still the legal as well as symbolic center of the government. Beyond that, only 1% of the male population could vote, as universal male suffrage would not come until 1925. Women would not get the vote until 1947, thanks to a democratic constitution drafted by the American Occupation.

60. The Mysterious Ninja

Few characters in traditional Japanese culture have survived the transition to the modern world as well as the ninja. Originally a guerrilla fighter from the time of the chaotic 15th

century, the ninja is a prototypical superhero, clad all in black and silently executing deft moves with deadly skill.

But the ninja, primarily known in their time as *shinobi*—"ninja" is a more recent coinage—began during the Sengoku or Warring States period of 1467–1603. The *shinobi* were often employed as spies and were tasked with doing the dirty work—sabotage, assassination, arson, poisoning, ambush, and guerrilla warfare—that was considered beneath the noble samurai code of honor. They were, essentially, terrorists, largely drawn from the lower classes, specifically from several clans. At the time, they were hardly romantic figures.

Still, the *shinobi* were known and admired for their stealth and for their cat-like abilities to scale walls and walk unheard. Unlike the proud, much-honored samurai, the *shinobi* ideal was that one's opponent shouldn't even know of the *shinobi's* existence—until it was too late.

What we now know as the ninja era did not last long—they were nearly all gone by the time of Japanese unification under the Tokugawa shogunate in 1603—but they remain iconic in the popular imagination. The exploits of the now-legendary ninja were recorded much later, during the Meiji period of the 19th century, based largely on legends and folktales that had sprung up around them more than two hundred years after they were most active.

Whatever the truth of their nature, the romance surrounding ninja has continued to charm and intrigue. So powerful is their myth that ninja were said to be superhuman, able to make themselves invisible or even walk on water. In modern Japan, the fictional character Sarutobi Sasuke's exploits have spanned the 20th century, from children's books to contemporary manga.

More recently, a young American named Chris O'Neill became the first American ever designated a real Japanese

ninja. He was hired by the tourism department of Aichi Prefecture, home to the big city of Nagoya, in a bid to raise tourism interest in the area. O'Neill, who has done stunt work as a ninja in Japanese movies, commercials, and television shows, was the first of six ninja to eventually be hired to assist with PR.

While being a modern ninja may not be a proper career path for most people, the ninja life survives, at least as entertainment, and can be experienced in a number of places thoughout Japan, especially around Mie and Shiga prefectures, east of Osaka, where the historical clans of *shinobi* were born and trained in the towns of Iga and Koka.

In Iga, the Igaryu Ninja Museum features daily demonstrations of ninja fighting techniques and other skills, complete with a female ninja (*kunoichi*). The museum also displays actual ninja gear, including throwing stars (*shuriken*), secret code books, and a museum gift shop selling ninja-themed reproductions. Other sites in the area—for instance, the Koka Ninja Village—offer training in ninja techniques, or *ninjutsu*, such as star throwing, rock climbing, and water walking. Near the village is the Koka Ninja Mansion, a three-hundred-year-old house complete with secret passageways, boobytraps, and other stealthy escape routes that ninja might have used.

Elsewhere in Japan, in Nikko, in Tochigi Prefecture, north of Tokyo, there lies Nikko Edomura (Edo Wonderland) a themed amusement park where visitors can see a re-creation of an Edo-period town. With replica architecture and townsfolk in period costume—and with visitors invited to dress up in period costume themselves—Nikko Edomura also features a gigantic ninja maze that is a challenge to escape, as well as the Grand Ninja Theater, where black-clad entertainers demonstrate sword fighting, magic, and *ninjutsu* martial arts.

Ninja-inspired tourist attractions abound in modern Japan, even in Kyoto (for example, the ninja-themed

Ninja were deadly accurate with their "throwing stars."

amusement park, Toei Uzumasa Eigamura), and the so-called "ninja temple"—the Ninjadera—in Kanazawa. The Ninjadera is so named because of its many deceptive defenses, similar to those the ninja employed against their enemies.

But like the samurai, the ninja themselves are gone with Japan's feudal era, which is no doubt a comfort for tourists who don't have to watch their backs for shadowy assassins.

61. The Role of Buddhist Monks in Modern Japan

Since it came to Japan in the 7th century, first from Korea, then from China, Buddhism has been a crucial part of the

nation's development. Even after it was relegated to a second-ary status, in favor of Shinto, during the Meiji Restoration, Buddhism has shaped the country's culture.

The people who daily connect Buddhism to society are its monks, or *soryo*, who live and work in the communities they serve, particularly when there is a death. They deliver the last rites and work with family members on funeral arrangements and counseling. Their work even extends beyond the funeral, as they conduct memorial services for dead ancestors, always a looming presence in Japanese life.

But *soryo*, and the religion they serve, are under great stress in Japan. The number of temples in the country—a recent count put it at around 77,000—is declining, particu-larly in the countryside, where towns are rapidly losing young people, and thus congregations, to the cities. Some 12,000 temples have closed in Japan in recent years, or roughly 1,000 a year. In fact, the Japanese Policy Council estimated that thousands of Japan's smaller towns and villages are in dan-ger of disappearing altogether: At the current rate, nearly *half* of the country's municipalities could empty by 2040—along with their temples.

Even in cities, participation in Buddhist temples is con-tinuing a long decline, and Buddhism's association with funer-als—the livelihood of many *soryo*—has made it less appealing to younger Japanese. The rise of independent funeral parlors is challenging the tradition from the financial side, so *soryo* find it increasingly difficult to make a living, so much so that many are taking up second careers, going into businesses one doesn't often associate with religion.

For instance, a chain of bars in Tokyo called Vows is said to provide peaceful, meditative spaces in which to drink beer and cocktails, mixed and served by bartenders whose other job is as a *soryo*. Along with the alcohol, the bartender monks

are said to serve up ancient wisdom. It makes a certain kind of sense—bartenders are often turned to for advice—but it is not exactly intuitive.

Monks in other temples have reportedly been creating cafes inside their temples, as well as hosting fashion shows (with monks and nuns as runway models), and operating beauty salons. Some present concerts and theater, even holding (and performing in) rap shows. Many temples, of course, charge visitors to visit their grounds and admire their enduring features and treasures.

In a bid to halt this decline, particularly in the countryside, some Buddhist organizations have taken to holding matchmaking events in which eligible monks aim to meet women who would like to help them continue the hereditary lines of succession, which has traditionally been the way that temples have passed on ownership. Traditionally, running a temple was a fairly secure business.

Clearly, the Western notion that monks live simple, pure, even celibate lives, detached from money and sexuality, does not generally apply in Japan. Monks marry, can drink, and may smoke cigarettes. The notion of the "rich monk" who makes good money as a monk is not a fiction, as even some monks have written. The asceticism that Westerners often attribute to Buddhist monks is often a misunderstanding of monastic practice.

Another way that Buddhists are combating this monastic decline is by approaching retired Japanese to study Buddhism and take on the monk's life. After retirement, some Japanese have found that golf and grandchildren aren't sufficient for lives that are still far from over.

Another new form of *soryo* are those in the *yamabushi* tradition, in which people who have had a call to seek enlightenment through discipline and immersion in nature find a

community where they can pursue their new mission. The word *yamabushi* means "one who prostrates upon mountains," and this *shugendo,* or "way of testing and training," is being pursued by some foreigners as well as Japanese. Still, in a country of more than 100 million, a small handful of *yama-bushi soryo* are not going to reverse what seems to be a permanent trend.

Meanwhile, the Buddhist monks of Japan still perform their more traditional duties of managing funerals and the emotions they provoke. But aside from those at the biggest and most popular temples, these monks face an uncertain future. Whether their work can continue is one of the biggest questions weighing on the minds of those who want to preserve Japan's traditional culture in the face of the overwhelming influence of modern life.

62. Who the Geisha Really Were—And Are

Few visions have captured the imaginations of non-Japanese— or indeed, of the Japanese themselves—as thoroughly as those of the geisha.

As any visitor to Kyoto will notice, geisha are not just historical figures. With some luck, a visitor wandering the city's Gion neighborhood may well catch a glimpse of these mysterious women as they move quickly through the narrow streets. But who are they? What do they do? And in the 21st century, what is their role in society?

Misconceptions about geisha are many, and their history

is full of contradictions and confusion. Right from the start, their identities were uncertain: What kind of women were they? Were they entertainers? Servants? Courtesans? Prostitutes? The answers are complex—to show just how complex, let's note that the first geisha were, in fact, not women at all. The first geisha were men.

The word "geisha" combines two *kanji*: *gei*, meaning "art," and *sha*, meaning "person" or "doer." A geisha, then, is a person who does art. An artist.

During the Edo period that began in 1603 and continued for more than 250 years, the court system that revolved around the samurai class saw the development of walled pleasure quarters, or *yukaku*, in Kyoto, Osaka, and Edo (Tokyo). Dancing, gaming, drinking, and legal prostitution were among the offerings, the last supplied by sophisticated courtesans who entertained the merchant class, the lowest rung of society during this period. The role of entertaining the men while they waited for their courtesans fell to the geisha—who were exclusively men at that time.

Meanwhile, teenage dancing girls called *odoriko*, of a lower class, would find themselves unemployed as they grew into adulthood, and many fell into prostitution. Around the mid-1700s some began referring to themselves as geisha, after the male performers. The first was a woman in Fukagawa called Kikuya, a prostitute who was also a skilled singer and *shamisen* player. Her success as a geisha inspired others to adopt the name. After two decades, the two notions of geisha, male and female, grew together, and female geisha became known for their entertaining skills rather than their sexual favors. The geisha's role became quite distinct from the courtesan's. Instead, as with the men whose name they adopted, geisha were hired for their expertise as entertainers, for their skill in conversation, and for the felicity of their company.

The geisha's shamisen has three strings and sounds a bit like a banjo.

These new female geisha added something of the courtesan's beauty and style. Developed in part from the styles worn in the Kabuki theater that had developed in Kyoto by the mid-19th century, the distinctive geisha style was emulated by many fashionable women.

Geisha certainly cut a distinctive figure: Geisha style was (and is) time consuming and expensive to achieve and maintain, and was often paid for by high-ranking men. At the peak of the Edo period, the geisha formalized a dramatic style that remains as powerful as it was two hundred years ago.

Everyone knows what geisha look like, but when you really break it down and examine it piece by piece, it is remarkable: Every hair is pomaded into its proper place; the clothes, elegant painted silk kimonos, are of the finest design; and the makeup—that astonishing makeup—is applied with methods that have been developed over the centuries, each detail refined to the brushstroke.

But that is just the beautiful packaging. Geisha also have extensive training, serving as apprentices for several years. Known as *maiko*, these young women learn the arts of conversation, music, calligraphy, and ikebana, and since they live

in and maintain a rarefied culture that is complex even by the standards of Japan, they are trained in all the intricate formalities that constitute the *hanamachi*, the geisha district.

The original geisha developed a business model that created one of the few places where a woman could be a success in what was an entirely male-dominated society. Thus the geisha ran the businesses, earned the money, organized the unions, and operated in a world populated almost entirely by women and devoid of men—except those who came as customers. In a world in which women, particularly unmarried women, had no rights or economic power, *hanamachi*, which also translates as "flower towns," were a powerful exception.

Maintaining such standards is so expensive that, after its peak 150 years ago, the geisha world gradually declined, almost disappearing entirely during World War II. Ironically, it was the abuse of the term "geisha" during the American Occupation—when GIs and the prostitutes who served them corrupted it into "geisha girls"—that prompted women who understood the historic place of geisha to restart the industry.

Today, even in Kyoto, even in streets full of young female tourists dressed in a simplified geisha style, there are not many real geisha left—probably no more than a few hundred—but their rarity makes them that much more magical. To be able to hear the sound of a geisha quickly moving down a quiet Gion street in her wooden sandals is one of the most satisfying delights to be had in that beautiful city.

63. The World of the Yakuza

Anyone with a passing knowledge of contemporary Japanese culture is likely to be aware of Japan's notorious gangsters, the yakuza. Immortalized in fiction, film, and books, the yakuza are often seen as a sort of modern samurai, in some treatments as almost romantic figures, akin to cinematic depictions of the Mafia in Western films.

But while Western Mafiosi are nearly universally considered the bad guys, in Japan, yakuza are seen in much more subtle shades of gray by average Japanese. Even modern "gangsters" are viewed through the complex prism of society.

The yakuza are certainly criminals: Among the areas they dominate are gambling (where they apparently began during the 17th century), prostitution, drug- and sex-trafficking, smuggling, extortion, blackmail, bribery, and anything else in which money can be made. Yakuza control many restaurants, bars, and trucking and taxi fleets, as well as factories, and in recent decades they have moved into white-collar crime, including the equity markets and real estate. They are active internationally, particularly in China, South Korea, and other Asian countries.

The population of yakuza currently rests well below half of their peak numbers—from nearly two hundred thousand in the 1960s to half, or even a quarter, of that now—though numbers are necessarily imprecise. But the yakuza's position in society remains unique. While they are feared, they are also respected, and in some ways, they have earned that respect. Most recently, they have earned it by appearing at the scenes of natural disasters, where in some cases they have reportedly been more efficient at delivering help to victims than national and local governments.

One recent example was the Great Tohoku Earthquake and Tsunami of 2011, with the resulting disaster at the Daiichi Nuclear Power Plant in Fukushima. The yakuza famously sent workers to go into the failing reactor area; as became apparent later, however, many of those who went had been forced into it by gangsters to whom they owed money or who threatened them with violence.

Which is to say that the yakuza are hardly the "good guys," let alone humanitarians—Japanese thought is more subtle than that. But in a country where efficiency, particularly in social contexts, is highly valued, the yakuza occasionally score well. Their rigidly hierarchical structure appeals to many Japanese.

The name *yakuza*—literally, "good for nothing"—reportedly comes from the traditional card game Oichi-Kabu. In it, the goal is to draw three cards that add up to nine; if one draws cards adding up to ten, that results in a score of one. The worst possible combination is the numbers eight, nine, and three, which add up to twenty, which in the scoring of the game equals zero. Thus, the words for those three numbers— *ya* (eight), *ku* (nine), and *za* (three)—mean exactly nothing: a fitting slang for this particular low-caste group.

There is a historical reason for describing them as such. More than half of the members of the yakuza come from the southern island of Kyushu and are members of Japan's lowest caste, the *burakumin*, literally "village people," whose trades traditionally involved activities having to do with death and animals and were thus considered to be unclean. Butchers, tanners, and even undertakers—the *burakumin* are literally Japan's "untouchables."

That Japan has an "untouchable" underclass is one of the unspoken shames of what is ostensibly a modern country, but it is a tradition that has yet to die: There is even an unofficial

but well-circulated list of the names of every single *buraku-min* person in Japan; it is familiar to employers, landlords, and others in positions of authority. If one is on that list, the chances of a good job, or university entrance, or even desirable housing, are slim-to-none.

Those Japanese designated as *burakumin*—as well as those of Korean descent, who are regularly discriminated against, even if they've been in Japan for decades—were left to make their own way in a society that didn't even recognize them as human, let alone Japanese. Thus were the yakuza born.

Yakuza are also said to be descended in part from *ronin*, the masterless samurai who roamed the country after the Meiji Restoration of 1868 ended samurai dominance. This seems suspect, however, since samurai were the ruling class during the shogunate and were thus unlikely to be *burakumin*. But there is a strong association between yakuza and an another element of the samurai class: the right-wing nationalists who led the country out of the feudal world and straight into the militaristic disaster of World War II.

Perhaps the most obvious identifying characteristic of yakuza to visitors is their passion for tattoos, which can cover their entire back and torso and upper arms. Tattoos are widely rejected in polite Japanese society, to the point that people who have them—yakuza, and also visitors from abroad—are often barred from visiting *sento* and *onsen*, public baths and hot springs.

A less-appealing mark of the yakuza is the *yubitsume*: a severed left little finger, offered as penance to a superior or merely as a symbol of toughness. It is more evidence that, in the unlikely case you encounter a yakuza—and the alleys and bars of Shinjuku offer some opportunities—you would do best to steer well clear of him.

64. The Great Japanese Empire, 1868–1947

The Meiji period, beginning in 1868, is known as the beginning of the modernization of Japan, but what occurred during that time went well beyond men adopting Western-style suits and the introduction of street cars and factories. Many of those factories also quickly went to work building weapons of war, and in the years between 1868 and the attack by the Japanese on Pearl Harbor in 1941, Japan developed from a closed, feudal country into a world power the Japanese called Dai Nippon Teikoku: The Great Japanese Empire.

Japan's meteoric rise stunned the dominant Western powers (the British, French, German, Russian, Dutch, and Americans) that had established global dominance and had been carving up the rest of the world, often fiercely competing for territory, resources, and influence. Japan, having just come out of its isolation, had quickly realized that the only way it would survive in such shark-infested waters was to become a shark itself.

Thus, from the Japanese historical perspective, the four years we know as World War II were merely the climax of several decades of conflict between Japan and China, Japan and Korea, Japan and Russia, and even Japan and its eventual World War II ally, Germany.

The newly modern country began creating a strong, outward-facing military soon after the Meiji Restoration. In 1894, in what the Japanese conceived as a defensive measure to shore up a vulnerable neighboring peninsula, Japan's military invaded Korea. This became known to history as the First Sino-Japanese War, since it was actually an attack on Chinese (Sino) dominance in the Korean Peninsula. When Japan's

modern military defeated China's in less than nine months, the humiliation upended the Asian power structure and, among other things, set China on a path to revolution and civil war in the 20th century.

Japan's presence on the continent prompted Russia, acting on its own ambitions, to invade northeastern China in 1900. Their close proximity precipitated conflict between the two imperial powers. Japan's preemptive 1904 attack on the Russians led quickly to a second victory, making the Russo--Japanese War the first modern instance of the defeat of a Western power by an Asian nation. By 1910, Japan had fully occupied Korea, and the seeds of the Great Japanese Empire had been established. It would endure and expand for the next thirty-seven years.

Japan entered World War I even before the United States, allied with Britain and France against Germany, and its navy fought as far away from Japan as the Mediterranean. Japan eventually made common cause with its old rival Russia as well. In its regional sphere, Japan took control of key Pacific islands until then claimed by Germany: the Caroline, Marshall, and Mariana islands, which Japan held until the U.S. took them toward the end of World War II.

The decade after World War I was a time of relative peace and economic boom in Japan, as it was in the West. The vote was expanded, two political parties vied for power, and the Japanese increasingly enjoyed their new position in the world. But the worldwide economic crash at the end of the 1920s came to Japan as well, and Japan entered the 1930s with its military once again politically empowered. By mid-decade, these conservative military forces had come to envision the re-creation of the old shogunate, ruled by the military, and driven by a nationalism not unlike the ideologies emerging in parts of Europe.

But the Japanese faced a persistent problem: a shortage of domestic raw materials. Now that it was an industrial power, its need for oil, iron, and rubber meant it had to buy them from nearby China, eastern Russia, and faraway Southeast Asia. Following the example of the expansionist Western powers, Japan decided to simply take what it needed.

To this end, in 1931, during the Great Depression, Japan launched an invasion of China's three northeastern provinces, north of Korea. Japan dubbed the conquered territory Manchuria (Manchukuo), after the Manchus who originated there, and installed a puppet regime. A similar puppet state followed in adjacent Inner Mongolia in 1936, and in 1937 Japanese troops entered China proper, taking advantage of the civil war between Mao Zedong's Communists and Chiang Kai-shek's Nationalists.

Thus began what would come to be called the Second Sino-Japanese War, vastly larger than the first, which would, with time, morph into the more familiar World War II. Japan's rapid expansion into British Hong Kong, Malaya, and Singapore, as well as the Dutch East Indies (today's Indonesia), would continue across Asia into the 1940s—eventually leading to total defeat in 1945.

65. The Imperial Family Today

Renewed international interest in the Imperial Family of Japan followed rumors in 2016 and 2017 that eighty-five-year-old Emperor Akihito would abdicate his position, which he finally did on April 30, 2019. The events surrounding the

abdication have also drawn attention to the troubles of what claims to be the oldest monarchy in the world.

Japan's monarchy is certainly the largest, in terms of the size of the country, rivaled only by Great Britain's. But as in Britain, in Japan the Imperial Family's role in culture and politics has been the subject of much discussion and even conflict. Akihito's request to step down, grudgingly granted by the parliament, has only inflamed those conflicts. Opinions and laws regarding the conduct of the family members, especially as concerns matters of marriage, childbearing, and the role of royalty in a modern society, have been fraught, to say the least.

Although it claims to be the oldest monarchy in the world—with a legendary founder, Jinmu, said to be born of the sun goddess, Amaterasu, in the 6th century BCE—actual historical evidence of the monarchy places its genesis a thousand years later, in the 6th century CE. Even then, there were gaps in its political presence: The current monarchy was only just restored 150 years ago, during the Meiji Restoration of 1868. Before that, the nation was ruled by the Tokugawa shoguns, and the Imperial Family existed on the fringes of power.

Still, as a repository of Japanese history, the Imperial Family is a part of Japan's national identity—for better or worse. While Emperor Akihito, the occupant of the Chrysanthemum Throne since 1989, was identified with good times in Japan—after his death, he was renamed Emperor Heisei, which means "peace everywhere," in recognition of the nature of the times he ruled. He succeeded his father, the Emperor Hirohito (known posthumously as Showa), who was associated with Japan's brutal imperial expansion of the first half of the 20th century, which ended with Japan's catastrophic defeat in World War II.

The Imperial Family's desire to stay above politics has thus

The chrysanthemum flower is the symbol of the Imperial Family.

always been a balancing act. Conservatives in the country resisted allowing Akihito to abdicate, because it lessened the claim of divine right that they want to preserve.

But conservatives are fighting an uphill battle. The Imperial Family is shrinking, as each time one of its female members marries outside the family she must, by law, leave it. The same month in 2017 that Akihito requested his abdication, his eldest granddaughter, Princess Mako, then twenty-five, announced that she would marry a commoner and leave the Imperial Family. That reduced the number of family members from nineteen to eighteen—of whom only five are male.

This gender imbalance has been the source of great drama and stress in the Imperial Family, as by law only a son can inherit the Chrysanthemum Throne. Forget the fact that there were eight empresses before the Meiji Restoration—none of them the wives or widows of emperors—because in modern times the law has said that only a male can sit on the throne. This has proven to be problematic on several levels.

It became most obvious in the 1990s, when the wife of Akihito's eldest son, Crown Prince Naruhito, married a commoner, Masako Owada, a former diplomat, in 1993. The expectation

of many was that this attractive young professional woman, whom many compared to Britain's Princess Diana, would help move the Imperial Family into the present by serving as a role model for young Japanese women in a culture in which women's place is still secondary to men.

Instead, because the last male child born into the Imperial Family was born in 1965, the pressure on Masako (as she was widely known) to produce the required male heir became a national obsession. Thirteen years into her marriage, her inability to produce a male heir created so much stress in this young woman that she was eventually said to have been treated for undisclosed but clearly serious psychiatric problems.

This almost medieval tableau has underlined for many the archaic nature of the Imperial Family. Thoughts were given to changing the Imperial Household Law to allow female children to inherit the Chrysanthemum Throne, and suddenly it seemed that the Imperial Family might enter the modern world with the rest of Japan.

But when Akihito's second son, Prince Akishino, and wife Kiko at long last delivered the desired male heir in 2006, thoughts of female succession were quickly dropped.

Where the Imperial Family goes from here isn't clear, but its challenges most certainly are. When the emperor can essentially retire like a typical salaryman; when daughters are ejected from the family for merely marrying a "commoner" (and when the "commoner" wives of male family members are hypocritically welcomed into the family); and when females are clearly treated as incapable of inheriting power and position—all this may keep conservatives happy, but it undermines the credibility of the monarchy among the majority, especially the young. How long this can be sustained in a modern, well-educated society is anyone's guess.

66. Japanese Womanhood

Being a woman in any culture is a conundrum, a balancing act, and often, a nearly impossible project, the parameters of which have too often been dictated by men. And a woman's role is especially complicated in Japan.

As in all modern societies, the role of women in Japan has expanded to become roles—plural—and many of them are contradictory: In addition to wife and mother, women are now in business, government, and all manner of public activity. But all of these are not equal in the Japanese mind.

Although Japanese culture has always had clear definitions of women, based on the Confucian ideal of *ryosai kenbo*—the "good wife and wise mother"—the challenges of maintaining that role while embracing new freedoms are many.

Japanese has a number of words and phrases to describe women and their place in society, from *ryosai kenbo* to *yamato nadeshiko* (the personification of the ideal woman), *futoku* (the feminine virtues), and even *joshiryoku*, which translates as "girl power" but is far less radical than the way that phrase may be employed in modern Western countries.

Yamato nadeshiko is a perfect example of how the feminine ideal is seen in Japan. While it may be translated as "personification of the ideal woman," its literal meaning is based on the second word, *nadeshiko*, which is a delicate carnation, and the *kanji* for which reads as "caressable child." Such metaphorical leaps, comparing women to beautiful flowers and adorable children, would be literally laughable in most of the Western world, but they go virtually unquestioned in modern Japan.

Joshiryoku (girl power) in Japan still boils down to being pretty, well mannered, good at taking care of others, being

not-too-smart (though a little sassy is cute), and above all, generally pleasing to men.

The pressure of maintaining these roles has concrete impacts on women in Japan. As a 2019 article in the magazine of the International Monetary Fund opened, "Japan is not making progress in gender equality." Regarding pay equity, admittedly a struggle in the West, Japan's gap remains 24.5%, the largest of any OECD country save South Korea. In Japanese companies, according to a 2016 study by the Japanese government, women hold only 6.4% of the positions of department director, 9% of section head jobs, and fewer than 15% of supervisor positions. The reason, said the article, is not that women aren't as well educated, it's that they're expected to be home taking care of the family.

In a recent World Economic Forum list of the top ten Asian countries with gender equality, Japan didn't even make the list. In that same organization's Global Gender Gap Report of 2017 Japan ranked 117th, behind neighbor China, at 103rd. By contrast, Britain was 21st, Australia 43rd, and the United States 55th.

Finally, the Inter-Parliamentary Union, which tracks women's participation in parliamentary bodies around the world, put Japan at number 164 out of 193 countries, below even Saudi Arabia and nearly 100 places behind China.

But statistics only tell part of the story, and Japanese women are obviously better off than their peers in, say, Saudi Arabia. Still, one need only talk to a few Japanese women to discover that their position in society is very much bound by traditional notions such as *ryosai kenbo* and the very particular tastes of Japanese men.

Women in Japan who take their careers seriously are largely ignored by Japanese men, and age remains an issue. At what would be considered a remarkably young age in other

developed countries, women over twenty-five are often dismissed as "Christmas cake," something that has passed its expiration date.

Most well-educated women, who have studied at university and have professional skills commensurate with men, are nevertheless expected to abandon their careers post-university to raise children. One does not need to look far in Japan to meet such women. When the "ideal woman" remains one who makes herself look good, makes her husband feel good, and supports her children's happiness—especially the boys'—there is precious little room for her to develop any skills beyond being the classic "good wife and wise mother."

There is a darker side of gender inequality: domestic violence. The issue was largely ignored until 2001, when female legislators were finally able to pressure the government into creating anti–domestic-violence laws. But domestic violence—which in 2018 registered its fifteenth annual increase since records began to be kept in 2003—continues to be considered a civil rather than criminal infraction, and thus abusers still face no consequences. Japanese women can face very unpleasant consequences if they report their abuse, and many are still disinclined to do so.

Japan is by no means the worst place in the world to be a woman, and the country is one of the best for women in terms of public safety. But despite its modern surface, and because of the Japanese obsession with maintaining *wa* (social harmony), women's place in society isn't nearly as pretty as the Japanese desire for pleasing appearances—and visitors' optimistic assumptions—might indicate.

67. Japan's Demographic Time Bomb

Underlying Japan's placid, efficient, and affluent surface are some hard realities that do not bode well for the nation in the long run. The economic crisis of the 1990s, combined with the relentless rise of China, has shaken Japan's dominant economic position in Asia. While the economy remains relatively strong, Japan has the largest government debt in the world and growth remains stagnant.

Many Japanese are worried about a matter only tangentially connected to economics, but more fundamental still: The Japanese have one of the lowest birthrates in the world. The country's population has already begun a decline from its 2008 peak of 128 million, and currently (2020) sits at roughly 126.5 million. Additionally, the Japanese population is aging rapidly, with the highest life expectancy rate in the world, at nearly eighty-four years.

Current estimates are that the population of Japan will continue to fall, plunging to 87 million by 2060, at which point the elderly (those sixty-five years and older) will comprise 40% of the population (they are currently 28%).

This is potentially catastrophic for a modern economy, with its focus on perpetual growth and ever-growing consumption, each generation ultimately supporting the aging generation that came before it. But the Japanese seem at a loss as to what to do about it. The government has taken to offering cash payments for each child produced, but the payments would do nothing to defray the actual costs of raising a child.

Other schemes have been suggested, but the problem seems to be a matter of psychology as much as of economics.

Shaken confidence after the so-called "Bubble Economy" burst in 1991, followed by decades of stagnant economic growth, has been blamed. The rising cost of starting a family has hindered the formation of households, the basic unit of many modern economies. Pressure to perform in school has dampened the enthusiasm of a whole generation to pursue careers. And many Japanese women are disinclined to marry and give up their careers and leisure time.

But slowing population growth is a common issue in most of the developed world. Japan just seems uniquely stymied. This impasse has come to be epitomized in the popular imagination by the distinctive problem of the *hikikomori* (see also chapter 68). Literally meaning "pulling inward," the *hikikomori* are younger people (now up to forty years old) who have dropped out of society and decided not to grow up. Avoiding jobs, homeownership, romantic relationships, and raising children, the *hikikomori* stay with their parents through their twenties and even into their thirties, surfing the internet in the safety of their childhood bedrooms and otherwise refusing to engage with the adult world. There may be more than a million *hikikomori*.

Add to this the pressures of caring for the increasing number of elderly, many of whom are barely scraping by financially. Despite Japan's social consciousness and community-mindedness, the social safety net is relatively thin—and fraying. An ongoing problem is Japan's enormous national debt, which, at roughly 236% of GDP, is the largest in the world, according to the IMF.

This declining population is compounded by the increasing urbanization that is also common around the world but especially acute in Japan. Tokyo has long been the largest conurbation in the world, at 35 million people, nearly a third of the Japanese population. In 1950, 53% of Japan's population

lived in urban areas; by 2014, 93% did. But the impact of this urbanization on Japan's smaller cities and villages is profound, leaving only the elderly to do farm work in towns that younger people abandoned when they moved to the cities. Hundreds of municipalities in Japan are in the process of depopulating, becoming ghost towns.

Exacerbating all of this is Japan's characteristically closed nature. Immigration is one way that countries like the United States, Canada, and the United Kingdom continue to grow. But nearly two-thirds of Japanese in a recent poll still resist the notion of allowing foreigners to become Japanese citizens. Even those whose families have been in Japan for generations—ethnic Koreans and Chinese—are set apart as different, not real Japanese. And if the Japanese aren't making enough new "real" Japanese, then Japan's fate is not just uncertain. It is dire.

Japan's character has long been defined by its self-conscious desire to hang on to its identity; it has done so with remarkable success. And the resourcefulness of the Japanese is undeniable: History teaches us to never underestimate what the Japanese can do when they put their collective effort into it. But the demographic drop is a challenge to match any the Japanese have faced before.

Without course corrections that could strike at the very heart of Japanese identity, the country is on the path to becoming a museum piece, and the elements of its culture, which so beguile the world, may become frozen in amber, beautiful but lifeless.

68. *Hikikomori*, Herbivore Men, and Parasite Singles

Japanese society rests on well-defined roles; clearly prescribed behaviors are what makes those roles, and that society, work.

Except, of course, when they don't.

Japan is a modern society, and the impacts of that modernity—especially as they clash with traditional roles—have brought forward a number of social phenomena that have been much fretted over by contemporary Japanese, and thus, Japanese media.

Social shorthand terms like *hikikomori*, "herbivore men," and "parasite singles" could be dismissed as media creations, and to some degree they are. But each highlights a very real Japanese phenomenon that expresses the anxieties of a society for which the transition from traditional to modern has been less than smooth.

All three of these phenomena have some parallels in other modern cultures, but the Japanese tendency to identify and name subtle variations in aspects of culture (and arts, and food, and everything else) means that they are easier to describe in Japan.

HIKIKOMORI

The *hikikomori* are perhaps the most worrisome of the phenomena, as their existence is seen as a threat to the existence of the nation itself. More than a million people have been described this way, which is nearly 1% of the population.

The word literally translates as "pulling inward" and "being confined," and it describes young men and women who have withdrawn from social life to live as near hermits, usually in their parents' homes. The government's Department of

Health, Labour, and Welfare uses exactly this term and has developed diagnostic criteria for anxious parents to evaluate worrisome children.

Reasons offered for this withdrawal have been varied, ranging from such untreated mental disorders as depression and autism, to the crushing emphasis on conformity in Japanese society, the pressures of high academic standards, the complexities of social life (on and offline), and even Japan's famously overprotective parents.

The problem is no longer limited to children. As an ongoing phenomenon, many *hikikomori* who began to withdraw as children—refusing to go to school, to socialize, even to leave home—have grown into adulthood. That means that they're not just missing school, they're missing life: dating, careers, marriage, and, always worrying in this rapidly aging country, having children. Ask any Japanese friend, and she can easily rattle off the names of a half dozen children of friends who fit the description.

The Japanese government has even laid out the looming "2030 Problem" in which the country finds itself approaching that year with hundreds of thousands of aging *hikikomori* who have lived their entire lives with aging parents who will be dying off, leaving the *hikikomori* with no partner, no children, and no way to make a living. A 2019 survey estimated that "adult *hikikomori*," aged 40–64, number more than half a million.

In a country with a shrinking and aging population, and a government with the largest deficit in the world (as a percentage of GDP), the *hikikomori* are a topic of great anxiety in Japan.

HERBIVORE MEN

Herbivore men (also called "grass-eater men," or *soshoku*

danshi) are an even bigger group than the *hikikomori*, and while not quite as problematic, they still worry Japanese culture-watchers. The term was created by a newspaper columnist named Maki Fukasawa to describe men who may have romantic involvements but are not aggressive sexually, or even particularly sexual at all. If a 2010 survey is to believed, 61% of men in their twenties and 70% of men in their thirties described themselves this way.

A subsequent 2016 study by the National Institute of Population and Social Security Research reported that comparable percentages of young men and women aged eighteen to thirty-four said they didn't have an opposite-sex partner, or *kosai aite*, which translates as "interaction partner." This led to predictable headlines about "sexless Japan" and much fretting that young Japanese have no interest in sex. This is of course an oversimplification, and less sexually aggressive young men might sound like a godsend in other contexts. But such young men have been blamed by some for the declining birth rate, as well as the decline in marriage, as they postpone the responsibilities of marriage and family.

Still, this complex phenomenon lacks convincing villains. Since the bubble economy burst in 1991, Japanese economic expectations have taken a beating, jobs are less secure, and a generation has grown up with less desire to take on the obligations of family—particularly young women, who see the costs their mothers have paid and are not blind to the fact that most Japanese men are still disinclined to take on domestic responsibilities. A corresponding decline in young professional women interested in marriage has also prompted much handwringing.

Of course, one sees young families all over Japan. The Japanese still obviously find partners and make babies, and this is a decline that is common in all the developed nations. It's

just particularly troublesome in aging Japan, which has one of the highest rates of population decline in the world.

PARASITE SINGLES

Parasite singles overlap the above groups and are another troubling trend emerging in Japan's demographic problems. These are young people who continue to live with their parents into their thirties. While this, too, is not uncommon in many traditional societies, and is well known in some developed Western societies, it has come to be a derogatory term in Japan.

But unlike the situation in other modern societies, this is not necessarily frowned upon by parents in Japan, whose living costs aren't considerably raised by adult children at home and who may see this interdependence as a down payment on the day when the adult children will take care of them as they age.

The Japanese fascination with naming subgroups extends to others cohorts: NEETs are young people "Not in Education, Employment, or Training" and are said to number nearly 1 million. Related are the "freeters," part-time workers, said to number more than 2.5 million.

When combined with the delay of marriage and family formation, a declining birthrate, and an aging population, the *hikikomori*, herbivore men, and parasite singles are just three expressions of a country in a demographic crisis. And regardless of events, the Japanese will most likely continue to fret— and to find catchy phrases to express their anxieties.

69. *Hentai* and Other Sexual Oddities

At the same time that the Japanese media fret over such phenomena as "herbivore men," their lack of sexual aggression, and the apparent lack of sexual activity among the young—and who thought *that* would be a civilizational worry?—Japan is also a culture that embraces sexual peculiarities.

So it may not be surprising that it was in Japan that "tentacle" sex (*shokushu gokan*) was created—in the 19th century! But at the same time, Japan has a relationship to sex that, while titillating to much of the rest of the world, has come to represent some of the country's most pressing concerns. Which is to say that, as with most cultures in the world, sex in Japan is fraught. They're just a lot more creative with it.

It is in Japan where one will encounter cartoon sexual material featuring, say, two ostensibly underage girls in erotic play with ... each other's penises? This is *futanari*, a popular subgenre of porn based in an interest in hermaphroditism.

Generally speaking, *futanari*, as well as *shokushu gokan* and many other adventurous sexual representations, fall under the label of *hentai*, or fetish. *Hentai* is short for *hentai seiyoku*, "sexual perversion." While the West knows *hentai* as a form of erotic manga, in Japan it is more broadly applied. But the sense of the word is not as loaded as it may be in the West; the Japanese apparently delight in "perversions" so outlandish that they can't be taken quite seriously.

How many Japanese actually practice these interesting variations on sex—which, in addition to *futanari*, range from bondage and sadomasochism to homosexuality (still more underground in Japan than in other modern countries) and oddities like *lolicon* and *panchira*—is unknowable. In recent

years, Japan has been focused on a different aspect of sexuality, one you wouldn't expect in a country so adventurous in its sexual expression: the decline in interest in sex, particularly among the young.

Whether mild or wild, the Japanese establishment is currently obsessed with the lack of sex, or as they put it, in one of those poetic expressions the Japanese excel at, *sekkusu-banare* (literally, "a drifting away from sex"), which has become a grave concern in a country with a declining population.

But it appears that the Japanese are in no danger of becoming less voyeuristic; indeed, the country's fascination with this wide range of pornographic expression leads to the conclusion that many would rather watch and fantasize than actually engage. And when one examines what they're watching, one understands the desire to keep a safe distance.

Such confusion likely has its roots in response to fairly tough government censorship, enacted in the early 20th century, and in nationalist militarism, with its strict codes of obedience, that led to World War II. Those restrictions were loosened after the war, but many endure to this day. And where there are restrictions, sexual expression can appear in some pretty twisted ways.

This is in contrast to America and Western Europe, where since the early 1970s, most restrictions on explicit sexual depictions have essentially disappeared. In Japan, by contrast, the showing of even pubic hair was outlawed until the 1990s, and to this day, Japanese porn, printed or filmed, is not allowed to show actual intercourse.

Beyond that rather substantial restriction, the only others, legally, are on child pornography, and even there, the lines are remarkably porous. Actual child pornography, with actual children, is illegal, but that's only since 2014. Despite that restriction, representations of children having sex are still

common, as in *futanari*, or *lolicon*, short for "Lolita complex" (young girls) and *shoticon*, which similarly focuses on under-aged boys.

It is even possible to encounter *lolicon* or *shoticon* in the hands or on the smartphone of a salaryman heading home on the Tokyo subway. Popular convenience stores have only recently begun to cover up porn in their aisles, and some have stopped carrying it entirely.

There is gay porn (*yaoi*) and lesbian porn (*yuri*), but both are surprisingly innocent, not to mention unrealistic, relative to their Western counterparts. Moreover, each is aimed not at the genders they depict, but at the opposite. Thus, *yaoi* may depict two young men in erotic embrace, but it is aimed primarily at the female market. This shouldn't be surprising to many straight men in Western cultures, who are regularly served up lesbian porn.

Panchira is another Japanese area of erotic expression. The word refers to a brief glimpse of a young woman's underpants and is common in anime and manga. Again, it reflects the culture of *kawaii*, but there is no way to underplay the fetishizing of young girls in Japanese culture.

There are others—*bukkake, gokkun, tamakeri*—but seriously, you may not want to know. Let it suffice to say that the Japanese, or at least a sizable portion of them, may not be having a lot of sex these days, but they sure are thinking about it a lot—and they are being very creative with those thoughts.

70. After Fukushima

It was an almost perfect storm of disaster, one that has given Japan nearly a decade of knock-on effects that have still not been resolved: The Great Tohoku Earthquake and Tsunami of 2011.

It began badly enough, on March 11, 2011, when an underwater earthquake approximately 70 kilometers off the east coast of Honshu shook the island for a full six minutes before subsiding. At 9.0 magnitude, it was the largest earthquake ever recorded in Japan and the fourth largest in recorded history.

But that was just the beginning: A tsunami created by the earthquake moved, at an estimated 700 kilometers per hour, toward the east coast of Japan. When the waves made landfall, they were nearly 15 meters high, among the biggest ever recorded.

A half-dozen waves caused flooding many kilometers inland, ultimately killing nearly twenty thousand people in the flat coastal plain. When the damage was assessed over the subsequent months, it was found that more than a million buildings were either partially or totally destroyed. Nearly a quarter million people were evacuated, and many tens of thousands have not yet been able to return to the area. Many have given up thoughts of returning home and settled elsewhere.

This was a natural disaster on an almost unimaginable scale, but it wasn't over: The tsunami easily topped the seawall that protected two TEPCO (Tokyo Electrical Power Company) nuclear power plants on the coast. The smaller one, Fukushima Daini, was badly damaged, but the larger, Fukushima Daiichi, found itself flooded and its electrical system incapacitated.

The emergency generators shut down under the encroaching water, and with no electricity to pump coolant into the over-heating reactor cores, there were explosions in three of the four reactors, which subsequently caused them to melt down, sending radioactive particles all over the area.

This was the most severe nuclear disaster since the Chernobyl disaster in the Soviet Union in 1986, and its location, right on the ocean, has made the subsequent decade a nightmare for thousands of Japanese. Thousands lost homes, businesses, and family members. Towns were either destroyed in the tsunami or contaminated with nuclear radiation. The region's once-thriving agriculture sector now sits atop contaminated, unproductive land. And this is not to mention the effect on the enormous fishery to the east, one of the most productive in the world.

Many have struggled in the wake of the disasters to get back on their feet, but the results so far have been limited. Though the coordinated effort of the Japanese has made impressive progress, the sheer scale and nature of the disaster has proven to be difficult to recover from.

Decommissioning the plants is expected to take at least thirty years, to 2040, but some consider this optimistic. The cost, originally set at ¥11 trillion ($96 billion), has more than doubled in the intervening nine years, and some estimate that the cost could be as high as ¥80 trillion, or $750 billion. TEPCO will pay a portion of it, but the rest must be borne by Japanese taxpayers, and for a country struggling with the largest government debt in the world this is a daunting figure.

More than thirty individuals or groups representing the tens of thousands of evacuees have sued TEPCO, arguing that internal company reports that a tsunami could breach the seawall were ignored, and millions of yen have been awarded. Many more cases have yet to be heard.

The impact on public trust—of the nuclear power companies, of course, but also of the government, which has been shown in subsequent trial disclosures to have been in a cozy, profitable relationship with the power companies as they cut corners on safety—has been perhaps the most damaging effect of the chain of disasters itself.

In a 2018 survey by the Japan Atomic Energy Relations Organization, a pronuclear advocacy organization, only 6.7% of the public rated the nuclear industry trustworthy or even "somewhat" trustworthy. The distrust extends to the government: Only 7.9% of the public trusts the government, even just "somewhat."

So it is not surprising that when TEPCO announced plans to start dumping the more than 1 million tons of contaminated water from the reactors into the ocean in 2021, fishing organizations, which have been enormously impacted, and the more general Japanese public, which takes food purity and safety very seriously, expressed outrage.

The fisheries may well have recovered significantly, as the government says, but the public is clearly skeptical. The ongoing damage of Fukushima's string of disasters has yet to come to an end.

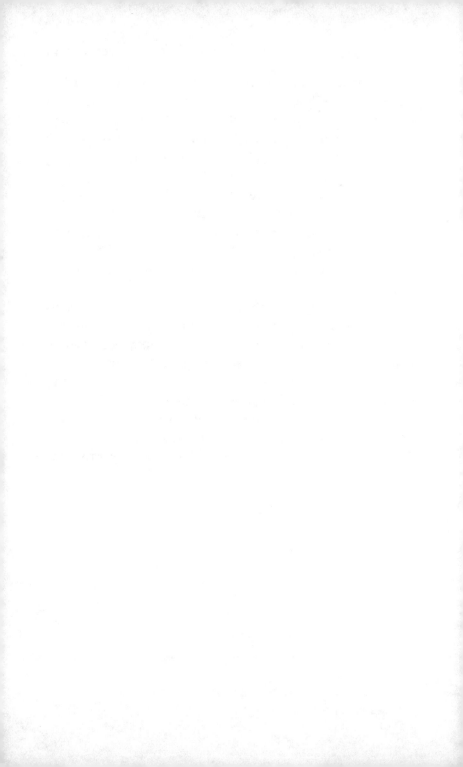

五

THE FOUNDATIONS OF

JAPANESE CULTURE

Japanese society can seem unfathomably complex to those uninitiated: Words change form and meaning depending on whom one is speaking to; respect is signaled in subtle but consequential ways; daily activities consist of movements prescribed by tradition; and the gods reside close to the mundane world. In this world, the outsider is walking blind. There are things the Japanese see, of which we are normally unaware.

Japanese culture recognizes hundreds, perhaps even thousands of *kata*—ways of doing things—that help the Japanese person live a life that is in harmony with his or her surroundings, both natural and societal. There are *kata* for every aspect of life, from bowing to giving a gift, from speaking to one's elders to addressing one's inferiors.

Earlier in this book we have already seen how, below all these *kata*, are the cornerstones of Japanese faith: Shinto and Buddhism. These two systems of belief and ritual lie at the basis of the country's arts, rites, and sense of self. In this chapter we will explore more rituals of Japanese life and the notions, formalized in Japanese culture, of *honne* and *tatemae*, the private face and the public face, as well as the concept of *uchi-soto*, of in-groups and out-groups within, and beyond, Japanese society. Looking at "high context" vs. "low context" societies, we'll see what really matters to the Japanese in any given situation—which may not be what non-Japanese think matters. We will also try to understand a fundamental aspect of Japanese society: the *kata* of *wa*, or harmony, which is pursued with great devotion, and sometimes at great cost to the individual.

These underlying concepts and understandings can be difficult to grasp, and even harder to see in the day-to-day of a short visit. But having some basic understanding of them should give the reader at least an inkling of the complexities that underlie life in Japan.

71. The Ubiquitous Power of *Kata*

The Japanese word *shikata* is often translated to mean "shape" or "form," or in other translations, "way of doing things." Familiar book titles such as *The Way of Zen* or *The Way of the Samurai* touch on this. But in Japan, numerous *kata*—the word used for the many individual forms of this devotion to the proper way of doing things—are simply an element of life. There are *kata* for nearly everything the Japanese do.

Taken together, *kata* govern much of Japanese culture. There are *kata* of how to hold chopsticks or a paintbrush, of the way of addressing business clients, even of the proper way to use the telephone. *Kata* have developed over centuries and are strictly adhered to by any proper Japanese person, which is to say, nearly all.

To a foreigner, the use of *kata* can get to a point that any non-Japanese would likely consider more ridiculous than sublime, a total society controlled by the notion that it is better to do the wrong thing the right way than the right thing the wrong way. And while that has bound the Japanese together in a nearly airtight certainty of the right and wrong ways to do things, it can seem absurd to outsiders—and oppressive to the Japanese themselves.

As a Japanese friend who has lived outside the country recently told me, she sometimes goes to Chinese restaurants in Japan simply to escape the constant self-consciousness and even social control represented by, and enforced by, *kata*. To visitors, *kata* are interesting; to the Japanese, they can be suffocating. On top of that, the utter ubiquity of *kata* can mean that the Japanese hardly even know what is suffocating them. They take *kata* so for granted that it is nearly invisible to them,

even as they do things in a strictly prescribed manner. That's just the way things are done, they say, if challenged.

For the visitor, knowing a bit about *kata* is helpful, because it can explain the ritualistic approach to even the most mundane activities.

Everything—from the way the Japanese bow or drink tea, the way they greet friends or hand a customer a package—is dictated by *kata*. The extreme precision of Japanese behavior makes more sense if one knows a few *kata*. But *kata* are one big reason that foreigners remain forever outside of Japanese society: We don't know the proper way. And in a society that values form more highly than most, this can also be intimidating; the good news, of course, is that the Japanese generally know this and don't judge foreigners for their inevitable lapses.

Shigoto no shikata, "the way of working," is a whole group of *kata* that oversee how Japanese interact at work, and for many foreigners who come to work in Japan it can result in much confusion and frustration. *Shiji no dashi-kata* is the way of giving direction at work; *meirei no shikata* is the way of giving orders; and *hanashi-kata* covers the area of how one is to speak. These are just the tip of a very large iceberg.

Kata are serious business. Because of that, the system of *kata* cuts both, or perhaps many, ways: Various *kata* are oppressive, but they also give form to a culture and society that is devoted to, even obsessed with, form in the service of harmony. *Kata* also give Japan a great deal of its charm and beauty, for many of these *kata* have evolved over centuries, and give to a function as simple as arranging flowers a grace and beauty, not to mention efficiency and utility, that can be breathtaking. *Shikata*—the "way of doing things"—rules Japan, and the Japanese, but it also offers an ease and bearing that can be a balm to visitors from countries where social

graces are often tossed aside in pursuit of individuality and personal advantage.

72. Bowing, Japan's Fundamental Courtesy

Bowing is a fundamental human motion, a way of paying respect that has had expression in nearly every culture in the world. While bowing has largely disappeared in Europe and was never common in the Americas—though entertainers still bow to their audience—it remains widely used in Asia. Nowhere, however, is it as crucial, and complex, as it is in Japan.

Perhaps one reason bowing is less common in the West is that it is largely driven by a respect for social rank, and the whole concept of social ranking is ostensibly frowned upon in the United States and Europe. This is not the case in Japan, which, despite its democratic politics, is at its core a hierarchical society. The Japanese will go to great lengths to determine the status of the person they are interacting with, and that awareness will appear first in the bow.

Bowing in Japan, known as *ojigi,* is so ubiquitous as to be daunting to visitors, but as a show of basic humility and manners it is not difficult once you get used to it. Simple attempts at bowing are appreciated by the Japanese, who will not expect a visitor to understand the numerous variations. Just don't overdo it by bowing too low or by bowing while you're shaking someone's hand and you'll be fine.

The variations of bowing in Japan are mind-boggling,

Bowing looks simple but has many important rules and conventions.

and the degree of a bow is literal. The numerical degree of each bow, from 15 to 90 degrees, is determined by the relative social status of the person to whom one is bowing. All of this explains why bowing can be intimidating to the visitor. But rest assured that as with all Japanese social manners, it is much more difficult for the Japanese themselves. Knowing the correct form of bowing is so crucial to business that many Japanese companies insist their (Japanese) employees take classes in proper bowing. There are wall charts that indicate the degree of the appropriate bow in any given circumstance.

The Japanese bow in virtually every social situation, even when they are not in the presence of another person. Seeing a Japanese bow while speaking to someone on the phone, when that other person can't even see them, underlines how deeply engrained this formality is. Japanese will bow to another driver in traffic. It's all about showing respect, whether or not the bow is actually seen by the person it is being addressed to.

(Note that in Thailand and other countries in Southeast Asia, people bow with their palms together, nodding their

head slightly. This is known as a *wai*. It is becoming more and more familiar to, and even used by, Westerners, but it is not used in Japan.)

In Japan, bows are done from either a standing position, called *seiritsu*, or from the kneeling position, called *seiza*. Bows can be done for different lengths of time, and as noted above, the angle varies depending on the situation.

Bows are made for a variety of reasons, from a basic greeting to the most dramatic, desperate, bow of apology. The deeper, longer, and more energetic the bow, the greater the apology, but bows are generally meant to express respect and appreciation, and they may show up when interacting with a shop clerk, any sort of public officer, a teacher, an employer, a superior at work, or even a mountain one has just climbed, since many mountains are holy, or even gods themselves, and thus, deserving of respect.

One situation in which it may feel especially important to visitors to get bowing right is during visits to temples and shrines; bowing isn't required, but it can have the effect of deepening your experience of a religious act. At Shinto shrines, you will want to first wash your hands (and rinse your mouth) if there is a basin provided; step up to the shrine and make an offering of a small coin, then bow in the following way: Do two *keirei* (formal, 30–45 degrees) bows, clap your hands twice in front of you, and end with a single *saikeirei* (deeply reverent) bow, which is 45 degrees or more (see chapter 81).

In other situations, it's best to watch the Japanese bow and follow suit. Remembering some basic elements of the bow will help serve as a way to show basic respect, humility, and politeness in nearly any situation.

Bow from the waist. The back remains straight, the eyes cast down, the hands on the front of your thighs. Bow when bowed to, with the exceptions of shopkeepers, whose bows

you are not expected to return. A bow of 30 degrees is about right. Don't bow and shake hands. Don't bow while walking, or while speaking. Stop everything and bow.

As a foreigner, you are not expected to get this right, but as with speaking a bit of Japanese, any attempt is appreciated.

73. The Individual and the Group

There is an old Japanese saying, "The nail that protrudes will be hammered down." This simple phrase says much about the place of the individual in Japan's group-oriented society.

All societies must balance the often-conflicting needs of the individual and the collective. But in Japan, the pursuit of harmony (wa) has usually meant that balance is maintained more often to favor society over the individual.

A recent court case in Osaka Prefecture made this point in a stark, almost ridiculous fashion: A young woman sued her school because she, with her natural brown hair, had been harassed and intimidated by school authorities into dyeing her hair black to match her fellow students' hair. The court upheld the right of the school to enforce its rules.

Social conformity is prized in traditional cultures, where social ostracism is typically the punishment. But Japan is a modern nation and most certainly a collection of unique individuals. Japan has produced singular creatives like the artist Yayoi Kusama and the writer Haruki Murakami, among many others. But such artists are also the exceptions that prove the rule: The "hammer" comes down on those average Japanese who step too far away from the culture's well-established norms.

There are several reasons for this, which may be rooted

in Japan's long geographic and cultural isolation, its ethnic homogeneity, and its legendary productivity. Its effects are largely salutary: Japan is a well-integrated and generally highly-functioning society that provides its people a strong sense of national identity.

There are other reasons: Japanese sociologists often note that Japan's economy, before the postwar industrial "miracle," was based on rice farming, which requires group efforts that an individual, or even an individual family, could scarcely manage alone. The creation of rice paddies, the management of water, the planting, harvesting, and processing of rice are fundamentally group activities, and in order to make that work, group cohesion became essential to group success— that is, survival.

The upshot was that any individual who decided that he didn't need to work with the group was very quickly disabused of that notion. The "rugged individualism" so admired by many in the West was anathema to the Japanese—and it still is.

It is telling that, in addition to the clear imagery of the hammer-to-nail, there was no equivalent of the word for "individual" in Japanese prior to the opening to the West in the Meiji period of the late 19th century. The words shakai (society) and kojin (individual) only appeared as translations of these concepts were introduced from outside.

What the Japanese had instead was the word mura, related to the verb mureru, which means "to flock together," as birds—and who thinks of birds as individuals? Thus, this "flock" of people were bound by something called seken, which means society, or more accurately, "the power of public opinion," which still holds enormous sway over the members of the flock.

This worked fairly well for the strict social hierarchy of

Japan's feudal period, which ended with the Meiji Restoration in 1868. But the industrialization and modernization that followed, accelerated by rapid globalization of the Information Age, has brought the conflict of these two competing vision to a head.

Thus, trends such as the rise of divorce, the decline of family formation, and other indicators, which have affected many developed nations around the world, have been particularly stark in Japan. Still, group cohesion, *wa*, remains of great importance, and any nail that sticks up too far above the others will continue to draw attention.

Thus, the need for the hammer has, if anything, increased, even as it has been challenged by schoolgirls who merely want to retain their natural hair color.

74. *Wa* and the Japanese Reluctance to Say "No"

The simple word *wa* is perhaps the most important in the Japanese language. It is so important to the nature of Japanese social interaction perhaps because it was the original name of the country.

Wa means "harmony," and the maintenance of that harmony is absolutely paramount in all Japanese relations, because the essential nature of social interaction in Japan is focused, above all, on the group and the individual's subordination to that group—whether family or business unit. The Japanese people will go out of their way to ensure that harmony is maintained.

This is why a second word—*iie*, which translates as "no"— is so rarely heard in Japan. To use that word is considered rude and even dangerous to social interaction and is avoided by most Japanese in all but the most basic, clearest circumstances. Even in what Westerners would consider a circumstance in which a simple yes or no would suffice, *iie* is avoided.

Whereas saying no to someone in most countries is simply a statement of preference or fact, in Japan it is seen as veering perilously close to causing a disturbance in the harmony of the moment, and the Japanese will go to significant verbal lengths to avoid saying *iie*. The verbal gymnastics can get quite elaborate, to a degree that many non-Japanese would consider excessive, even comic. But to the Japanese, it is no laughing matter.

This is particularly important because the Japanese are acutely aware of social standing, and every Japanese will very quickly assess their relative social status to others in any given situation. A person of lower social status will try even harder to avoid saying no to anyone above them, a concept alien to most Westerners, who don't focus on relative social status, at least not consciously. The Japanese do not have that luxury.

Thus, a question will be answered in a roundabout way that avoids using the word *iie*, such as giving an excuse or redirecting the question or reframing it in order not to give offense or anger the questioner. These phrasings are subtle, but they get the message across, and they manage to avoid the use of the dreaded *iie*.

For example, if you asked if someone likes something or agrees to an idea, rather than saying no, the person you asked might ask for a little more time to consider the question. Or if someone asks if something is possible, the answer will never be a direct no; instead, one will be told that what is being asked "would be difficult" or that it "may not work out well"

or even simply "I don't know," all of which can confidently be read as "no."

Even an answer in which a direct no would be sufficient, a yes (*hai*) is likely to be substituted: "Yes, it is difficult for me to do that." The meaning is obvious, but the word "no" is scrupulously avoided and social harmony preserved.

One situation in which the response must be finessed is when one is extended an invitation to a party, especially an after-work gathering where there will be a considerable amount of drinking—a typical invitation for anyone working in Japan, or even visiting for any length of time—and one is, say, not drinking. In a work situation, these invitations are difficult, even impossible, to refuse.

Probably the best approach—and one that won't be unfamiliar even to Westerners who are comfortable with using the word "no"—is to make an apology or an excuse: "I'd love to, but my mother-in-law will be visiting." Or, "That sounds awesome, but I have to do homework." Or even, "I'm sorry, that's my night to wash my hair." Virtually any excuse is acceptable, as long as it avoids the using the word "no."

Now, some of these are niceties that any civilized person would observe. A curt "no" is rarely dispensed to someone about whom one cares, and most "no" answers are usually couched, to some degree, in softening tones or phrases that will spare feelings or not offend. Social invitations are rarely shut down with a simple "no" but are often accompanied by an excuse. This is just being polite.

But in Japan, as in many things, scrupulous attention is given to even the smallest details in conversation, and as in all matters regarding interactions with foreigners, leeway is given to people who aren't Japanese. But knowing of the Japanese aversion to direct statements using the word "no" is one of those little tricks that will smooth social interactions

and give just a touch more insight into the sensitive, finely attuned Japanese mindset.

75. Japan's "High-Context" Society

It is a truism to say that every culture is unique, and it is also unnecessary: Everyone can see that food, dress, language, architecture, and social customs can vary greatly from country to country, or even within countries.

But some differences are not so obvious, and that makes them harder to grasp; indeed, some differences are so subtle as to be all but invisible to visitors, because they are, in some ways, invisible even to those who "know" them. Some established ways of behaving are so "natural" that even their practitioners are unaware of them.

Japan is full of such subtleties. It is what some sociologists call a "high-context" culture, similar to other Asian (and Middle Eastern) cultures and in contrast to many European (and American) cultures, which are described as "low context." The explanation was formalized by the anthropologist Edward T. Hall in his 1976 book *Beyond Culture*.

High-context cultures are those in which the culture is homogeneous and well established, in which communication is often subtle or even unspoken. The goal is almost always intergroup harmony.

By contrast, low-context cultures are much more heterogeneous, with many different actors engaged, and often with new members, so that things must be better spelled out. This

can result in the need for longer and even more contentious discussions; thus, low-context cultures may seem less harmonious. Because such cultures also tend to focus on individual freedom and expression, rule breakers are sometimes honored for their ability to "think outside the box."

In Japan, because of its exceptionally low immigration rate and its broad cultural homogeneity, the result of nearly everyone having been raised according to the same set of cultural rules, much can go unsaid; in Western cultures, with high levels of cultural mixing, even basic things must be worked out, often out loud. Those who keep their real feelings or opinions to themselves in low-context cultures are considered insincere or even two-faced; in high-context cultures, that ability to discern (and express) two different "faces" may be a sign of maturity and social grace.

Thus, in Japan, much communication goes on nonverbally, through subtle gestures, facial expressions, and voice tones, in ways that Western visitors may not even notice, let alone understand. The problem comes when the Japanese, accustomed to being understood by each other without explanation, don't understand why they're not being understood.

In social situations, for example, an intent to please may be interpreted as the opposite. In a restaurant, the host may order for everyone; his intent is to acknowledge that we are all in the same group, together, and to show that he is doing all he can to attend to his guests. A Westerner may find that such behavior offends her sense of individual will, and she may feel controlled or her opinion discounted.

In conversation, Japanese are more likely to listen than to talk, assuming that they are being told what they need to know; they are also more likely to defer to the group than to assert their own opinions. In personal conversation, Japanese are less likely to discuss personal details, while people from

low-context cultures may ask personal questions as a way of showing their interest; Japanese may find this invasive of their privacy.

While Westerners may complain about service or something they don't approve of, Japanese are more liable to overlook discomforts to assure everyone in the group that they are happy. Japanese act as individuals, certainly, but are culturally sensitive to the needs of the group; Westerners see the group as important but are reticent to subordinate themselves to the group.

Japanese who are accustomed to interacting with foreigners are aware of this difference and make allowances for it; foreigners would be wise to reciprocate. Just being a bit more observant can go a long way toward smoothing interactions. Western visitors should try not to assume that the Japanese are being purposely misleading, deceptive, or intentionally "mysterious"—accusations that have been hurled at the Japanese over the decades—simply because they don't spell everything out.

This requires some effort on a visitor's part, but that effort can make for a wonderful opportunity to learn more about others—and ourselves—in marvelous and subtle ways. And isn't that why we're traveling in the first place?

76. *Honne* vs. *Tatemae*: The Two Faces of Japan

In English, it is called a "white lie": the not-quite-true fabrication, or shading of the truth, that is designed to soften what

262 ■ JAPAN FROM ANIME TO ZEN

would otherwise be a hurtful comment or uncomfortable social reality. Most cultures around the world recognize that giving an unvarnished opinion or stating a truth plainly can cause not just personal distress, but social discord.

In other words, we lie sometimes not to hurt another's feelings or to create social awkwardness, but to avoid it. It is, arguably, a universal human solution to a universal human problem.

In Japan, of course, this is not just commonly done, it has been formalized into a pair of opposing concepts that describe this social reality perfectly: *Honne* ("true sound") is the word for what is really thought, or said privately; *tatemae* ("facade") is its opposite, the constructed "white lie" that avoids hurt feelings and smooths social functioning. Such a social construction seems indispensable in a country so densely populated.

Honne and *tatemae* jostle with each other through every conversation in Japan, each participant assessing what needs to be said and how, internally weighing what can be said and what must not be said. Such is the complicated mental chess that many Japanese interactions require.

For foreigners who are struggling with the basics of the Japanese language (or just the accents), or with the country's complex social conventions, trying to figure out when an invitation or compliment or question is *honne* or *tatemae* can be daunting. Some suspect that the Japanese hide behind *tatemae* as a convenience rather than manners, and some have even gotten angry at what they consider the presumed "dishonesty" of the Japanese.

True, some Japanese, being human, may find the notions of *honne* and *tatemae* to be convenient ways to escape responsibility, to mislead, and to otherwise gain advantage in a conversation. As with the elements of high- and low-context

cultures—Japan is decidedly "high-context"—the generous use of these "white lies" has the potential to create misunderstandings between the Japanese who use them and the foreigners who often feel that it is difficult to take the Japanese at their word. Foreigners may be forgiven for finding it difficult to determine whether a Japanese is being kind or simply lying.

Invitations may be extended that any Japanese would understand to be only a formality, never to be accepted, but which *gaijin* (foreigners) may actually accept. Compliments may be a way of being nice, but they may also be a way to manipulate someone into favors. But who, in any culture, doesn't do these things from time to time?

So in some cases, *tatemae* is a way of maintaining the modesty that the Japanese value. In others, it may be a way of maintaining position, or it may be a way of defusing an awkward situation or even flattering an important client. The ways in which *tatemae* and *honne* are played against each other are virtually limitless.

More to the point, in Japan, as in much of the world, no one wants to stand out too much from the crowd. This is complicated for many Westerners, who take it as a personal virtue to rise above the crowd. This is not a typical Japanese attitude, and in order to fit in, the Japanese may say what is required to appear a part of the group, while simultaneously believing, or knowing, themselves to be thinking quite the opposite.

This can be a matter not just of manners, but of survival in a culture that values group cohesion. As frustrating as it may be to try to decipher what, exactly, a particular Japanese person thinks or feels, there are reasons why these "two faces" exist. For a visitor, the trick, then, is in getting a sense of how the two faces are being employed. As any *gaijin* can tell you, that can take a lifetime to figure out.

77. *Chinmoku, Sontaku,* and the Uses of Silence

It is said that in music, the space between the notes can say as much as the notes themselves. This idea also applies to language, through which the pauses in speech, the unspoken words, and the implications of the context can say as much as any overt comment.

And that, it need hardly be said, goes double in Japan.

The Japanese, as a homogeneous, "high-context" society—in contrast to "low-context" societies in Western Europe and the Americas—share a huge number of common assumptions about life (see chapter 75). As assumptions, they need not be stated, and communication can take place with a minimal amount of explanation. The Japanese can get by with using fewer words.

Or, perhaps, with no words at all. Thus, silence (*chinmoku*) can reveal as much as speech, and the artful use of silence in Japanese communication is one of the subtleties of Japanese culture. But it can also be used to obscure, and silence and other non-verbal subterfuge have their dark side—as well as their profound effects.

With much understanding already baked into any given conversation, the Japanese can communicate what is required or desired by speaking indirectly, or not at all. *Chinmoku* is a powerful form of communication, reflecting the Japanese appreciation for the value of simple silence. Or it may just seem simple to the outsider; to the Japanese, silence can be loaded with meaning.

Examples range from Zen Buddhism, in which silence may hold the secrets of existence—indeed, language is considered inadequate to expressing real truth—to deep cultural

tropes that characterize those who speak as more shallow and common than those who maintain silence: *Mono ieba kuchibiru samushi aki no kaze* ("when you speak the lips feel cold like the autumn wind," meaning roughly that you are better off saying as little as possible) is a popular Japanese proverb.

Silence, then, isn't empty and it isn't meaningless. Silence can be taken to mean the other person is taking what you just said seriously enough to be considering it carefully. Or that person may just be buying time to consider how to respond without offending you when they think you are wrong. Worse, they may simply have nothing worthwhile to say; silence can obscure shallowness as well as depth.

While in the West, people seem in a hurry to fill every pause with talk and aren't shy about disagreeing with another, the Japanese are comfortable with silence and do not run from it. But there is a flip side to this comfort with silence: The Japanese will avoid direct contradiction of another's position merely to avoid confrontation.

There is a subtext here: the Japanese preoccupation with maintaining harmony (*wa*). Japanese will often talk around a topic, certainly when it comes to their own opinion, largely in order to maintain this harmonious equilibrium. Japanese society and manners and especially language are all built around the desire to maintain *wa*, particularly as regards the social group, at nearly any cost. Thus, the Japanese are anything but "plain-speaking"—in fact, to speak plainly is to be seen as childish, unsophisticated, even arrogant, and to upset the delicate social balance.

While this use of silence allows the Japanese to maintain *wa* (see chapter 74), it can be at the cost of unresolved disagreements. This is one of the frustrations of foreigners in Japan, especially those engaged in business, which often

involves disagreements that must be resolved. It isn't so great in personal relationships, either.

A related concept is captured by the current vogue word *sontaku,* a previously obscure word that was chosen as the top buzzword of 2017 by the publisher Jiyukokuminsha. *Sontaku* literally translates as "guess" or "speculate" but is better explained by the phrase *"gyokan o yomu,"* which evokes a familiar English expression: "to read between the lines."

Sontaku became popular after it was used to describe actions in a scandal involving Prime Minister Shinzo Abe and his wife, in which underlings were suspected of acting on orders that were given indirectly, thus avoiding implicating anyone higher up the chain of command.

Sontaku in turn evokes another, somewhat darker, aspect to this use of silence "between the lines" to obscure the truth. The word *haragei* literally means "stomach art," but in its usage by businessmen and politicians there is a less polite translation, usually abbreviated to BS.

While even those who have been in Japan for many years tend to struggle with these counterintuitive concepts and behaviors—how can we communicate if we're not *communicating?*—approaching conversation with the Japanese with an openness to silence can be a revelatory experience. In this way, Westerners may yet find the truth in one of *our* oldest sayings: Silence is golden.

78. *Uchi-Soto*: In-Groups and Out-Groups

Japanese social customs are complex and dynamic and often depend, and change, based on circumstance, social standing, age, professional position, and myriad other considerations. The dichotomy of *honne* and *tatemae*—the concept of a true face and a public face—is one expression of this duality. The duality of *uchi-soto* is another.

Uchi literally refers to home, as in the family, but also the nation, the religion, the social class, the business role, or the many other groups within which a person feels secure and accepted. This is common to all societies, but it is particularly fine-tuned in Japan.

Soto literally means outside, and can refer to people who are outside of a social group, whatever its nature. For example, within a business setting, an employee of a company is *uchi*; a customer is *soto*.

These ever-shifting distinctions between *uchi* and *soto*, which can be different in nearly every situation in Japan, can become enormous barriers for foreigners in Japan—as they are intended to be. Foreigners are, by their very nature and standing, outside of Japanese society; the word for "foreigner," *gaijin*, in fact means "outside person." Getting past the barrier between *uchi* and *soto* can be virtually impossible for foreigners, even for those who spend decades working in Japan, marrying in Japan, even raising children in Japan.

The language and customs perpetuate these distinctions. Learning the language is hard enough, but learning all the various cues and meanings and manners required by the proper observation of the *uchi-soto* distinction is extremely difficult. Most foreigners never manage it; even those who eventually

268 ■ JAPAN FROM ANIME TO ZEN

understand the distinctions may well be still subject to it in ways beyond their understanding, let alone their control.

Foreigners of course aren't the only ones subject to the distinctions between *uchi* and *soto*. Japanese themselves are constantly shifting in and out of each position, depending on the situation. The *uchi-soto* distinction we are concerned with in this book, however, is between Japanese and *gaijin*. This is the essential distinction that you will have to deal with, especially if you are working in Japan; but even when you are traveling as a tourist, it explains many behaviors that are otherwise surprising or perplexing.

The distinctions can play out along a variety of lines, from body language to grammar. Many verbs in Japanese are conjugated not just to distinguish tense and person, but also forms of politeness. Some of these distinctions aren't just unknown to foreigners, they are actually counterintuitive when they are pointed out—*if* they are pointed out, which they probably won't be. The Japanese take such things for granted to the degree that they may not fully appreciate how invisible and incomprehensible the whole structure is to outsiders.

For instance, one of the key ways *uchi-soto* plays out in social and professional situations is that the members of the in-group treat the members of the out-group with a greater deference, even humility. This may seem counterintuitive, given that in most cultures those who are part of the in-group—whether it be family, or company, or nationality—are proud of their membership in the in-group and look down on the outsiders. This is true of the Japanese as well, except that the Japanese are forbidden by manners to *show* that pride; instead, they go in the opposite direction, adding extra humility to, say, their language, in order to humble themselves and even their entire group, so as to not offend the outsiders.

This matters enormously in business, and whole chapters in business books have been written about why and how to work around the complex grammatical and behavioral consequences of being an outsider working with insiders.

But visitors with less of a stake in any social outcome—tourists who are passing through relatively briefly, for example—can relax. You are not expected to understand these fine distinctions, and the deference shown visitors ensures that this will not unduly affect your experience of Japan. It may, in fact, enhance it, as you may find that Japanese go out of their way to please and accommodate you and your needs.

But just be aware that all of this goes deeper than mere hospitality. The *uchi-soto* distinction is always present in social and business interactions in Japan, and it adds a layer of complexity that a visitor ought to be aware of—you can be assured that your Japanese hosts certainly are!

79. What Is *Ki*?

Ki is possibly the most powerful, useful word in the Japanese language. Familiar to everyone from fans of modern manga to practitioners of aikido, alone or in combination with other syllables, *ki* can mean many things.

Among the words and concepts incorporating that one sound are the words for feelings (*kibun*), weather (*tenki*), energy (*genki*), and gloom (*kiomo*), as well as the words for heart, mind, spirit, flavor, spark, value, humor, scent, interest, essence, energy, atmosphere, will, and intention. The list is long, and when combined with other words, *ki* can create phrases of great nuance and versatility: *Ki ni iru* means to like

something; *ki ga kawaru* means to change one's mind; *ki ni kakeru* evokes the notion of worry.

Uniting all those various words is a sense, though hard to pin down in other languages, of change, of something moving within the spirit or emotions of a person, a place, even a thing. The problem of assigning any clear, unambiguous definition of *ki* is obvious: *Ki* is ephemeral, ambiguous. In fact, the difficulty comes because that ambiguity is a part of *ki* itself.

Perhaps the most important of the many meanings of *ki* is what is often translated as "spirit" or "energy." This is the meaning of the word that came to Japan from China with Buddhism in the 6th and 7th centuries CE. This Chinese word, *chi* (or *qi*), is familiar to many in the West and is written today in Japan as 気 but in its Chinese form traditionally as 氣, representing the symbols for rice and steam or vapor, combining a simple inanimate thing with an animate force that brings it alive as some sort of energy is released in the form of heat and vapor.

But the meanings of *qi* and its descendent *ki* are different. While the Chinese use *qi* to describe the life force that animates everything—which makes it casually comparable to words used around the world, *prana* in Hindu, *ruach* in Hebrew, "spirit" and its variations in the West—the Japanese use of the word is far more subtle, ambiguous, and thus, much more widely useful.

Ki's function in life is well understood in the martial art aikido, whose actions are focused almost entirely on the flow of *ki*. Aikido teacher and theoretician Stefan Stenudd refers to *ki* as "the ether of intention," and others have equated it with creative flow and inspiration. An attack in aikido is less about the body of the attacker than about the flow of energy he has initiated and "ridden." Consequently, the person being

attacked is inclined to use evasive moves to get out of the direction of the attacker's *ki* flow.

In his 1962 book *What Is Aikido?* the aikido master Koichi Tohei wrote (slightly edited for clarity):

> What is the right meaning of ki in our daily life? A good feeling, a bad feeling, a great feeling, timidity, vigor, courage, a retiring disposition, et cetera—these are terms we use in our daily life. Japanese use "ki" in these words to describe different aspects of life. The reason is that human beings were created from the ki of the universe. As long as a person receives ki, he is alive. Deprive him of ki and he dies; he loses his human shape. So long as his body is filled with ki and it pours forth abundantly, he is vigorous and filled with courage. On the other hand, when his body runs out of ki, he is weak, cowardly and retiring. In aikido training, we make every effort to learn how to fill our body with ki and how to use it powerfully. Therefore, we must understand the deeper meaning of ki.

But ordinary Japanese do not perhaps put nearly as much importance on defining *ki* as outsiders do. Its meaning is so basic, so woven into the language, into daily life, that few give it a second thought. *Ki* is just that: *ki*. A small word that expresses a concept that can be as deep, or as ephemeral, as any given moment.

80. The Two Pillars: Buddhism and Shinto

Japan is home to not one, but two main religions, Shinto and Buddhism (Christianity, Judaism, and Islam are practiced as well, but by relatively few Japanese). Shinto shrines and Buddhist temples often stand side by side, and the Japanese see no inconsistency in worshiping the Buddha and the many Shinto *kami* (gods or spirits) with virtually the same breath. After nearly fifteen hundred years, the two religions are deeply, culturally interconnected—though that was the result of a long, complex process known as the *shin-butsu shugo* (Shinto-Buddhism coalescence).

In some ways, Shinto and Buddhism are very different: Shinto was born and has always lived only in Japan. Buddhism came from India via China and has spread all over the world. Shinto observes what it has always has—nature—with relative historical continuity. Buddhism has developed many different schools of thought in Japan, from Pure Land to Zen to Shingon, among others.

Shinto is a combination of the Chinese words *shen* (gods) and *tao* (a way, or path), thus the Way of the Gods. Shinto has *kami* to spare, many with distinct personalities. Chief among them are Amaterasu-omikami, the sun goddess who is regarded as the divine ancestor of the Imperial Family, O-Inari-sama, the god of rice harvests, and Hachiman, the Shinto god of war (see chapter 52).

The numerous *kami* of Shinto are familiar to all Japanese, many of whom live near a shrine or display a small family shrine in a place of honor inside the home. But *kami* are not exactly gods; they are spirits of nature that want to help humans be happy. All they desire is some devotion and attention.

The grounds of Shinto shrines are usually marked by a torii *gate.*

As an animistic religion, Shinto sees *kami* in everything, from large structures that could easily be called temples—the shrine/temple distinction is just for convenience—to locations as simple as a rock outcropping, a waterfall, a single tree, or even a whole grove that have gained spiritual significance over the centuries.

It is this very ubiquity that best expresses the total integration of Shinto into Japanese daily life, as these shrines show the rather homey nature of Shinto worship. When a particular natural object is said to have a spirit (*kami*), it is often marked with a strip of white paper, or by the *shimenawa*, a braided straw rope.

Shinto has no scriptures, no central profession of faith, no leader, no holiest place, not even a concept of an afterlife. One does not need to be a "member" of a Shinto group; it is just there, for everyone. Shinto does not see human beings as "fallen" or "sinful" but merely as needing occasional guidance from the *kami*. Shinto concerns staying in harmony with the world, not escaping it, and the main purpose of Shinto ritual

is to keep the human soul in balance with the spirits of the natural world.

You will know you are at a Shinto site by the presence not just of *shimenawa* but by the bold, upright gates known as *torii*. These simple, distinctive structures—two bright orange uprights topped by curved cross-beams—are everywhere in Japan. They symbolize the gateway between the natural world and the spiritual world and serve as daily reminders of the interconnection between the two.

Shinto is at the root of Japan's most distinctive cultural expressions, especially the desire for balance and harmony with nature, which underlies such arts as ikebana, architecture, and garden design.

Buddhism, by contrast, came to the archipelago much later, in the 6th century CE, brought by the same Chinese and Korean monks who brought Chinese language and *kanji*, art and architecture, and such staples as tea. The Buddha ("Enlightened One") himself, who was born and lived in India in the 6th century BCE under the name Gautama Siddhartha, is known to Japanese as Sakyamuni or O-Shaka-sama.

Buddhism has no god *per se*. Buddhism is a religion of ethics and transcendence, with disciplines such as meditation designed to free the Buddhist from the worldly trappings of ego. Buddhism has many scriptures, a priestly caste that studies those scriptures, and ethical lessons from the Buddha to be learned and followed.

The form of Buddhism that arrived in Japan in the 6th century CE is Mahayana, or Great Vehicle Buddhism, which is also dominant in China and Korea. Theravada ("The Teachings of the Elders") Buddhism is the form practiced in India, Sri Lanka, Thailand, and other South Asia countries. Mahayana took on many elements of local worship as it moved north and east.

Japanese Buddhism has distinctly Japanese qualities. One particular form, Zen Buddhism, arrived in Japan from China in the 12th century and quickly became popular. Another form of Buddhism is Jodo-kyo or "Pure Land" Buddhism, in which devotion and prayer to the Amida Buddha will take the deceased to the "Pure Land" or the Western Paradise, aka heaven. For a discussion of these two forms, see chapter 82.

Buddhism and Shinto have coexisted since the arrival of Buddhism centuries ago, as the newer religion blended with the native religion. But there have been conflicts, even as recently as the late 19th and early 20th centuries, when the modernizing Emperor Meiji tried to create a state religion by separating the perceived interloper, Buddhism, from the native Shinto.

But after fifteen hundred years in the same culture, Buddhism and Shinto are woven together in a particularly Japanese way, and most Japanese have no problem observing both religions, albeit for different reasons: While weddings are usually performed under Shinto auspices, funerals are almost always a Buddhist affair, to the point that even many Japanese have occasional trouble telling where Buddhism ends and Shinto begins.

81. Things to Remember When Visiting a Shrine or Temple

The twin religions of Japan are accessed through the country's tens of thousands of Shinto shrines and Buddhist temples. Despite superficial similarities, these are quite different

institutions. But the rules for visiting them are similar, and most are simple common sense.

Most public Shinto shrines (*jinja*) are marked by either the iconic *torii* gates, which separate the mundane world and the spirit world, or by the braided straw ropes (*shimenawa*), which mark a particular tree or other natural object as a shrine. There are also enormous structures of national importance, such as the Ise Grand Shrine in Mie Prefecture and the Itsukushima Shrine near Hiroshima, with its grand *torii*.

Unlike Buddhist temples, which usually contain statues of the Buddha, Shinto shrines rarely feature depictions of the *kami* to which they are dedicated. More likely, they will have statues of foxes, horses, or other animals that serve the *kami*. Most shrines are simple structures with little decoration, a stark contrast to vast, extravagant Christian cathedrals and Hindu temples.

Buddhist temples (*otera*) are more familiar to many travelers, as similar temples are all over Asia. But the Japanese have put their own cultural stamp on them. With the forced separation of Buddhism and Shinto during the Meiji period, stronger distinctions were made between the two, with Buddhism, the "foreign" religion, downgraded.

Buddhist temples are not necessarily for worship, though that takes place in them; they are also used to house sacred objects, often (but not always) statues of the Buddha. Architecturally, they often look very much like Shinto shrines, right down to the *torii* gate—shrines and temples often share the same grounds. Temples can serve as monasteries as well, as indicated by the presence of monks (and often nuns).

On balance, Buddhist temples are the grander, with their enormous, dominating roofs and expansive interiors, rooted in the Chinese styles that have long dominated Japanese architecture.

Whether visiting Buddhist temples or Shinto shrines, remember several things in order to show simple respect. The world is full of tourists doing stupid or insensitive things. Don't be one of them.

- As you do almost everywhere else in Japan, remove your shoes at the door. At any entrance or *torii* gate, it is respectful to bow. Nothing elaborate is required, just a simple bow. You will thank yourself a hundredfold for traveling with slip-on shoes.

- Modesty is important in all places of worship. Shorts are simply not worn, and women should be sure to make sure no cleavage is showing. This is not a nightclub.

- Places of worship are considered pure, and all visitors must make a symbolic effort to purify themselves. Most Shinto shrines have a *temizuya* basin at which you rinse your hands. Take the ladle provided with one hand and rinse the other; switch hands.

- When you approach the shrine, ring the bell if there is one, and if there is a box for donations, a few coins are sufficient. It is best to simply observe others until you know the proper manners.

- Taking photos is often allowed, but don't assume it's OK. Watch for posted signs. If photography is not allowed, don't try to sneak a photo.

- At the shrine itself, the main form of ritual is to bow twice and then clap your hands twice, holding the second clap in front of your heart. After your prayers are said, a final bow is made.

- It shouldn't need to be said, but please: No smoking.













Most Japanese temples and shrines are made largely of wood. Burning down a centuries-old temple—or merely stinking it up—would not advance international understanding.

- The larger Shinto shrines have several chambers, the main hall (*honden*) being the sanctuary where the *kami* are said to live. Do not go into the *honden*; only priests are allowed there. The *honden* is marked by a *heihaku*, a stick with hanging streamers.

- Natural sites that serve as Shinto shrines are called *mori*, and they must be treated with the same respect as more familiar buildings. If it is a rock, don't climb on it for a picture.

- The *shintai* is the sacred object that often denotes the presence of the *kami*. It may be a rock or other natural object, often beautifully wrapped; it may be a mirror, which is a neat metaphor indeed.

- If you feel so inclined, offerings may be made at most Shinto shrines and Buddhist temples. Food (fruit, fish), *tamagushi* (branches), *shio* (salt), *gohan* (rice), *mochi* (rice cakes), and sake may all be offered.

82. Zen Buddhism vs. Pure Land Buddhism

Buddhism has, in two thousand five hundred years, taken many different forms. Spread over most of the Asian

continent, it was born in India in roughly the 5th century BCE, as both a religion and philosophy. As it traveled to Sri Lanka, Tibet, China, Myanmar, Thailand, Cambodia, Vietnam and other nations over many centuries, it developed in ways congruent with those cultures.

Buddhism reached Japan via China and Korea, but even before it got to Japan, Buddhism had split into two main sects. As noted in chapter 80, Theravada spread more to the south and east, through Sri Lanka, Myanmar, Thailand, and as far as Indonesia, while Mahayana spread more to the north and east, to Nepal, Tibet, China, Korea, Vietnam, and ultimately, Japan.

The two branches have historically been less antagonistic than, say, Shia and Sunni Islam or Catholic and Protestant Christianity, but there are differences. Theravada thinks of itself as being the truest to the Buddha's teachings, whereas Mahayana is a great umbrella over a variety of sects and schools, from Tantra to Pure Land to Chan (Zen) Buddhism.

Despite being a nonnative religion in many of these countries, Buddhism has survived in its several forms, less the result of splits as of refinements. The two forms that came intact from China—and that remain the forms one is most likely to encounter in Japan—are Pure Land Buddhism and Zen Buddhism. (To make things even more confusing, Pure Land Buddhism has itself split into two forms, Orthodox and Shin (True) Pure Land Buddhism. But for clarity's sake, we'll treat them as a single school for comparison with Zen.)

The basis of Pure Land Buddhism is devotion. Buddha was, if anything, a philosopher who had found a secret to understanding life; he never claimed divinity, nor did he talk about gods or heaven. But Pure Land Buddhism would nevertheless sound somewhat familiar to devotees of Islam and Christianity, since the basic idea is to show one's devotion to what

has been named Amida Buddha, the Celestial Buddha. (This Buddha is actually an entirely different historical person, a monk called Dharmakara, rather than the historical Buddha, who was an Indian prince known as Siddhartha Gautama.) Through devotion—prayer, chanting Amida Buddha's name, and other acts of devotion—one is assured one's place in the Pure Land, or Western Paradise or, as English speakers of any religious stripe would call it: heaven.

In Pure Land, moreover, one's own works and deeds have no impact on one's salvation. All that matters is one's devotion to Amida Buddha. Thus, in Pure Land, which was brought to Japan by a man named Honen in the 12th century, the way to salvation (the Pure Land) was not through philosophy or meditation but by "behaving themselves like simple-minded folk." Likewise, the only practice required of Pure Land devotees is the recitation of the words "Namu Amida Butsu" (homage to Amida Buddha).

Zen (Chinese *Chan*) Buddhism, by contrast, is more austere, with many more practices and conceptual pursuits. It is also more in the here-and-now and would thus seem to be a return of sorts to the Buddha's original teachings. One way was, in a word, meditation. Rather than chanting in a devotional prayer to a deity, the student of Zen sits quietly, probing inward to find his "true nature," which is, in Zen teaching, nothingness. The great difficulty of doing this gave rise to many schools of Zen, as well as to some of Japan's greatest arts and works of philosophy. That is because, while inquiry also plays a role, there is a clear understanding in Zen that no concept or explanation can deliver the realization that is *satori*, or "enlightenment." This has allowed Zen to travel farther in the West, where it has been fused with other religious or even non-religious belief systems.

But both forms of Buddhism are important in Japan

and Japanese culture, for together, they offer two different paths—the path of the heart and the path of the head—to the same goal.

83. The Subtle, Confounding Zen *Koan*

The Zen *koan* is one of the least understood of Japanese creations, by either foreigners or even most Japanese—but that is by design. The essence of a *koan* (pronounced as two syllables, *ko-an*) is that it is not comprehensible by the rational mind but instead works subtly, over time, on the subconscious.

The *koan*—based on the Chinese word *gong'an*, which is a compound word meaning, literally, "public case"—is an extremely complicated form, one that is deeply embedded in monastic discipline and Buddhist study. It is the result of more than a thousand years of development and discussion, and yet can appear relatively simple; thus the koan is easily misunderstood and even more easily caricatured.

But the *koan* serves a very specific function within Zen Buddhism. It is meant to test the student, first to create what is called "great doubt" and then to measure how far he has developed in his understanding. A teacher can see, through the way the student processes a *koan*, how much progress toward understanding he or she is making. There is, in fact, a whole "curriculum" of more than a hundred *koan* that a student will slowly work through over many years of study.

Some *koan* may be familiar and have come to express a general insight that we've gained through even casual familiarity

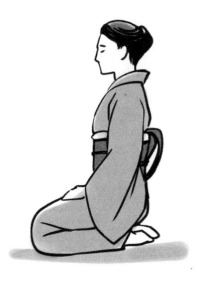

Seiza *is the formal posture for seated meditation.*

with Zen. The most famous *koan* of our time is very famous indeed; it asks a question that anyone can understand, yet few can adequately answer:

What is the sound of one hand clapping?

Spoiler alert: There is no answer. A *koan* is not always a question—it can be a short conversation, it can be a declaration, or it can be a dialog.

But no matter the form, even if it is as simple as the one above, the "answer" is not to answer the question. The "answer" is to keep asking the question.

Perhaps you're already confused. Perhaps that's good.

Other *koan* that have become well known through their appearance in conversations or even popular media through the decades include:

What was your original face before your mother and father?

If you meet the Buddha on the road, kill him.

Look at the flower and the flower also looks.

Koan have been compared to court rulings that are subsequently modified or expanded or redefined by subsequent courts, that is, subsequent Zen masters. But they are also most certainly a literary form, based on the wordplay, metaphor, and use of allusion to any number of Chinese and Japanese literary forms. Yet there is a practical purpose to the use of a *koan*, and that purpose is not literary: It is simply to keep one practicing Zen.

The *koan* works because it is not a thing; it is an activity, a process, a verb more than a noun. While there may eventually be an answer that comes, or an insight, it may also be that that insight is still not all the *koan* can teach. Perhaps one will contemplate the *koan* for years; perhaps its essence will be revealed in an instant; perhaps it never will.

This is a tough concept to understand. But the point is in the attempt: The *koan* is both the "thing" being sought and the attempt—or the ongoing attempts—to understand.

At the same time, there *are* correct answers to the *koan*, though how that plays out is a result of the interaction between the student and the master, and may be assessed based on the master's interaction with the student. The master's assessment of the student's understanding comes through in the way the student handles the *koan*.

Obviously, despite the fact that many people have heard some of these *koan*, they are not simply aphorisms to be trotted out to explain a spiritual truth. Any use of them in this manner will fall short of what a *koan* can do. The only way a *koan* is likely to "work" is through a long, detailed process of dialog between master and student.

In some traditions, this can take ten years or more,

depending on the student. There is a point at which the successful student is said to have "learned" the *koan* curriculum, but it is a complicated, lengthy process and a deeply obscure form of knowledge—which is the whole point. The processes around it are daunting, but a mastery of that process is something to which serious students of Zen aspire.

For the rest of us, the *koan* may remain a thing of mystery, or perhaps just a momentary diversion, something to play with. It may have value in this manner, but it is also clear that any understanding of it is liable to be ephemeral at best. The *koan* will continue to elude rational understanding—for that is its purpose.

84. The Five Elements in Japanese Culture

When traveling around Japan, you will quickly become used to seeing a number of different religious representations: the *komainu* (lion dogs) that stand at either side of a Shinto shrine entrance; orange *torii* gates; and, of course, the Buddha.

Then there are the representations of the *godai*, the concept of the five elements that inform all of reality. *Godai* is often represented by the *gorinto*, a sculptural form that can best be described as a stack of geometric shapes, like a totem pole or a particularly elegant (not to mention gravity-defying) stack of child's blocks. A cube forms the base, with a sphere on top of that, then a pyramid, then a crescent, and at the top, a form reminiscent of a lotus flower.

The *gorinto* isn't so ubiquitous or striking that it jumps out

at you, but once you know about it, you may notice it more often, particularly in five-tiered lanterns and small pagodas in Japanese gardens.

The word *godai* stands for the one of the fundamental concepts in Japanese culture: the five elements. The word combines the *kanji* for "five" (*go*) and "great" (*dai*). Based on concepts that came to China from India, the *godai* elements are universal: earth, water, fire, wind, and, perhaps strangely, void. Each element is said to represent a certain tendency in the world, whether it be in physics, in spirituality, or even just in personality. Together they are said to explain the nature of things, of action, of societies, and of people.

In Japanese cosmology, one by one, beginning with the most basic, they are:

- **Chi** (earth): Represented by the square, *chi* (not to be confused with *ki*, the essential energy of the cosmos) is the fundamental element, the fundamental base upon which all else rests. It is the element that engages all five human senses. Earth is basic matter, often represented by (and in) stone, which is not sentient, doesn't move of its own accord, and has no great motivating energy. *Chi* is acted upon only. It is inanimate. In terms of personality, it is similarly inert: stubbornness, yes, but also stability, heft, and gravity. *Chi* is basic, fundamental, even dumb; but as a quality, it is also dependable, sure, solid. It is a good base on which to build the *gorinto*.

- **Sui** (water): Represented by a circle, *sui* sits upon the solid base of *chi*, but look at the difference! Instead of stable and unmoving, *sui* is ready to change at the slightest movement, it is a ball ready to roll—or to bounce. *Sui* flows, representing the formless things of

the world, including the emotions to which humans are subject, ever changing, ebbing and flowing, like blood, like the tides. *Sui* is water, but it is also plants, which grow from earth (*chi*) and water, reaching for light, expanding and twisting, but forever anchored.

- *Ka* (fire): A flame-like pyramid represents fire, sitting upon the sphere of *sui*, pointing upward; the motivating energy that lifts, animates, and, ultimately, destroys. Animals, including humans, are *ka*, fire. Ka is creativity; it is life, it is the way the body burns food for fuel, and it is the heat from that process—all are *ka*. Motivation, intention, desire, drive, passion—these are *ka*.

- *Fu* (wind): Atop the triangle of *ka* lays the crescent-shaped *fu*, representing wind, emblematic of things that move, that have freedom, that fly through the air. *Fu* is the mind in action, thoughts flying about, our mental agility and freedom to create anything out of nothing. Air is invisible, it can't be touched or smelled or even heard ... until it connects with one of the other elements, and then *everything* happens: Fires blaze, water falls as rain, dust moves across the face of the planet. *Fu* isn't just air: *Fu* is air in motion. *Fu* is motivation, growth, and change, all forms of movement. *Fu* is freedom, it is breath, the breath of life, of compassion—even, perhaps, of wisdom. *Fu* is spirit.

- *Ku* (void): The fifth element sits atop even *fu*'s crescent, a shape that seems to combine the circle of water with the rising energy of fire but is most recognizable as that central Buddhist icon, the lotus flower. Despite that, *ku* represents the void,

nothingness. *Ku* is emptiness, *ku* is ... not. *Ku* can be translated as sky, as heaven, but at its core, *ku* is the absence, the hole at the center of who we think we are, the womb from whence we came, knowing nothing, having nothing; *ku* is the death that looms before us. And yet, this fifth element is also our spirit, our knowing beyond thoughts, the mystery we glimpse from time to time as we cycle through the other elements. *Ku* is the source of our creativity, the source of the creativity of the world.

Together, the five elements—the *godai*—and their sculptural manifestation, the *gorinto*, are a wonderful representation of the elements of life, the building blocks, as it were, of existence, and a delightful, thought-provoking sight in the temples, shrines, and gardens of Japan.

85. What Does *Wabi-Sabi* Mean?

If one were to pick one phrase that sums up the traditional aesthetic sensibility of the Japanese, it might well be *wabi-sabi*. A combination of two words with overlapping definitions, *wabi-sabi* might be the quintessential Buddhist view of the facts of existence: Life and art are beautiful not because they are perfect and eternal, but because they are imperfect and fleeting.

If you note a touch of melancholy there, you have begun to understand *wabi-sabi*.

Born of the Mahayana Buddhist understanding of life as impermanent, marked by suffering, and, ultimately, empty,

wabi-sabi adds to that recognition a distinctly Japanese sensitivity to natural processes and materials and to the pleasures of simplicity. Whereas classical Western aesthetic ideals were of beauty and perfection, of symmetry and a fine finish, *wabi-sabi* is hard-nosed and realistic: Nothing lasts; nothing is perfect. Accepting these hard facts opens the door to the realistic appreciation of a deeper beauty.

The words were born separately and referred to different things. *Wabi* originally described the loneliness of living in nature, far from society; *sabi* meant withered, as is a flower past its bloom. But during the 14th century, the two words began to take on more positive meanings, with *wabi* describing the more positive aspects of living alone in nature: a quiet, rustic simplicity. *Sabi*, on the other hand, began to find beauty in old age and focused instead on the serenity that can come with time, when inevitable wear becomes a patina, and scars become signs of experience.

What drove the conflation of these two words—their change into the more optimistic *wabi-sabi*—was Buddhism, as Buddhists in Kyoto during the 14th century saw the acceptance of this reality as a positive step toward enlightenment. At the same time, the simple, elegant, rustic craftsmanship that became known as *wabi-sabi* came as a reaction to the extravagant perfection of Chinese art and culture. Thus, Japan claimed its own unique aesthetic.

In Japan, signs of *wabi-sabi* are so ubiquitous that one hardly notices them. But they are there in the pottery from which one drinks tea or sake, in the weathered wood of Kyoto's temples, and in the Japanese gardens where dead petals cover the mossy ground.

Wabi-sabi is widely discussed at design conferences, in art galleries and symposia, and in interior decorating magazines, foreign and domestic, which regularly run features on how to

Bare branches and dry leaves epitomize the wabi-sabi *aesthetic.*

adopt the principle of *wabi-sabi* to decorate the living room with old family furniture and properly chosen (and positioned) thrift store knick-knacks.

Thus, in contemporary culture, *wabi-sabi* has been relieved of much of its existential melancholy and has been embraced as a pleasure in authentic expression, natural materials, rough edges, imperfect glazes, even deliberate flaws. It stands in particularly marked contrast to the characteristics of modernism, with its mass-produced uniformity and its seemingly indestructible materials like plastic, stainless steel, silicon, and the rest. In Japan particularly, the contrast can be startling.

Wabi-sabi preceded modernism and starkly contrasts with it. The clean, smooth lines of modern design and architecture are the opposite of the uneven, asymmetrical, and always curved lines of *wabi-sabi*. The technological polish and visual

290 ■ JAPAN FROM ANIME TO ZEN

clarity of the modern is nothing like the naturalism and ambiguity of *wabi-sabi*.

In Japan, as in other cultures, the rise of technological perfection has driven a corresponding appreciation of natural materials and organic processes. It is no surprise that the promise of perfection through technology—and the increasing awareness of its limitations in an imperfect world with imperfect people—has given a renewed appreciation to a concept like *wabi-sabi*.

As with many Japanese concepts, *wabi-sabi* can refer to something as quotidian as the design of a tea set or as fundamental as enlightenment (*satori*) itself.

In Japan, as in other cultures, these concepts and their products coexist. But in Japan, both are perhaps more strongly felt and more elegantly displayed. How these two concepts continue to interact, or even if they will continue on parallel paths, will be part of the story of Japanese culture well into the 21st century. But no matter the course of modernism, given the Japanese character, it is likely that the concept of *wabi-sabi* will endure.

86. *Ikigai*: A Reason for Living

In recent years, the modern world has been inundated by books, workshops, and public lectures about the importance of finding one's purpose in life. Those spreading this notion assure their audiences that knowing their purpose will not only bring spiritual well-being, it can raise their income and improve their health.

In Japan, the idea of having a purpose—what the French

call a *raison d'être*—is hardly groundbreaking. The Japanese have long had a word for this sense: *ikigai*.

Formed of the word roots *iki* ("life") and *kai* ("the realization of what one hopes for"), *ikigai* is most often translated as "a reason to live." On the island of Okinawa, Japan's southernmost and sunniest region—and home to some of the longest-living humans on the planet—it is translated as "a reason to get up in the morning."

That colloquial saying almost vibrates with the feeling it intends to convey. *Ikigai* is familiar to most Japanese, and is something that many Japanese feel is worth taking the time to discover—and discovering one's *ikigai* can indeed take time. You can begin to formulate a coherent sense of purpose by asking yourself four initial questions. The questions and the answers may overlap, in some profound ways, but all four questions must be answered in order to develop a clear sense of your *ikigai*.

1. The first question is: **What do you love, what is your passion?** This question gets at a great motivator in life, especially in the modern world, where many of us are focused on satisfying our desires as quickly and as often as possible. What do you love? What would you do if you didn't have to make money, if you could just follow your heart? This question will resonate with many, but it can also be intimidating. Perhaps the second question is easier.

2. That second question is: **What are you good at?** This is the question you ask to discover your vocation. For many, the answer is perhaps the same as the answer to the first, but for many, it is not. It is a more practical question, less emotional, and perhaps easier, for we all know on some level what we are good at. We

292 ■ JAPAN FROM ANIME TO ZEN

may want to be an actor, that is our passion, but we find ourselves pushed into running the box office instead, because we're good at it. This is our vocation.

3. The third question is: **What does the world need from you?** This gets more difficult. It is, ultimately, the question of what your mission is. Why are you here on earth? What can you achieve that will help others; what will make you valuable to society; what will make the world a better place? What do others value about you, those aspects of yourself that you may not value so much yourself?

4. The last question is the most practical, particularly in modern times: **What can you get paid for?** What is your profession? This, again, is somewhat simpler, since, unless you're still a child, you have had to work to make money. It is also a variation on the third question: What do others value about you, and value enough to give you money to do?

We can see how the answers to these questions may overlap, or may be different. When they are all different, how do you manage to combine them or integrate them, so that all four questions are answered harmoniously?

You can quite easily get caught up in one or the other of these. Pursuing your passion or focusing exclusively on what makes you money are ways you can get out of balance. Fulfilling your mission without being able to support your family doesn't work. Making lots of money without satisfying your passion or mission can leave you feeling empty and unfulfilled. Doing something you love but that contributes nothing to others may feel self-indulgent.

This is the puzzle of *ikigai*: figuring out what your distinctive combination may be. It may be that asking these

questions produces answers that all fit together and that you quickly move forward, confident in your knowledge of your *ikigai*. But it may not work that way; finding your *ikigai* can be a time-consuming, challenging process.

But that's why, in Japan, solving the riddle of your *ikigai* is a process well worth the effort. Together, these four elements can bolster and anchor a well-rounded, satisfying life that not only provides pleasure when you do what you love, or money when you do what you can be paid for, but a sense that you are fulfilling your destiny as well as helping others. It may also be the Japanese concept that travels the best, presenting a way of approaching life that will be useful to you, in any culture, as you make your way through the world.

30 EXCELLENT BOOKS ON JAPAN

Bookshelves around the world are filled with thousands of different books covering every aspect of Japan and its people, food, culture, and history. So any bibliography covering Japan is bound to be incomplete. Still, the following nonfiction books on Japan are an excellent path forward for anyone whose appetite for knowledge of Japan has been stimulated by this book. If you're interested in Japanese fiction, see chapter 30 for a small selection of titles to start you off.

GENERAL INTEREST

The Chrysanthemum and the Sword: Patterns of Japanese Culture by Ruth Benedict (Mariner Books, 1946). Writing at the behest of the U.S. War Department, Benedict was unable to actually visit wartime Japan, but her well-researched book informed much understanding of Japan, even among the Japanese themselves, who have bought more than two million copies of it in translation.

Japan Unmasked: The Character and Culture of the Japanese by Boyé Lafayette De Mente (Tuttle Publishing, 2005). De Menthe was a penetrating observer of Japanese culture, warts and all, able to boil complex concepts down to easily understood language. Despite his passion for the country, he refused to romanticize or idealize Japan, and his books are balanced explorations of the country.

The Donald Richie Reader: 50 Years of Writing on Japan, edited by
Arturo Silva (Stone Bridge Press, 2001). An excellent place to begin
discovering the works of one of Japan's greatest expatriate writers,
covering decades of his writing, on every conceivable topic regard-
ing Japan.

JAPANESE HISTORY

The Making of Modern Japan by Marius B. Jansen (Belknap Press,
2002). Covering the centuries from 1600, Jansen's in-depth look at
the development of Japan as a coherent whole is a grand overview
that provides excellent context for further explorations.

Shogun: The Life of Tokugawa Ieyasu by A. L. Sadler and Stephen
Turnbull (Tuttle Publishing, 2009). More accurate than James
Clavell's popular novel of the same name, this detailed history
describes the creation of the epoch-defining Tokugawa shogunate
and vividly brings to life one of Japan's most important leaders and
his colorful period.

The Last Samurai: The Life and Battles of Saigo Takamori by Mark
Ravina (2004, John Wiley and Sons). This is the remarkable story of
the samurai who helped overthrow the shogunate and restore the
emperor, only to see his class abolished by the new ruler.

Emperor of Japan: Meiji and His World, 1852–1912 by Donald Keene
(Columbia University Press, 2005). An in-depth (nearly 1,000-page)
look at Japan's most important emperor, who oversaw and still
symbolizes Japan's transition from a feudal to a modern state.

Japan At War: An Oral History by Haruko Taya Cook and Theodore F.
Cook (New Press, 1993). This is the first comprehensive oral history
of the experience of the Japanese before and during World War II, a
story not often told in English.

Hirohito and the Making of Modern Japan by Herbert P. Bix (Harper,

2000). The true story of Japan's wartime emperor has been shrouded in layers of positive, postwar propaganda that was needed to rebuild Japan and unite it with the West. Here he is in newly documented, and not-so-idealized, detail.

Embracing Defeat: Japan in the Wake of World War II by John W. Dower (W. W. Norton and Company, 1999). The definitive history of the American Occupation of Japan, this book is crucial to understanding Japan's place in the world after World War II—as well as the impact the Occupation had on U.S. history.

The Rising Sun: The Decline and Fall of the Japanese Empire, 1936–1945 by John Toland (Random House, 1970). This history of Japan's imperial overreach won the Pulitzer Prize, and it's obvious why: highly detailed, with a clear-eyed view of imperial Japan's military mentality, from its brutal invasion of Manchuria to its fiery conclusion in Hiroshima and Nagasaki.

TRADITIONAL JAPANESE CULTURE

Zen and Japanese Culture by D. T. Suzuki (Pantheon Books, 1959). While foreigners tend to overestimate Zen's role in Japan, and contemporary Japanese largely ignore it, Suzuki's classic work ably demonstrates that this Buddhist sect's role in Japanese culture, particularly as regards the arts, is nevertheless significant.

Learning to Bow: Inside the Heart of Japan by Bruce Feiler (William Morrow, 2009). A light, entertaining tale of one American's experience teaching English in Japan for a year, with insights into the vast differences between the two cultures.

Etiquette Guide to Japan by Boyé Lafayette De Mente (Tuttle Publishing, 1990). This slender volume features De Mente's characteristically bracing insights into Japanese manners, providing one of the best ways to get a grip on the country's slippery cultural concepts.

Exploring Kyoto: On Foot in the Ancient Capital by Judith Clancy (Stone Bridge Press, 2018). While ostensibly a guidebook for travelers, Clancy's in-depth exploration of a fascinating, beautiful city, the heart of old Japan, is an excellent primer on Japanese culture and history.

Kansai Cool: A Journey into the Cultural Heartland of Japan by Christal Whalen (Tuttle Publishing, 2014). Japan is rich in culture from top to bottom, but while Tokyo is crucial, it is the Kansai area—the western region that includes Kyoto, Kobe, Nara, and Osaka—that is the longtime cultural, religious, artistic, and political heartland of Japan.

Japan's Cultural Code Words by Boyé Lafayette De Mente (Tuttle Publishing, 2011). This short, pithy book is rich with brief summations of ancient concepts that still exert a strong pull on the Japanese psyche,.

Anthology of Japanese Literature: From the Earliest Era to the Mid-Nineteenth Century, edited by Donald Keene (Bradford and Dickens, 1956). The sheer volume of Japanese literature can be overwhelming, so it is nice to have Keene's expert curation here. Now more than a half-century old, Keene's work stands up.

CONTEMPORARY JAPAN

Cool Japan Guide: Fun in the Land of Manga, Lucky Cats, and Ramen by Abby Denson (Tuttle Publishing, 2015). Short, and in the form of a comic book, Denson's personal take on all things contemporary Japan is light and enjoyable, a fine palate cleanser when Japan's complex history and cultural intricacies become a bit overwhelming.

Tokyo Vice: An American Reporter on the Police Beat in Japan by Jake Adelstein (Pantheon, 2009). This entertaining, occasionally hair-raising first-person account of a young American's

twelve- year stint as a crime reporter for a Japanese newspaper exposes the many dark sides of modern Japan.

A Geek in Japan by Hector Garcia (Tuttle Publishing, 2011). In his lighthearted guide to *otaku* (nerd) culture, from *pokemon* to *manga*, Garcia looks at aspects of internet-era Japanese culture that are a nice complement to more common guides to traditional arts.

Dogs and Demons: Tales from the Dark Side of Japan by Alex Kerr (Hill and Wang, 2001). Longtime Japan resident Kerr's look at the failures of modern Japan—from the inadequacies of its education system to its tenuous pension structures—is a healthy antidote to the often-expressed notion of Japanese superiority.

Modern Japan: All That Matters by Jonathan Clements (Teach Yourself, 2013). This breezy, brief introduction to postwar Japan is a great place to start getting a grip on the enormous changes wrought by the U.S. Occupation and the nation's subsequent, partial democratization.

Lost Japan: Last Glimpse of Beautiful Japan by Alex Kerr (Penguin, 2015). This personal memoir ranges from corporate boardrooms to the secluded valley the author calls home, sounding a warning about the environmental destruction that threatens Japan.

Japan and the Shackles of the Past by R. Taggart Murphy (Oxford University Press, 2014). In this sweeping, in-depth look at modern Japan since the Meiji Restoration, author Murphy explains Japan's current malaise in the context of world history and explains why, despite its current difficulties, Japan remains a crucial actor on the world stage.

ASPECTS OF JAPANESE PSYCHOLOGY

The Japanese Mind: Understanding Contemporary Japanese Culture, edited by Roger J. Davies and Osamu Ikeno (Tuttle, 2002). Exploring

a wealth of Japanese cultural concepts, Davies and Ikeno neverthe-less manage to make even the most complex ideas comprehensible.

Shutting Out the Sun: How Japan Created Its Own Lost Generation by Michael Zielenziger (Deckle Edge, 2006). Reaching beyond the emblematic phenomenon of the *hikikomori* (young shut-ins), Zielenziger looks at all the ways contemporary Japan is failing its people and at what this portends for the future.

The Anatomy of Self: The Individual Versus Society by Takeo Doi (Kodansha USA, 1986). Along with his *Anatomy of Dependence*, this is a psychologist's in-depth look at the complexities of Japanese family and social life and their often-unexamined impacts on individuals.

In Praise of Shadows by Jun'ichiro Tanizaki (Leete's Island Books, 1977). The author of *The Makioka Sisters* and other popular novels offers this brief, poetic essay on Japanese aesthetics, a good key to the Japanese mind and character.

A Beginner's Guide to Japan by Pico Iyer (Random House, 2019). One of today's greatest travel writers, Iyer has lived in Japan for more than thirty years but still finds it confounding and contradictory. Eloquent and witty, his observations may surprise even some Japanese.

INDEX